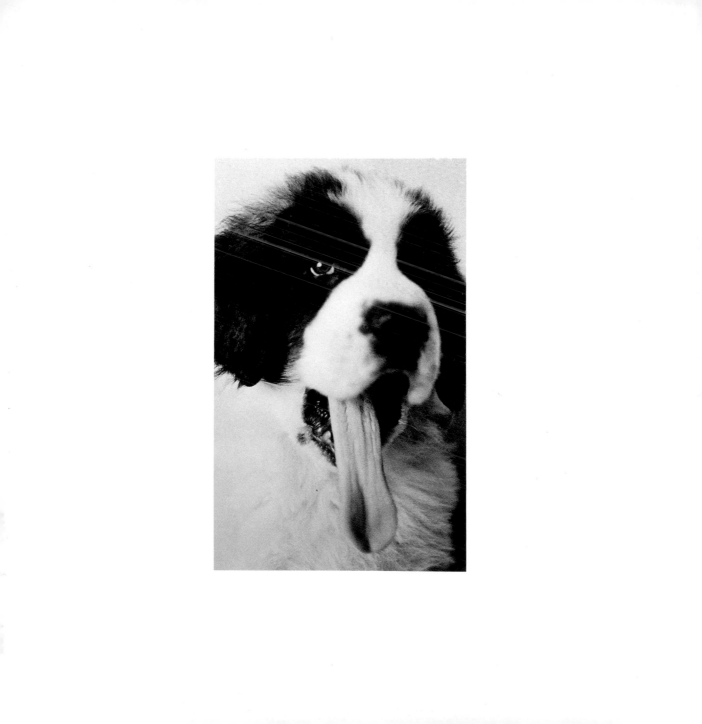

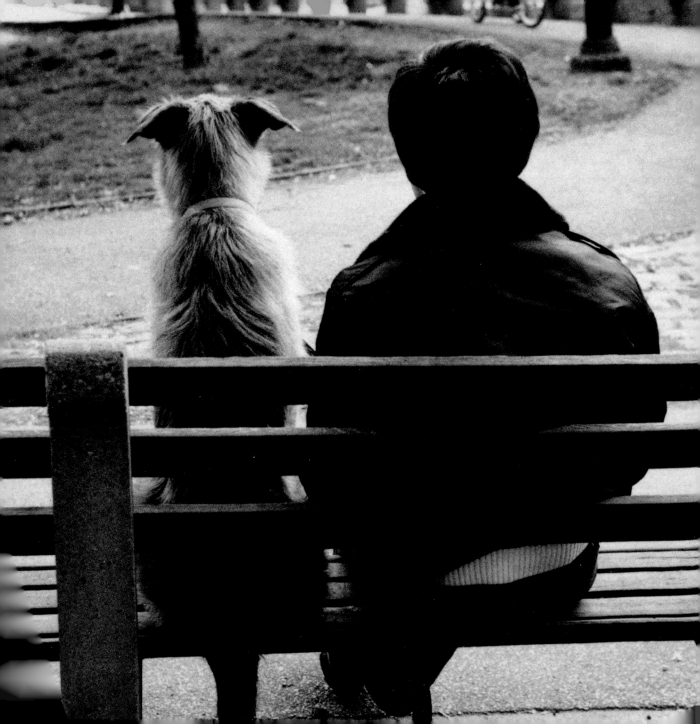

# THE BIG BOOK OF

# DOGS

EDITED BY J.C. SUARÈS

welcome
BOOKS

NEW YORK • SAN FRANCISCO

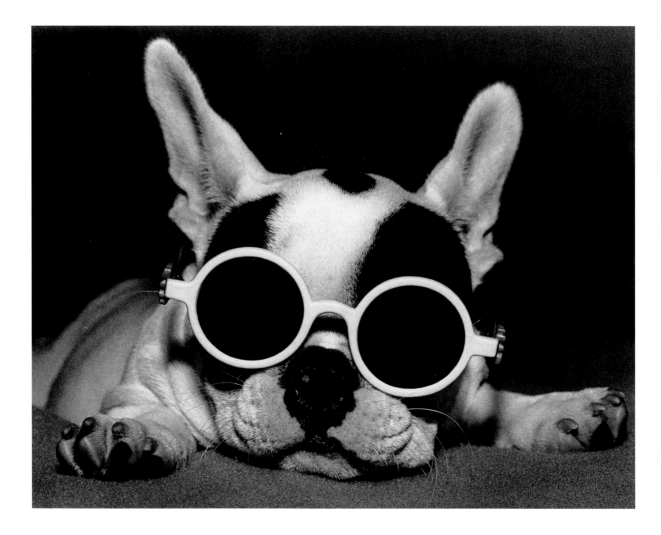

# f o r e w o r d

I'VE SHARED MY HOUSE WITH A SERIES OF LARGE, GENTLE ANIMALS, the kind of pure-bred urban pet—nicely groomed, well fed, and well behaved—that could never survive in the wild. And I've learned a good bit about dogs by walking them three times a day on the Upper East Side of Manhattan, an upscale neighborhood where people are as self-conscious about their dogs' pedigrees as Angelinos are about their cars. Here are some of the things I now know.

**FACT NO. 1**

Little dogs just don't realize how small they are. And it seems that the smaller they are, the worse their temper. They'll challenge any dog, even some twenty times their size. They're noisy and sometimes work themselves up to such a state of fury that you'd think they could take a hyena's head off.

**FACT NO. 2**

It's a mystery, but pretty dogs know how pretty they are. They've got an attitude not unlike move stars and models. They expect fans to gush, and their owners to spoil them rotten, including buying them winter coats to keep them warm and raincoats to keep their fur (which has been groomed to the nines) from getting wet in the rain.

# f o r e w o r d

**FACT NO.3** Some dogs, the smarter ones, actually know the difference between enthusiasm and butt kissing. It's the few that don't know the difference that give dogs the reputation for being groveling idiots.

**FACT NO.4** Dogs—unlike cats, who have immaculate toilet habits—are only housebroken out of fear. If it were up to them, they'd be pooping in every room.

**FACT NO.5** Big dogs never know just how big they are. Some think that they're actually small enough to fit in your lap. In fact, they're dying to sit in your lap, even if you're standing up.

**FACT NO.6** There have been some great hero dogs in history, but the greatest dogs of all time are fictitious. The greatest of these is Snoopy, the product of Charles M. Schultz's imagination—and an aviator, scoutmaster, tennis pro, philosopher, and companion to Charlie Brown, star of Peanuts. The forerunner of Snoopy was a real black-and-white dog named Spike given to a thirteen-year-old Schultz. "He was a mixed breed and

slightly larger than the beagle Snoopy is supposed
to be," wrote Schultz. "He probably had a little
pointer in him and some other kind of hound, but he
was a wild creature. I don't believe he was ever
completely tamed."

When Schultz decided to put a dog in Peanuts, he
used the general appearance of Spike. "I had
decided that the dog in the strip was to be named
Sniffy," recalled the cartoonist, "until one day,
just before the strip was to be published, I
glanced down at a row of comic magazines
and saw one about a dog named Sniffy." He
then recalled that his mother had once said that
if they ever had another dog, they would name
him Snoopy!

—J. C. Suarès

A skeptic world you face with steady gaze;

High in young pride you hold your noble head;

Gayly you meet the rush of roaring days.

(Must you eat that puppy biscuit on the bed?)

Lancelike your courage, gleaming swift and strong,

Yours the white rapture of a winged soul,

Yours is a spirit like a May-day song.

(God help you, if you break the goldfish bowl!)

........................................................

**DOROTHY PARKER**
**Verse for a Certain Dog**

LAURA BAKER-STANTON
DASH, 1993

*He's about eight or nine years old in this picture, and it's the only one
I'll ever get of him where he's not three feet in the air—let alone standing still.
He's a multistate frisbee champion, and doesn't laze around very much.*

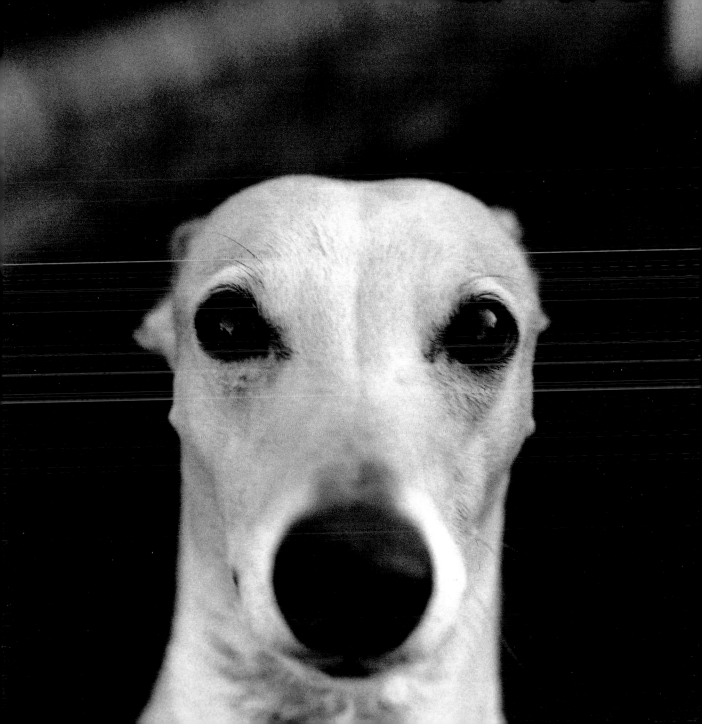

Muggs was afraid of only one thing, an electrical storm. Thunder and lightning frightened him out of his senses (I think he thought a storm had broken the day the mantelpiece fell). He would rush into the house and hide under a bed or in the clothes closet. So we fixed up a thunder machine out of a long narrow piece of sheet iron with a wooden handle at the end. Mother would shake this vigorously when she wanted to get Muggs into the house. It made an excellent imitation of thunder, but I suppose it was the most roundabout system for running a household that was ever devised. It took a lot out of Mother.

......................................

**JAMES THURBER**
**The Dog That Bit People**

ANTONIN MALÝ
EDA, PRAGUE, 1980

*Eda belonged to some married friends of mine, Michaela and Peter. She was a present from Peter for Michaela, who was about to have a child in the hospital. It took two strong men to get the dog onto the bookshelf. Their fee was eight pork sausages—a Czech national food.*

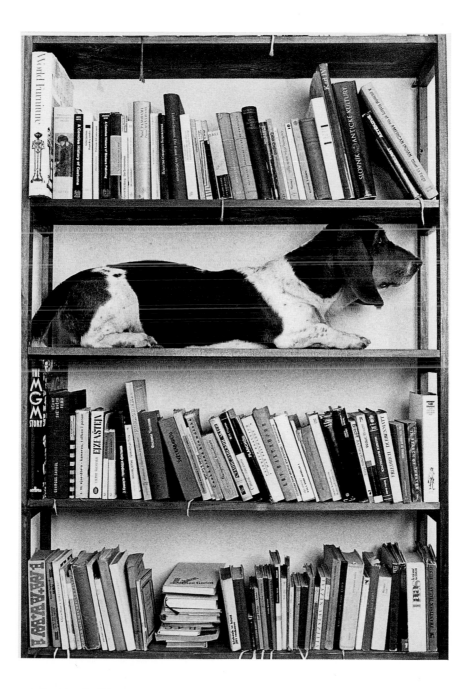

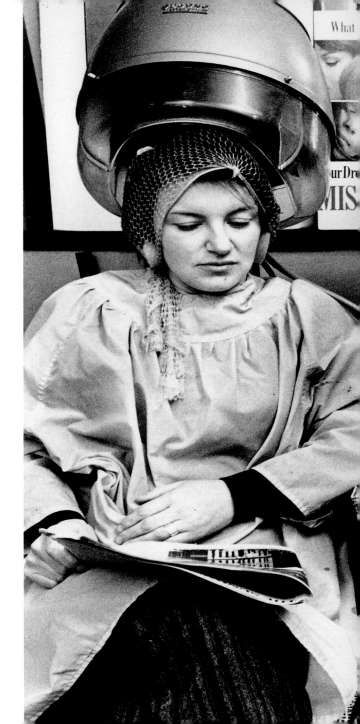

## JOHN DRYSDALE
### HAIRDRESSER'S HOT DOG, 1969

*George Constantine's problem with his London salon
is that he can't get it into full production. His dog Rex, a
six-year-old Labrador-Mastiff cross, has taken up a seat
nearly his whole life. Most of the regular clients are so used
to it, they just ignore him. The curler and hairnet wig are
for the benefit of the new customers, who often ask why Rex
is under the dryer. Rex just sits there with a "humans are so
silly" expression and never bats an eyelid.*

### OVERLEAF: JOHN DRYSDALE
### HOLLOW LAUGHTER, 1975

*The strange animal inhabiting this tree trunk near Daventry,
England, happened while Trace Clunes was playing follow
the leader with Winnie, her Bulldog. Her grandfather had
just brought the log over for firewood and Winnie, who goes
into everything from a box to a hole, couldn't resist.*

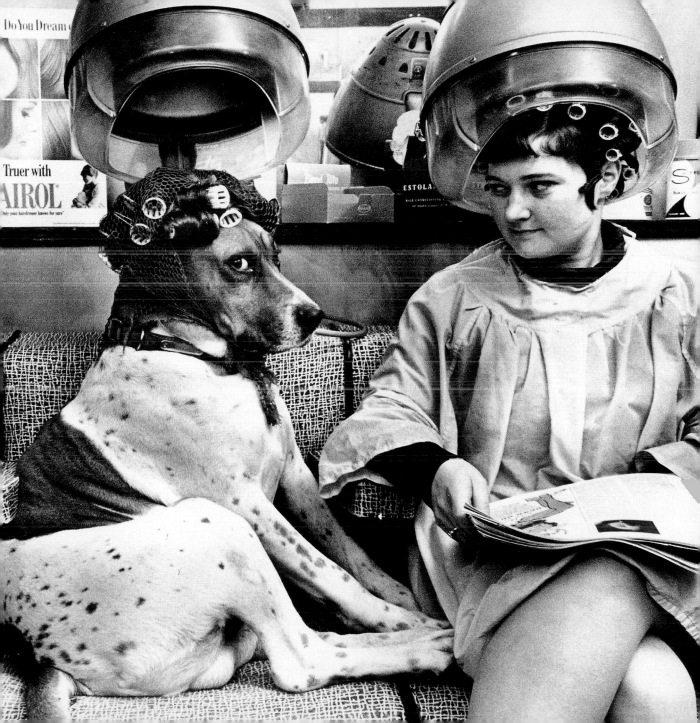

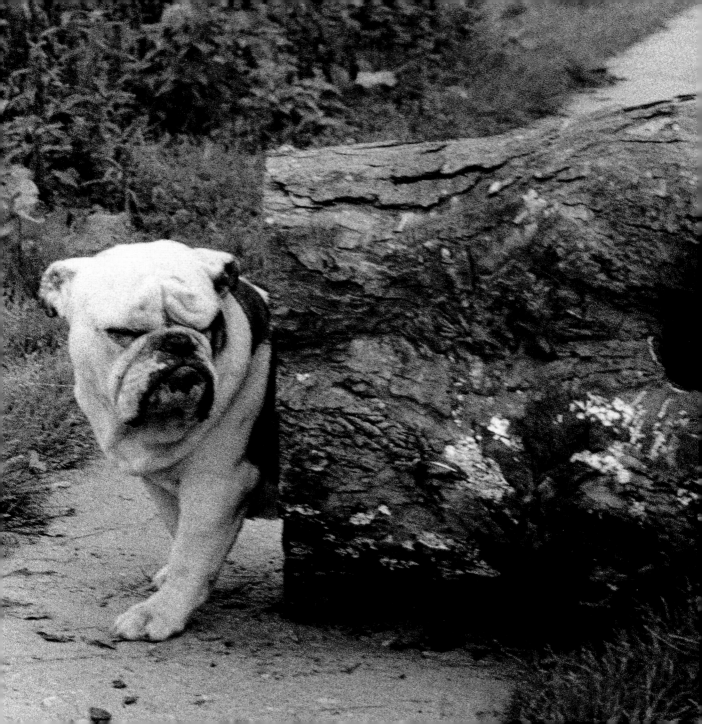

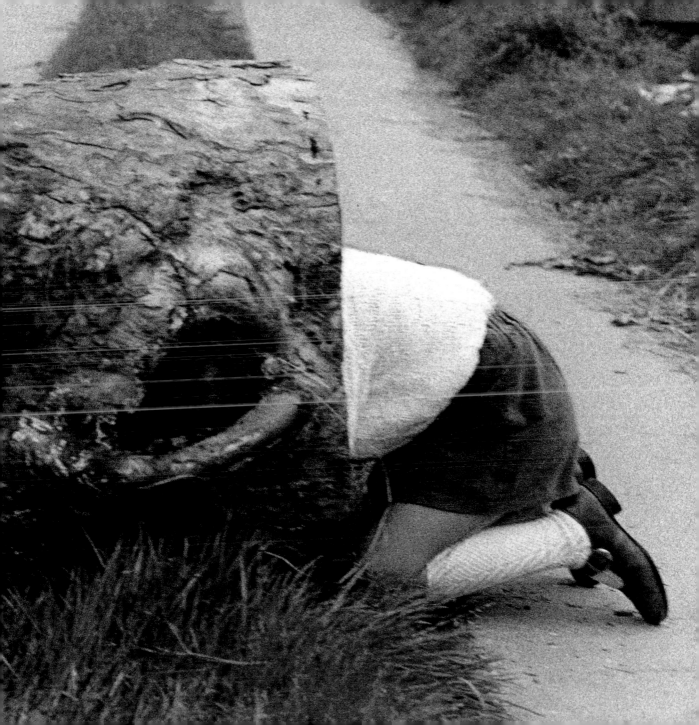

## A Puppy's Point of View

Our dog Pepper had six puppies. They're little fluff balls. They don't know anything when they're born. They think Pepper will leave them alone and never feed them unless they follow her everywhere and cry. They think the cat is a monster and that my hand is a chew toy, and that the backyard is a giant forest and they are the great hunters. If I lie down on the floor, they come and climb all over me. Then, they think I'm a mountain.

DAN PATTERSALL

KINDERGARTNER

PITTSBURGH

MASATOSHI MAKINO
*Puppy Pals*
Okinawa, Japan, 1996

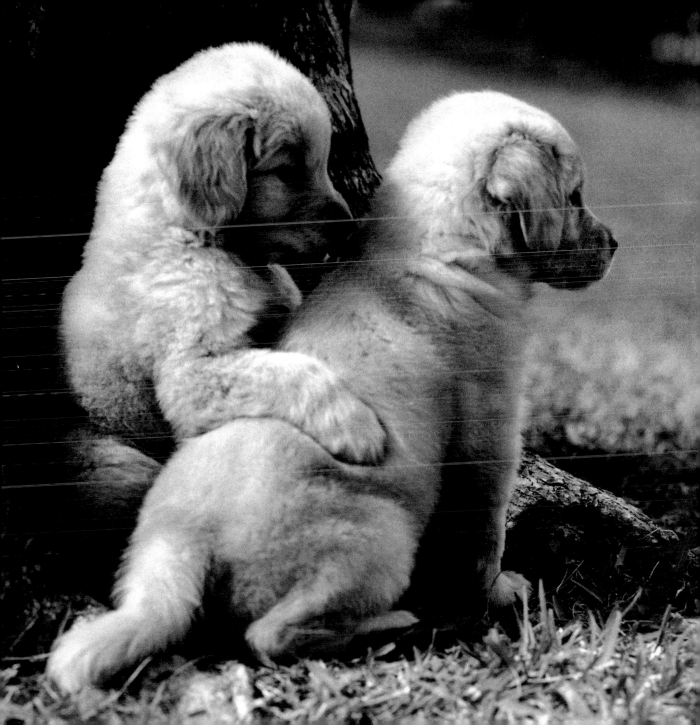

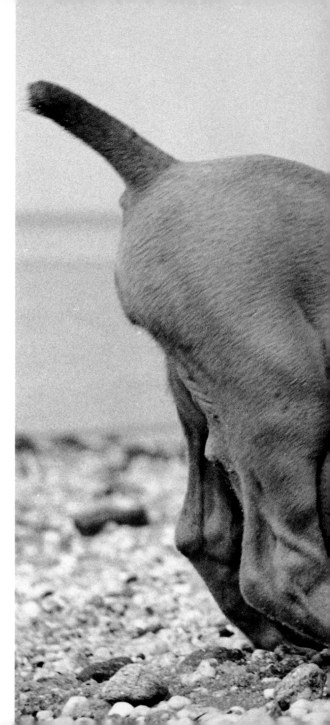

WALTER CHANDOHA
*Weimaraners on the Loose*
Long Island, New York, 1971

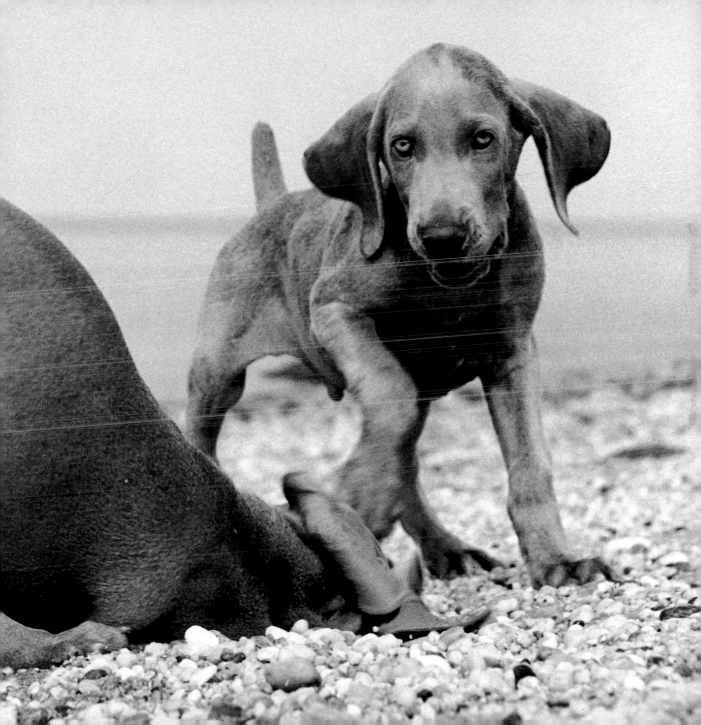

WALTER CHANDOHA
BATHTIME, 1965

*I was working for a vitamin company and they wanted to promote their new coat lustre product.*
*The shot called for a hairless dog, but it would've been so ugly. The Weimaraner was a good dog,*
*a well-trained dog, and he had a fine time in my bathtub in Annandale, New Jersey,*
*once he got used to standing on the porcelain.*

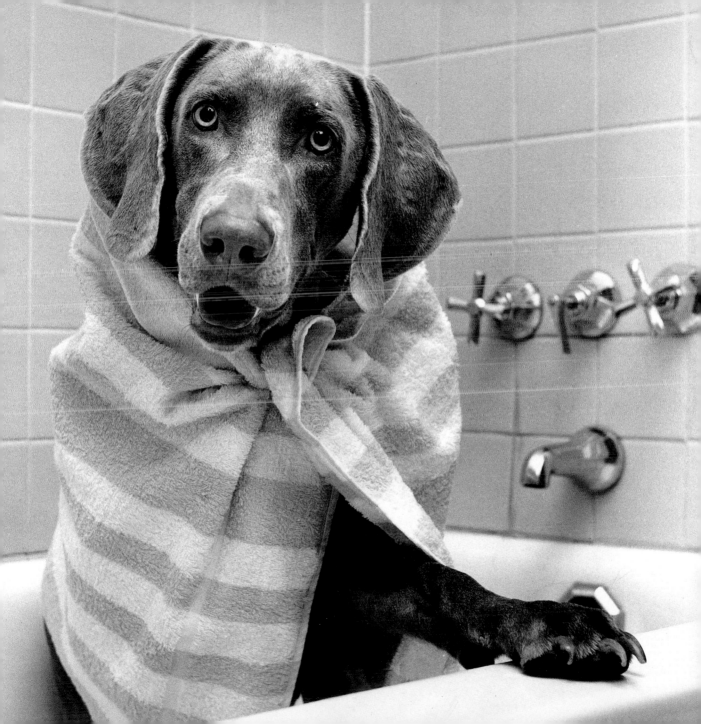

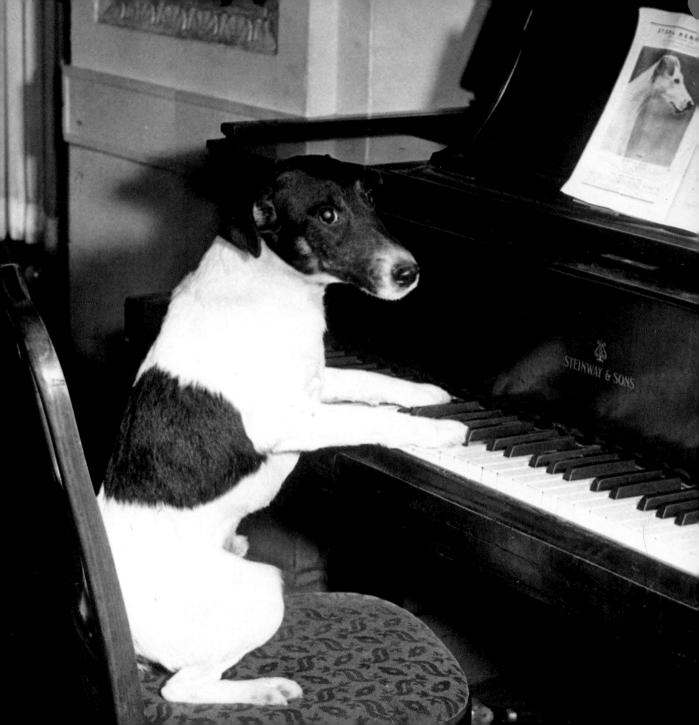

My husband Marc's little dog Suzette got us back together. Marc and I had split up after two years because we thought we wanted different things—a modern story, but dogs aren't modern. I like to think Suzette couldn't stand life without me. She'd run up to women on the street and jump all over them, looking for me. So Marc met a lot of women, but none of them liked him. Then Suzette ran away and wound up at my house, almost a mile away. When Marc came over to take her home, she hid under my bed and refused to come out. Cupid just took over from there.

MADELINE VISALLE, PARIS

RIGHT:
**KARL BADEN**
**DACHSHUND UNDER DRESS,**
**RHODE ISLAND, 1992**
"I couldn't tell whether this Miniature Longhaired Dachshund was scared, or whether it just loved being surrounded by the shelter of its handler's skirt."

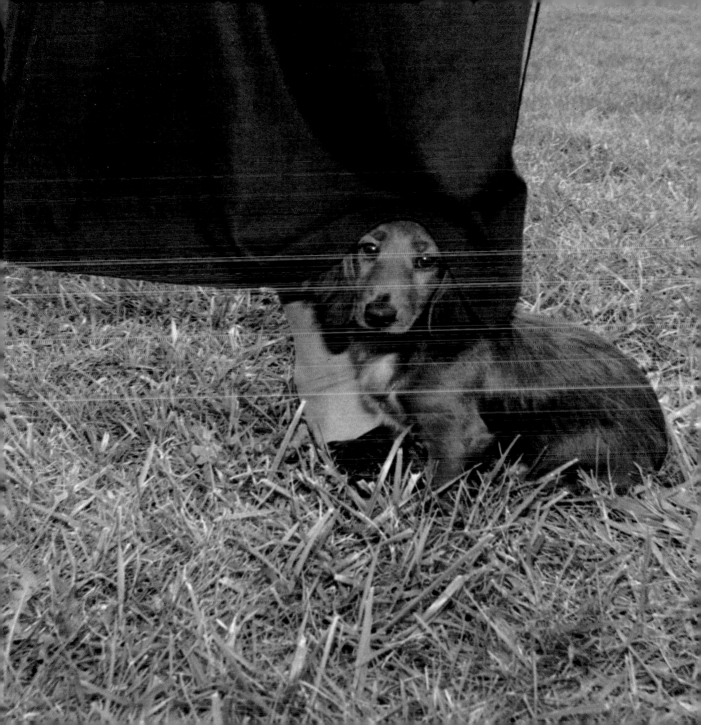

Of the pup: discourage biting, for that will decrease his civility, but encourage his antics, for that will increase his intelligence. You may let him roam, but insist he mind your borders. For like any youth, a pup will be careless and disloyal; prone to wandering and picking up fleas.

GENTLEMAN'S HANDBOOK, 19TH CENTURY

NINA LEEN
*Tank, Three-Month-Old Yorkshire Terrier Puppy*
Westport, Connecticut, 1964

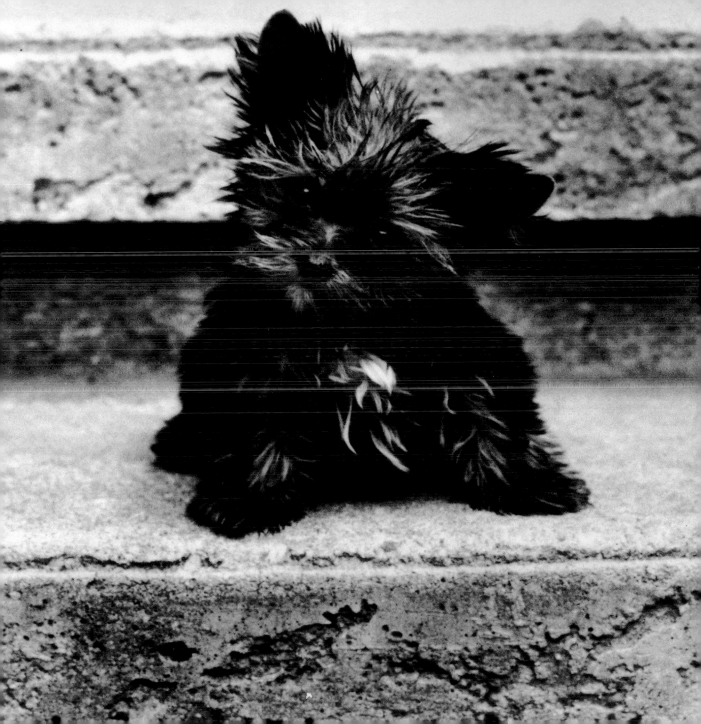

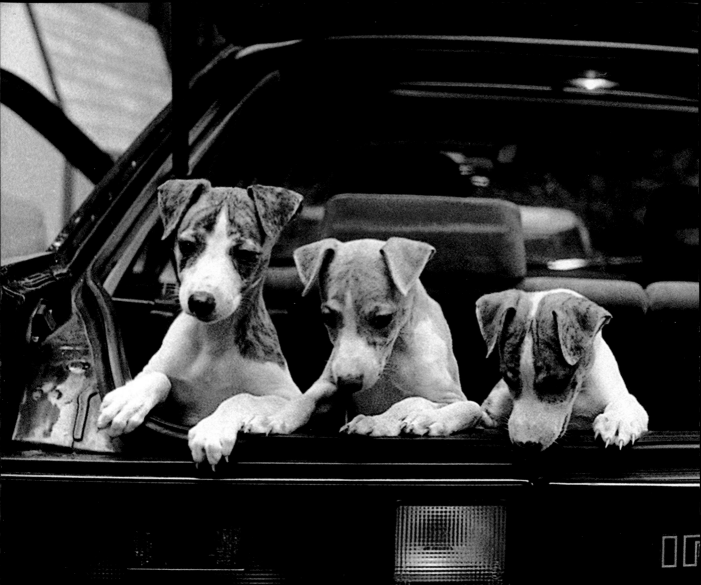

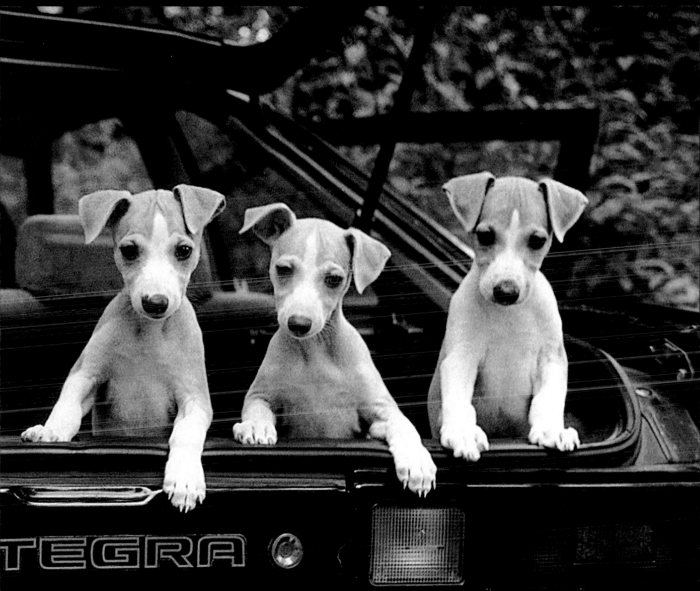

Dogs love their friends and bite their enemies, quite unlike people, who are incapable of pure love and always have to mix love and hate in their object relations.

SIGMUND FREUD

PREVIOUS PAGES:
**ROBIN SCHWARTZ**
**MORRISTOWN, NEW JERSEY, 1995**
The Diablesse Whippets:
Vello, Aprila, Guy, Liam, Truly, and Wilham.

**ELLIOTT ERWITT**
**TROUVILLE, FRANCE, 1965**
While strolling in Trouville, I noticed
a very quiet, inquisitive mutt peering
over a fence. He didn't make a sound.

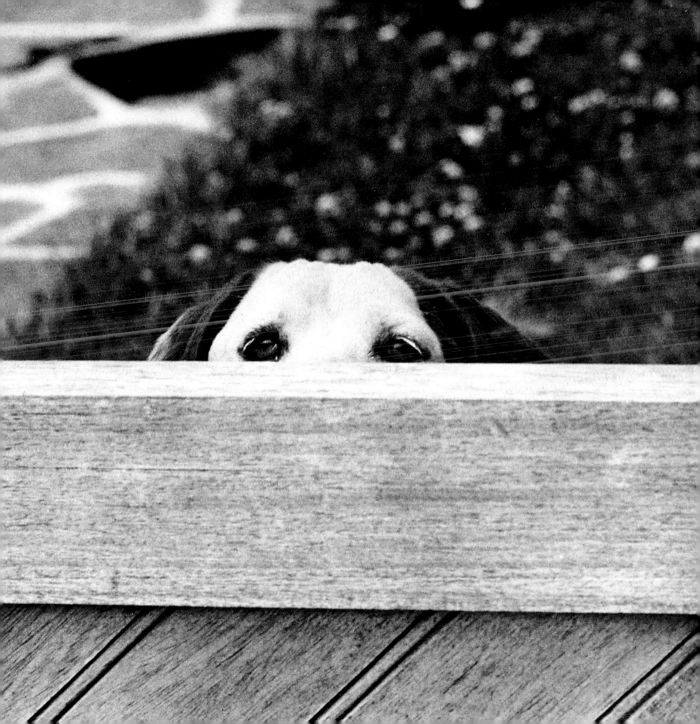

## The Young Connoisseur

Fidel, our Shepherd puppy, finds peanut butter irresistible. Also butter, chocolate milk, any kind of ice cream, and spaghetti with olive oil. I think the rule is that if it's all over Fidel's fur, it tastes even better. His breeder promises me he'll get more dignified with age. And I always say, Can I get a second opinion on that?

JOE McBRIDE

WRITER

BOSTON

NANCY LEVINE
*Four-Month-Old Maxie and Her Big Sister Lulu,*
*Miniature Australian Shepherds*
New York City, 1995

overleaf:
ROBIN SCHWARTZ
*Bella Rose, Beagle Puppy, at Eleven Weeks*
Jersey City, New Jersey, 1995

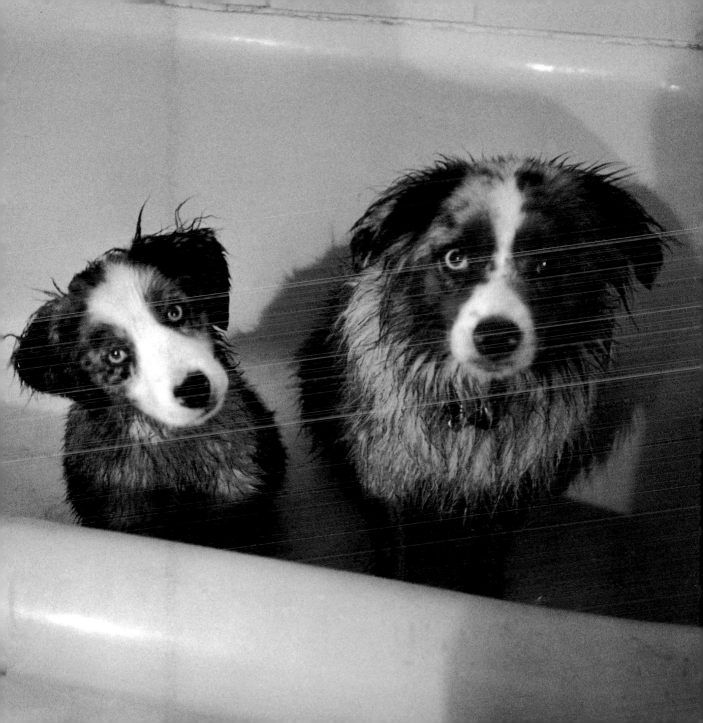

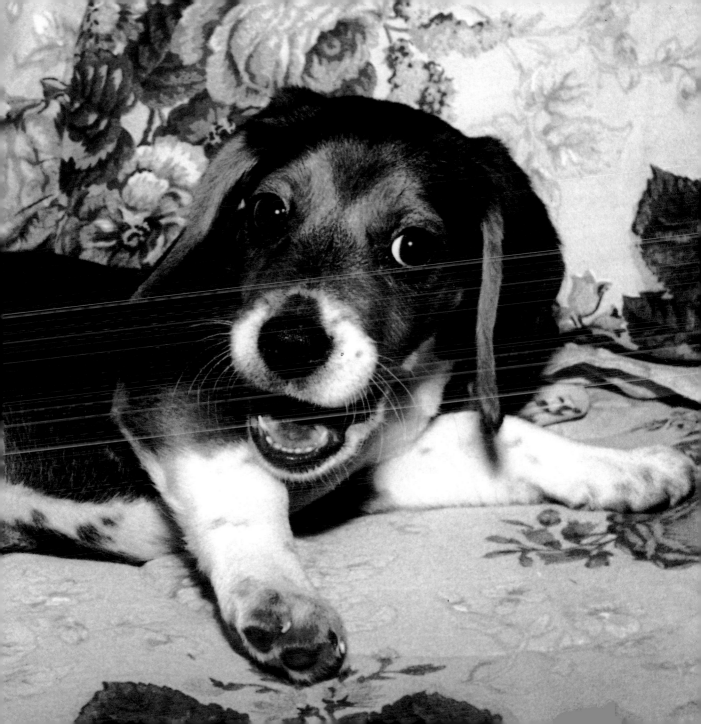

JOYCE RAVID
*Dalmatian*
Los Angeles, 1989

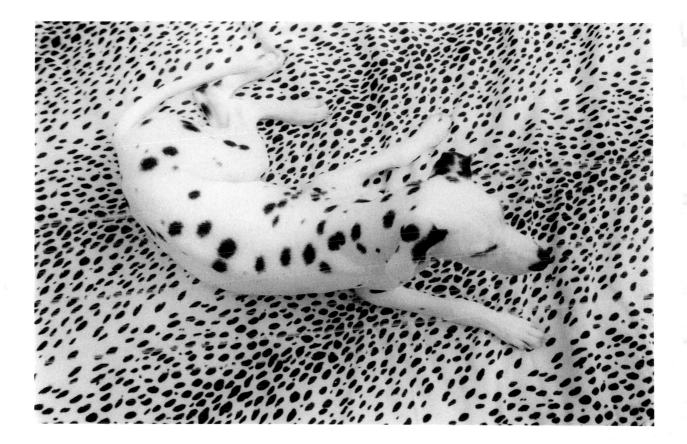

JOHN DRYSDALE
NUTS ABOUT SQUIRRELS, 1975

*Someone brought three tiny Grey Squirrels to Graham Hughes's farm near Southam, England.*
*They'd been abandoned by their wild mother and had to be fed every two hours with a syringe.*
*It was a laborious task. When Graham's Bulldog Suzie—whose maternal instincts had already*
*saved other abandoned animals—produced a litter of puppies, Graham gave Suzie the squirrels.*
*The only problem is that the squirrels have such a fearsome looking mother,*
*they've lost all their wariness. In a sense, Suzie domesticated them.*

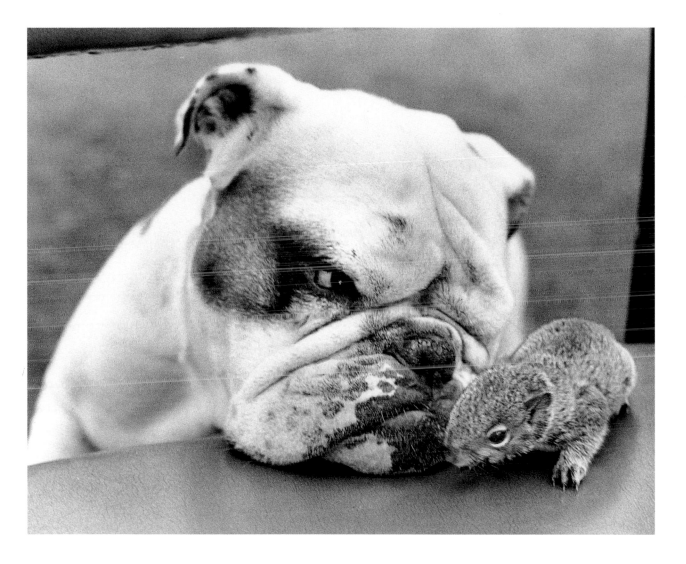

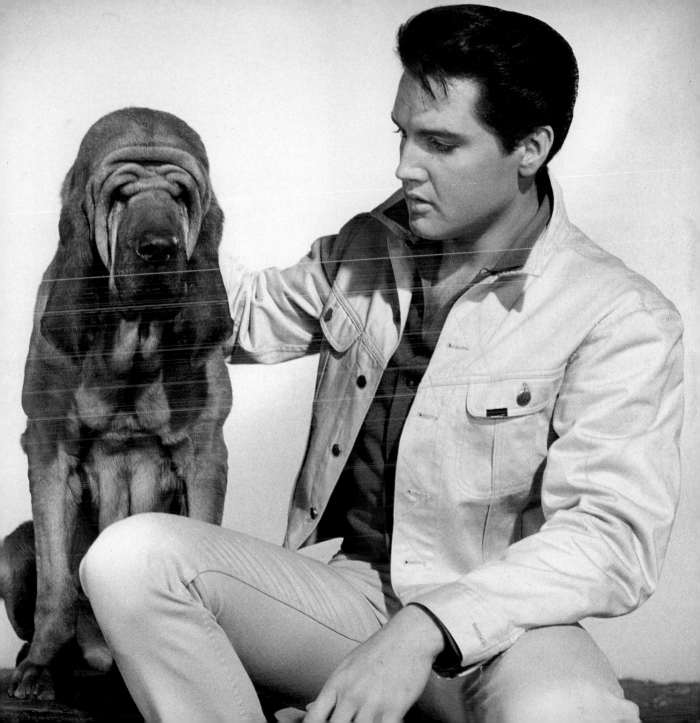

**Dog, n.** *A kind of additional or subsidiary Deity designed to catch the overflow and surplus of the world's worship. This Divine Being in some of his smaller and silkier incarnations takes, in the affection of Woman, the place to which there is no human male aspirant.*

*The Dog is a survival—an anachronism. He toils not, neither does he spin, yet Solomon in all his glory never lay upon a door-mat all day long, sun-soaked and fly-fed and fat, while his master worked for the means wherewith to purchase an idle wag of the Solomonic tail, seasoned with a look of tolerant recognition.*

.......................................................

AMBROSE BIERCE
**The Devil's Dictionary**

LARS PETER ROOS
MIOJE, STOCKHOLM, 1993

*One day I accompanied my neighbor, an old lady who has a Pug, on one of their daily walks. I went because I really like that dog. A lot of old ladies in Sweden have Pugs.*

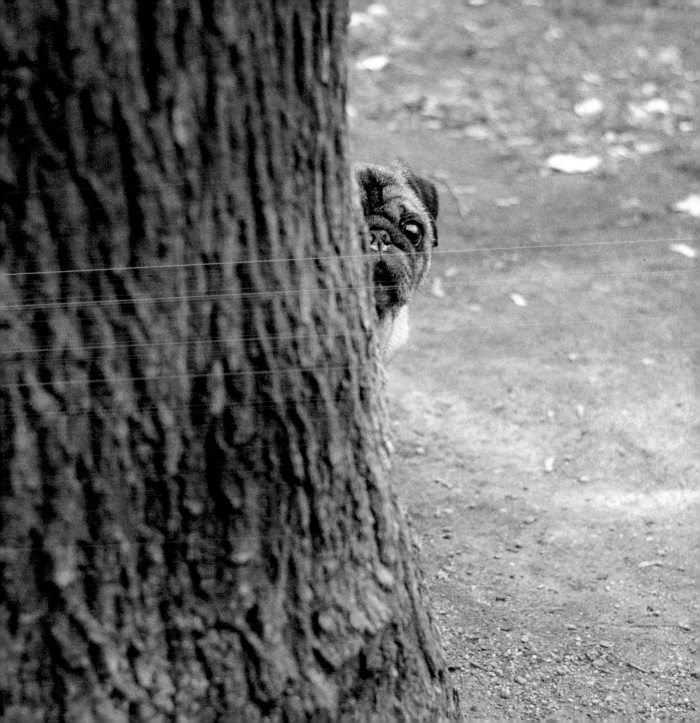

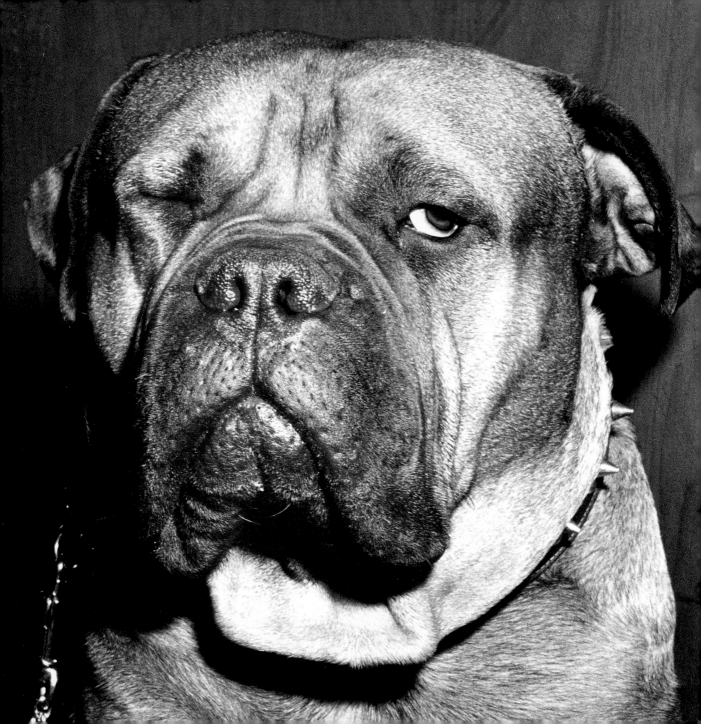

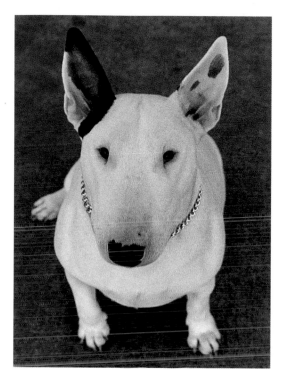

LAURA BAKER-STANTON
ACIE'S JUST MADE IT, 1993

*They call her Mada. She's the sweetest doll of a dog. She was
at a dog show in Tulsa, competing with all the other Bull
Terriers. I don't know if she won anything or not.*

WALTER CHANDOHA
WESTMINSTER DOG SHOW, 1965

*The Mastiff was just sitting there with that spike collar
and a look that said, "Watch out." But you know, looks don't
mean a thing, especially in New York.*

*The famous director of such thrillers as* Spellbound *and* The 39 Steps *was known to be fond of terriers such as this Sealyham. His indomitable companions were treated with great respect—not only allowed on the master's bed, but given a special pillow so they could sleep between Hitch and his wife. Often they seemed to take on his character as well: irascible but not without humor—able to scoff at and mug for the press at the same time.*

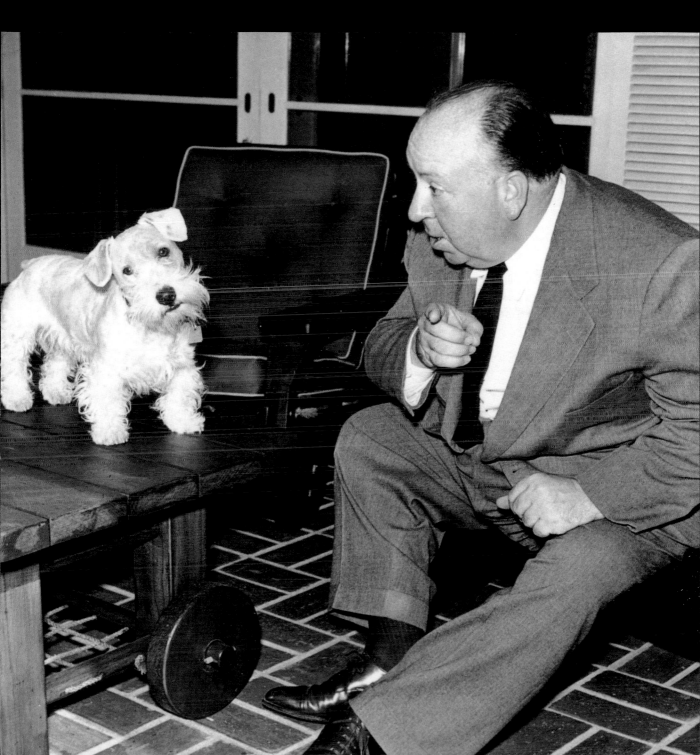

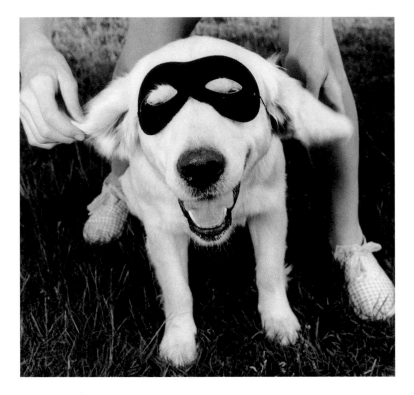

**ULNIKA ÅLING**
**STOCKHOLM, 1994**

"I was taking pictures of people in a newly built
section of Stockholm. I put a mask on each person to
make him or her more anonymous. Then the dog
turned up and he too wanted to be photographed
and joined in the spirit of the moment."

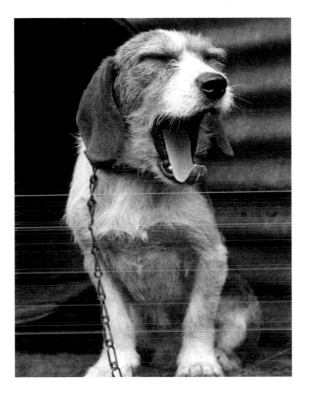

**YLLA**

**NEW YORK, NY, PRE-1945**

This sweet yawning puppy became
famous after the Humane Society
hung this picture in its offices.

I believe that dogs are very capable of applying

their minds in an array of situations. And the

degree of their intelligence can vary from breed

to breed and dog to dog—just like people.

WARREN ECKSTEIN WITH ANDREA ECKSTEIN
How To Get Your Dog To Do What You Want

### JOHN DRYSDALE
### OUNDLE, ENGLAND, 1981

Mr. Magoo, the pet of an elephant trainer in Oundle, England,
loved to go mountaineering on Maureen, a three-ton elephant with
a tolerant nature. Magoo, a poodle-pinscher mutt and six months
old in this photograph, would make the perilous ascent up the
elephant's leg. Then Maureen would raise her leg, enabling Magoo to
scamper onto her shoulder and continue onto her trunk. Maureen
curled her trunk around the tiny pup as the finale to this circus trick.

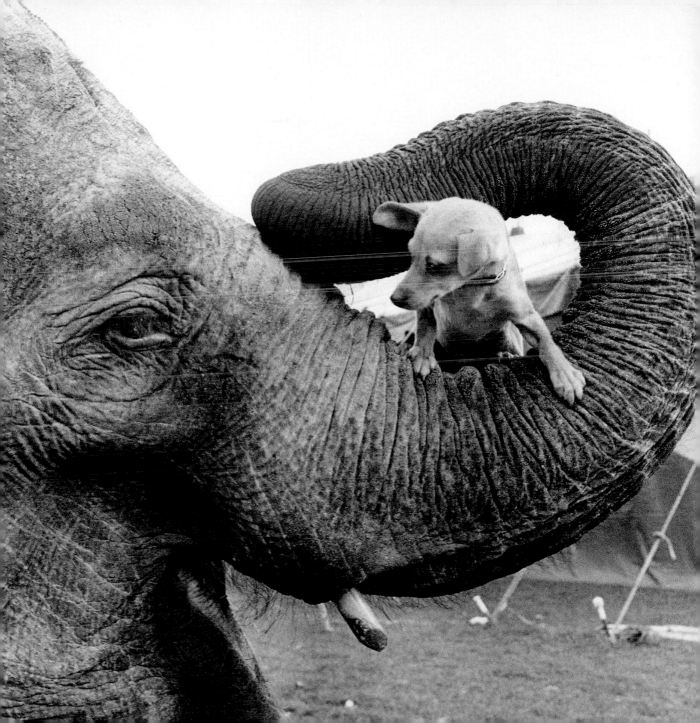

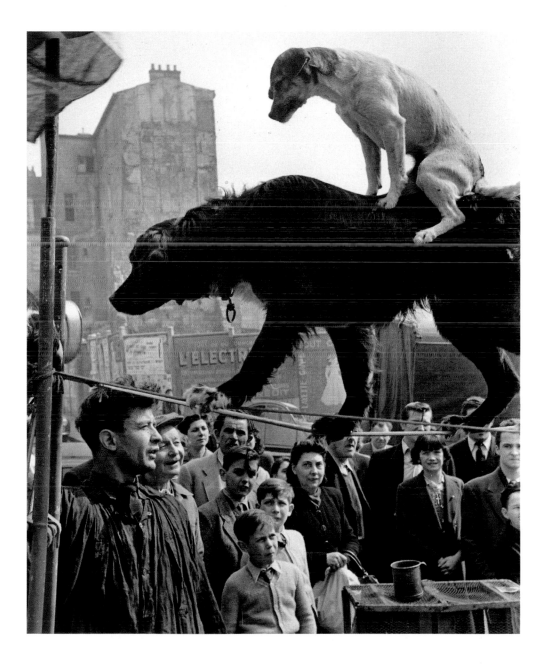

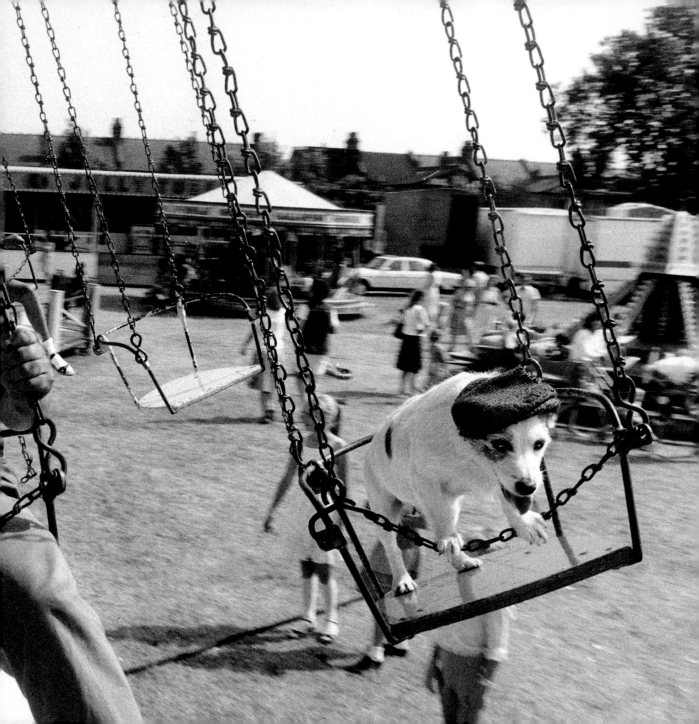

# Just a Phase

Whitey, our three-month-old Neopolitan Mastiff, is really dark gray. His bones are made of rubber and he never walks, he galumphs. When his feet give out—about every other minute—he rolls the rest of the way. Last week he dive-bombed a pile of cherry jello my daughter accidentally dropped on the kitchen floor. Then he ambushed a pile of clean laundry. My daughter, who's six, will not let us scold him. She says this is Whitey's preschool phase, when kids are supposed to make a mess.

JACK RANGLE

MUSIC PRODUCER

SACRAMENTO

STEPHANIE RAUSSER
*Eva, Labrador Puppy*
Berkeley, California, 1990

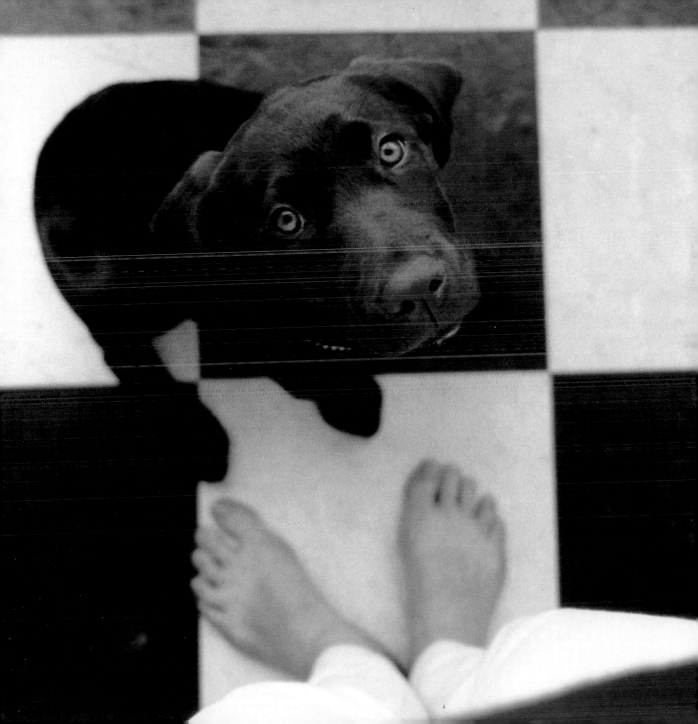

*Watson: Is there any point to which you would wish to draw my attention?*

*Holmes: To the curious incident of the dog in the night-time.*

*Watson: The dog did nothing in the night-time.*

*Holmes: That was the curious incident.*

......................    ............................

**SIR ARTHUR CONAN DOYLE**
**The Memoirs of Sherlock Holmes**

BRUCE DAVIDSON
ENGLAND, 1960

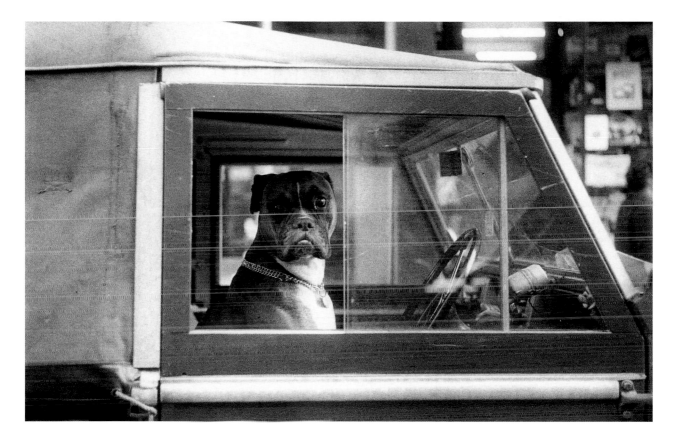

ROLF ADLERCREUTZ
RECOGNITION, C. 1990

OVERLEAF: JACK JACOBS
SAMMIE, 1988

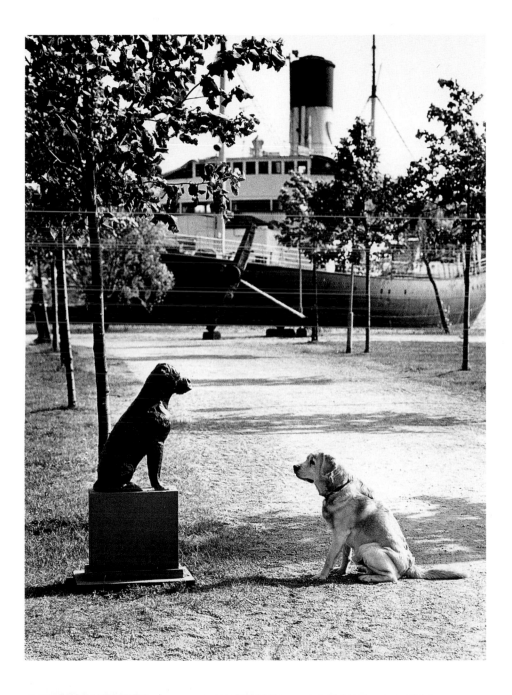

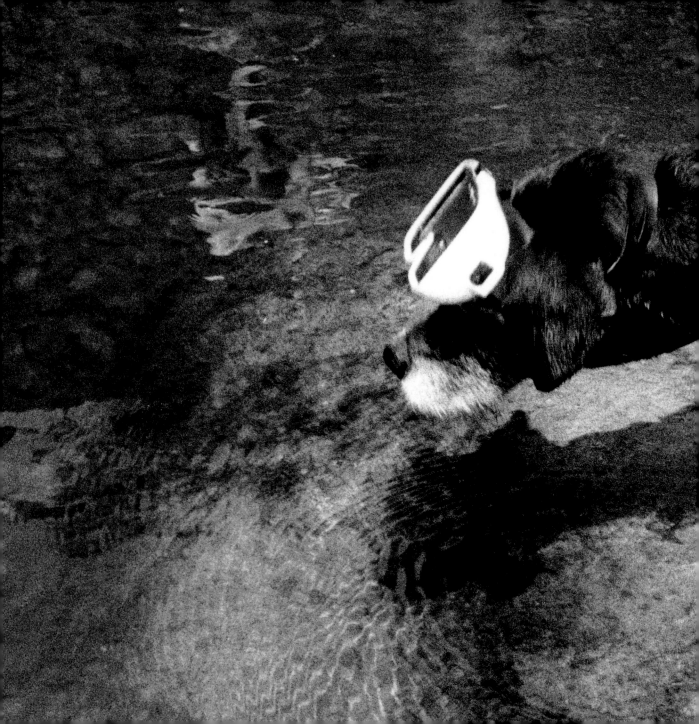

JOYCE RAVID
COSMO TIGER, 1994

*This is his most recent official portrait, taken in the country near New York.
I don't know what kind of dog he is, but he's a nice dog.*

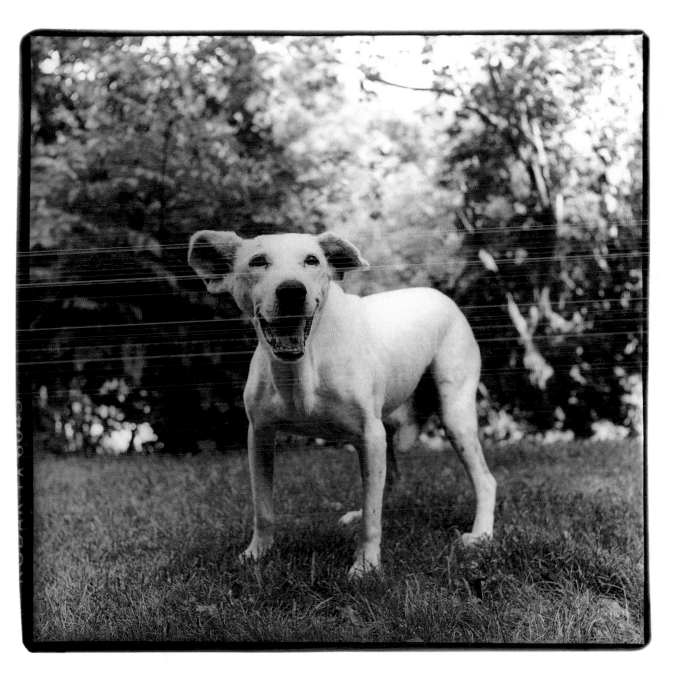

*They're Airedales, in their owner's costumes. I was very interested in Guinevere since she was very pretty. She was the younger one. But since they were a couple, I included Martin too.*

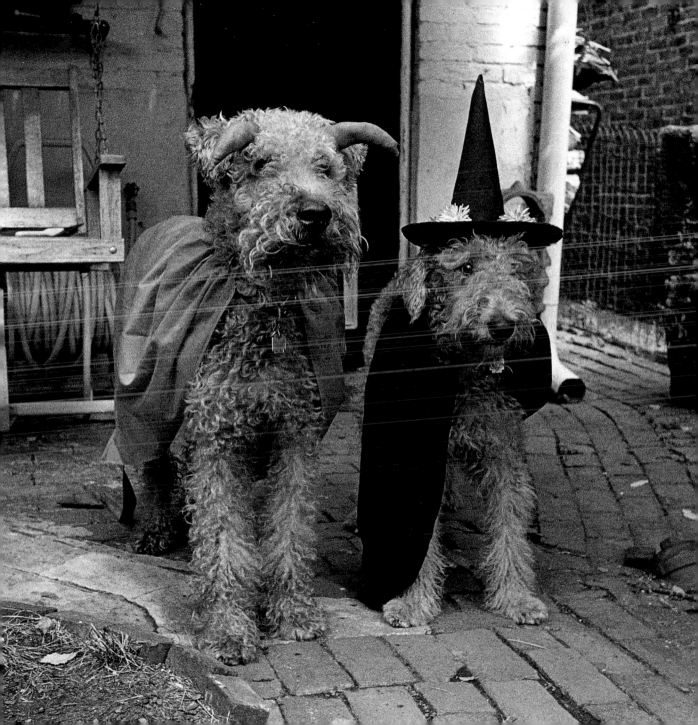

**ROBIN SCHWARTZ**
**BLAZE,**
**COLT'S NECK, NEW JERSEY, 1993**

"This was at a lure coursing meet for sighthounds.
Blaze, a Whippet, was now done for the day. He likes
to rest his head on his owner Marcia's shoulder when
he's really tired. He's like a kid, very affectionate. His
owner's shoulder is a very natural place for him to be."

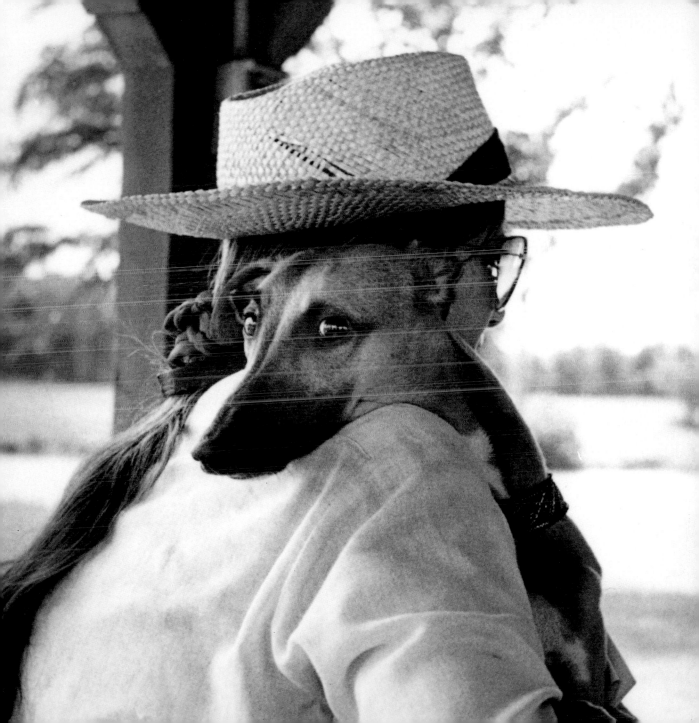

RIGHT:

**JOHN DRYSDALE**
**MONKEY MOTHER CARE,**
**BANBURY, ENGLAND, 1990**

"This young chimpanzee was being reared in-house.
The owner also bred Jack Russell Terriers. When the
chimp was shown a puppy, it was fascinated and tried
to mother it. The puppy welcomed the attention."

OVERLEAF:

**TEDDY AARNI**
**COLLIES, STOCKHOLM, 1980s**

Is it just breed recognition, or something stronger?
Two rough-coated Collies touch noses in
profile, creating a regal silhouette.

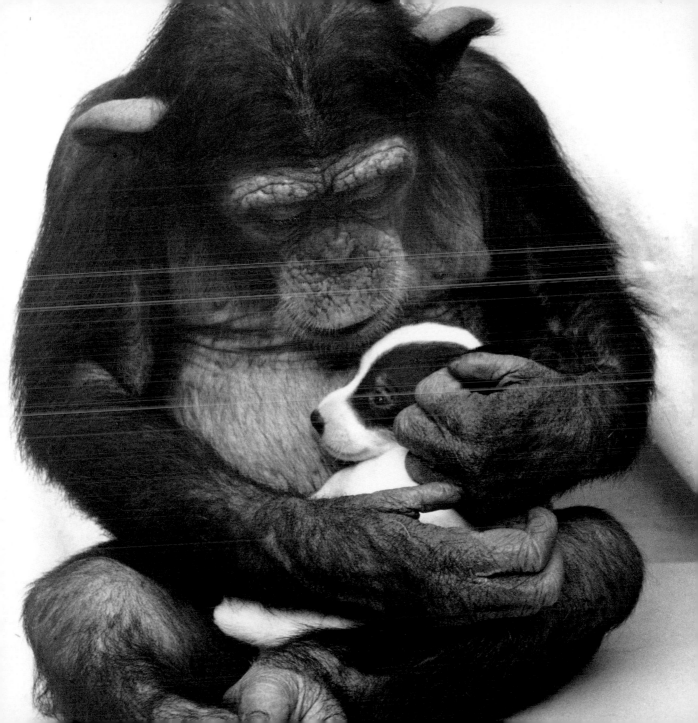

## A Sneaky Sweetie

When I was young we had a Samoyed, Sobaka (dog in Russian). He was a bitey, domineering dog who had to be the boss, though there was much love between us. In the winter we'd hitch him up to a sled—that was his proudest moment. A few years later we got another Samoyed to keep him company. She was a real sweetheart named Zöe. But she was also a master thief. Anything big old Sobaka had—a ball, a bone, a stick, a treat, even a smelly old sock—she'd take. She'd wait patiently nearby until he was distracted, then sneak up right under his nose to nab the prize and romp away. Sobaka never knew what happened.

EVE MINKOFF

EDITOR

MASSACHUSETTS

KENT AND DONNA DANNEN
*Samoyed "Chinook" CD, WS, and Her Pup*
Estes Park, Colorado, 1986

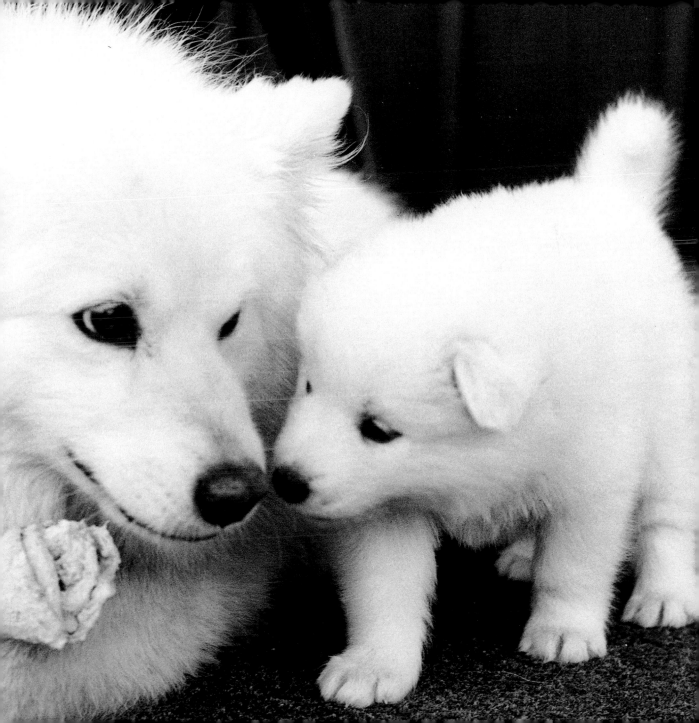

## My Hero

**M**y dog was always my hero. I remember him licking away my tears when I was sad.

MAN, OF HIS CHILDHOOD PET

Opposite:
LIZZIE HIMMEL
*The Kiss*
*New York City, 1991*

Overleaf:
ROBIN SCHWARTZ
*Isis and Tina,*
*Piscataway, New Jersey, 1996*
"The big white Borzoi is four months old here, and Tina, the Whippet, is three months old. They share the same last name of McDonald, and they're cousins. You can tell right off that they like each other. Sighthounds sleep a lot, and these two love to sleep arm in arm. At this age, Tina was like Isis' baby. Even for a Borzoi, Isis was very tall."

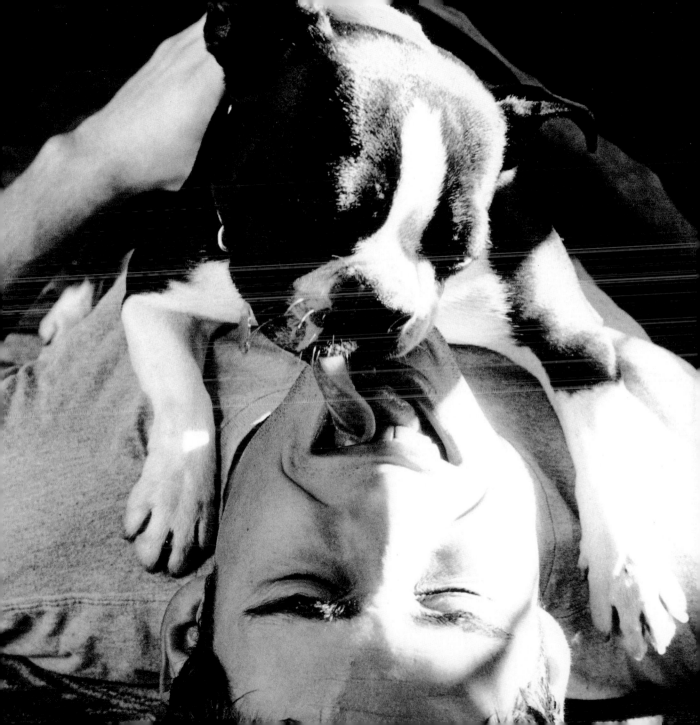

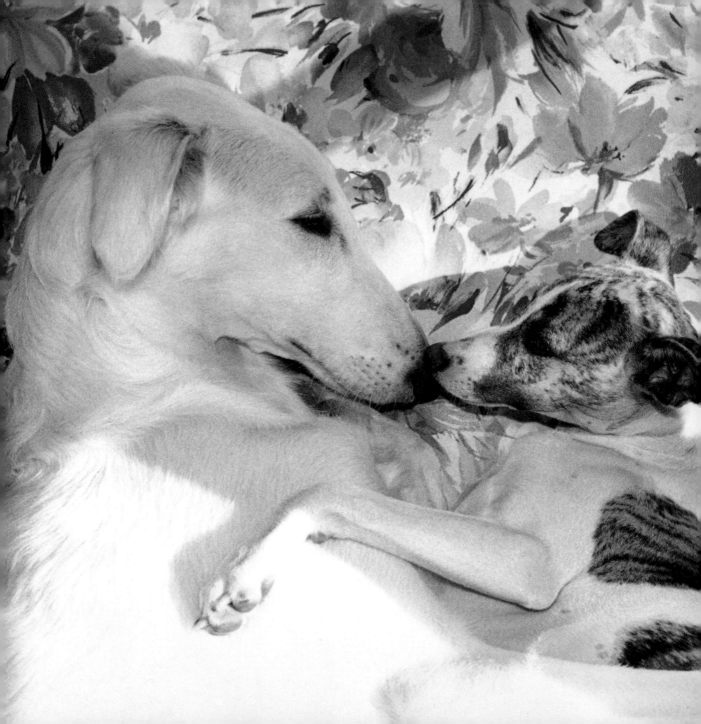

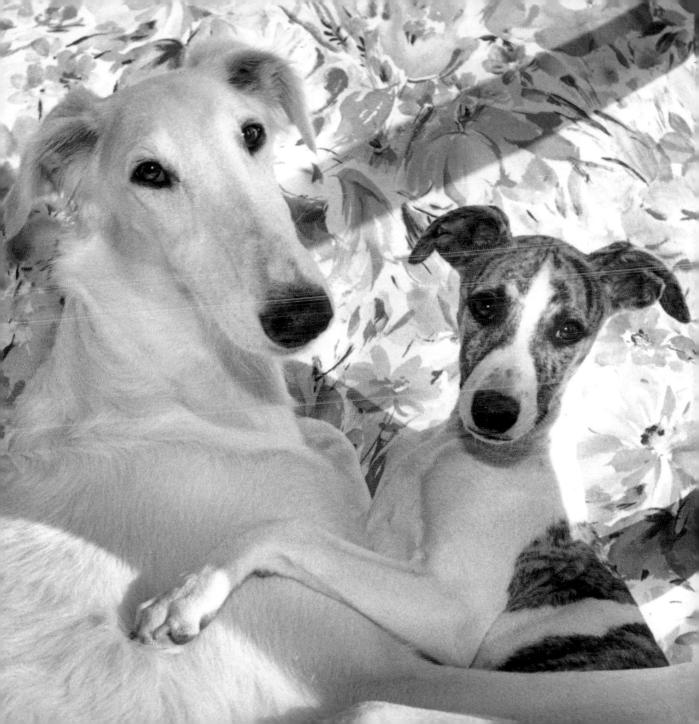

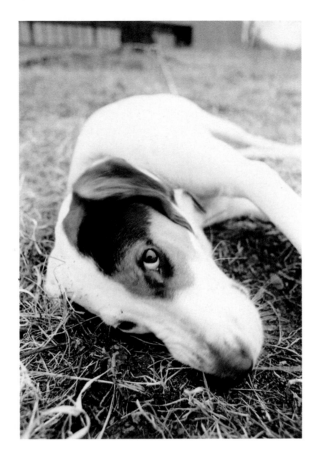

**DONNA RUSKIN**
**PURCHASE, NY, 1980**

"I was working in the photography department at SUNY. One day on my way to work, I saw this dog tied up outside. He was very vulnerable and sweet-looking. After I took this picture, I never saw him again."

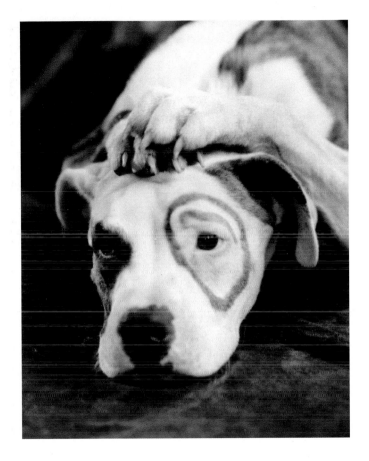

Pete the Pup, a star in his own right,
poses for this close-up publicity shot
for the *Our Gang* comedy film series.

PHOTOGRAPHER UNKNOWN
*Sleeping It Off*
Cincinnati, Ohio, November 21, 1947
With trucks at a standstill on the third day of the 1947
truckers' strike, a dog named Sparkplug finds some rest
in the rear wheel of a ten-ton trailer.

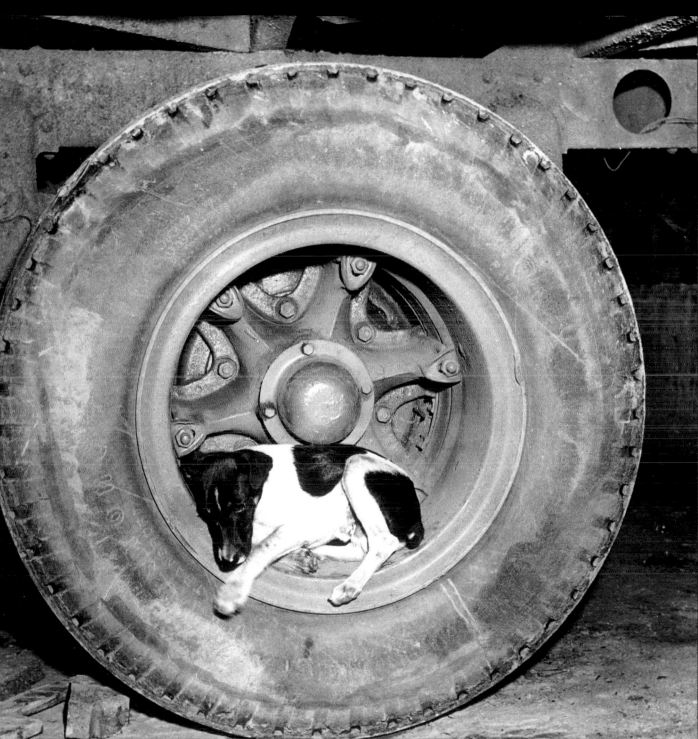

**ELLIOTT ERWITT**
**FRANCE, 1968**

A very casual and unconcerned basset hound mix
snoozes on the sidewalk as people walk around him.

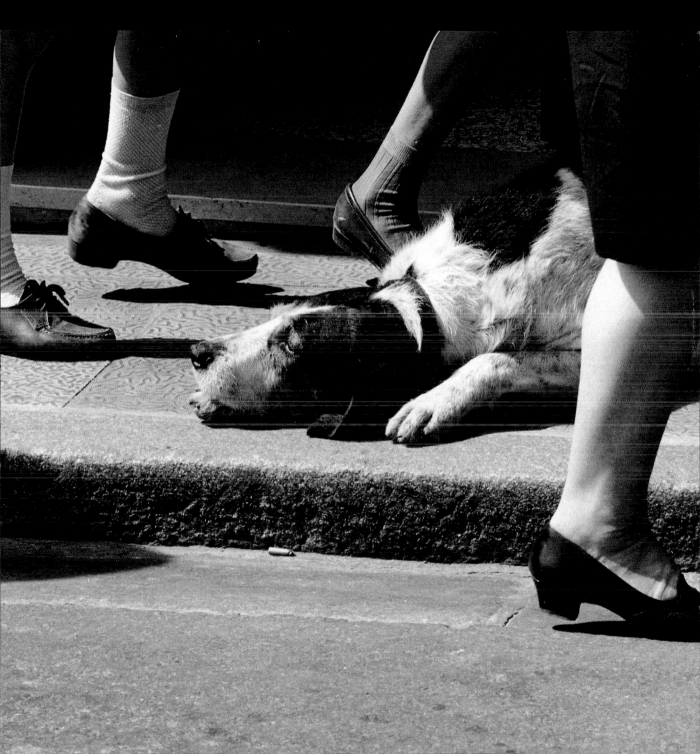

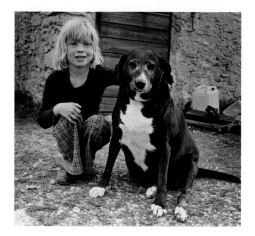

**PELLE WICHMANN**
**FARO, SWEDEN, 1978**

"I took this picture while I was bicycling around the island of Faro
in the Baltic Sea where Ingmar Bergman lives. I met this boy and
dog when I passed some houses near the sea. The dog belonged
to the boy's grandfather whom the boy was visiting for the summer.
The old, fat dog who could not move easily and the thin, young boy
who was quite nimble appeared to be very good friends."

RIGHT:

**PHOTOGRAPHER UNKNOWN**
**HOLLYWOOD, CA, 1920s**

The Little Rascals from the *Our Gang* comedy film series
included Pete, the Pup, a pit bull mix, complete with his
movie makeup, a freshly drawn circle ringing his right eye.

OVERLEAF:

**THOMAS WESTER**
**SMÅLAND, SWEDEN, 1986**

A dog and his master relax on a hot summer day with their friends.

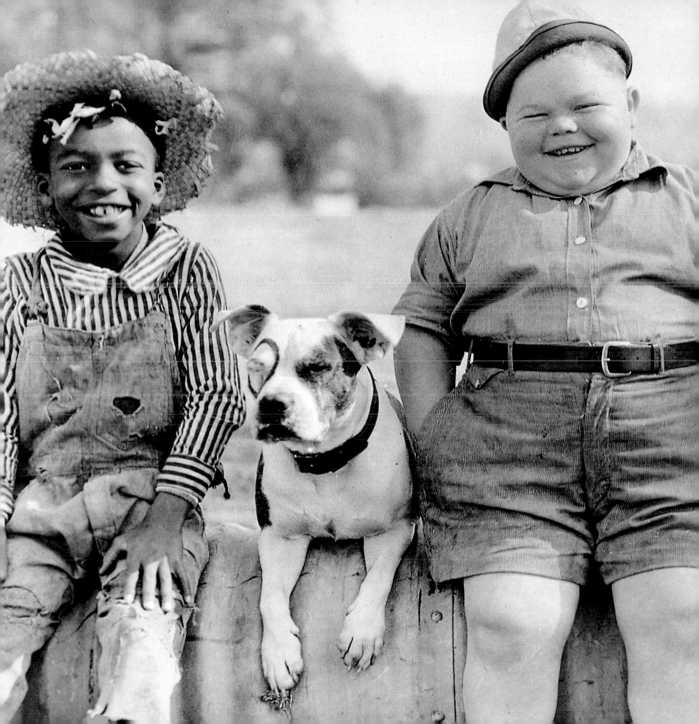

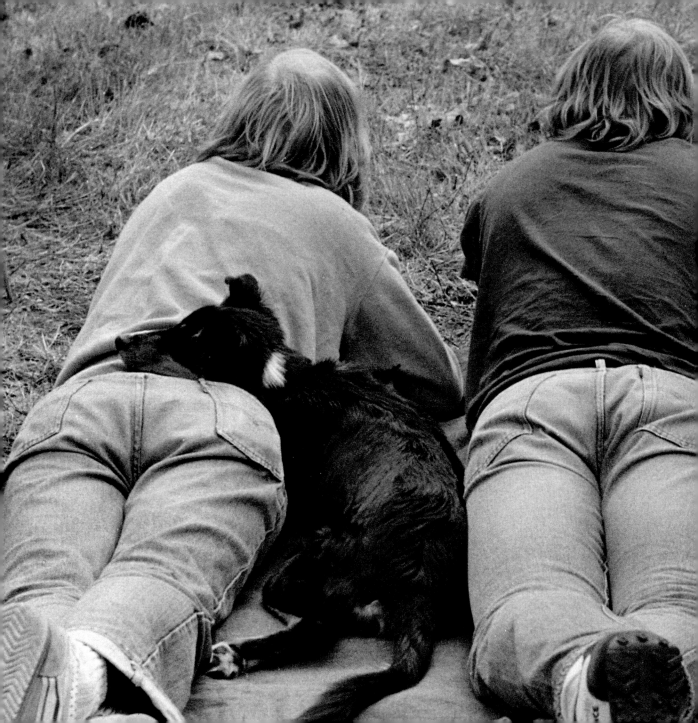

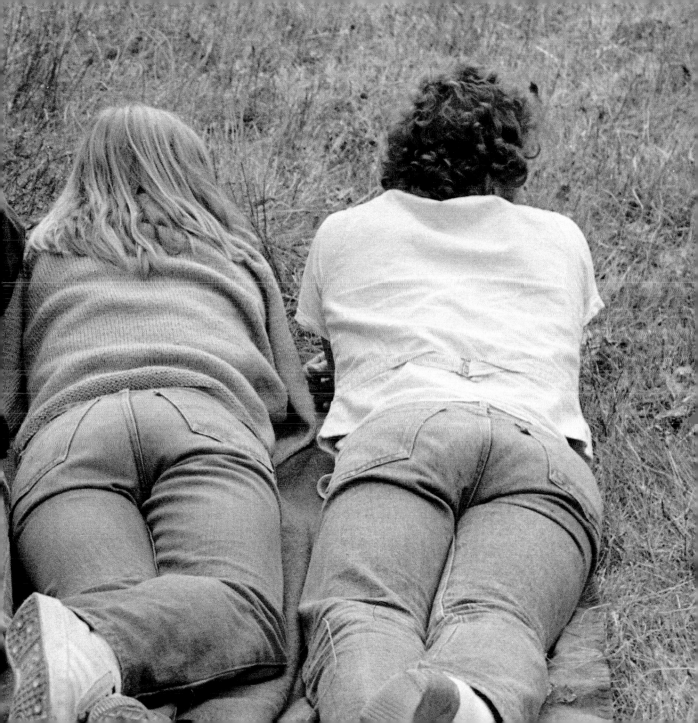

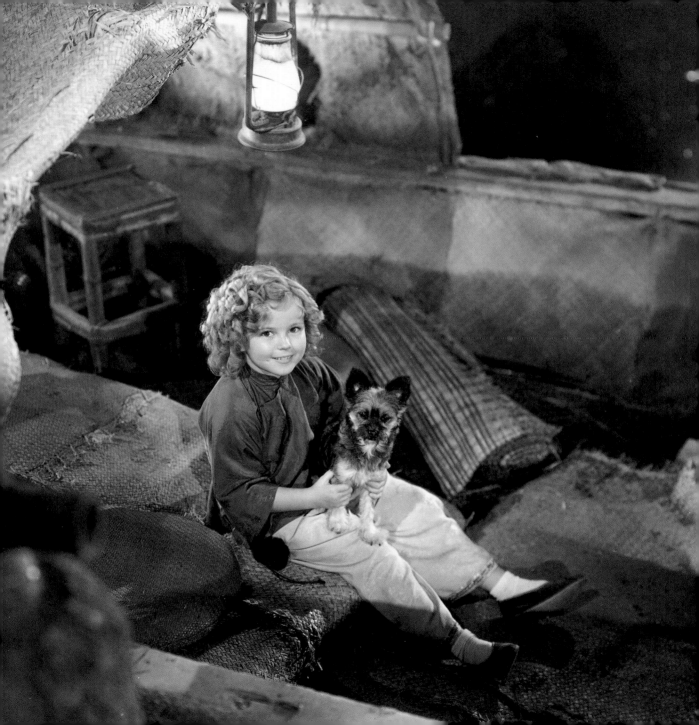

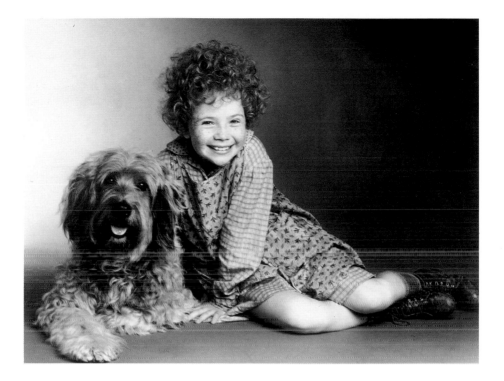

AILEEN QUINN AND SANDY. 1982
Above: *The orphan and her dog are the stars of Columbia
Pictures' version of* Annie, *directed by John Huston.*

THE STOWAWAY. 1936
Left: *Curly-topped, tiny Shirley Temple played a talented waif
orphaned in China who is befriended by this curly-topped,
tiny mutt.*

I like a bit of a mongrel

myself, whether it's a man or

a dog; they're best for every day.

GEORGE BERNARD SHAW

JANE LIDZ
EUGENE, OR, 1976

Zak, the bathtub martyr. The expression
on his face illustrates exactly how he
feels about getting a bath.

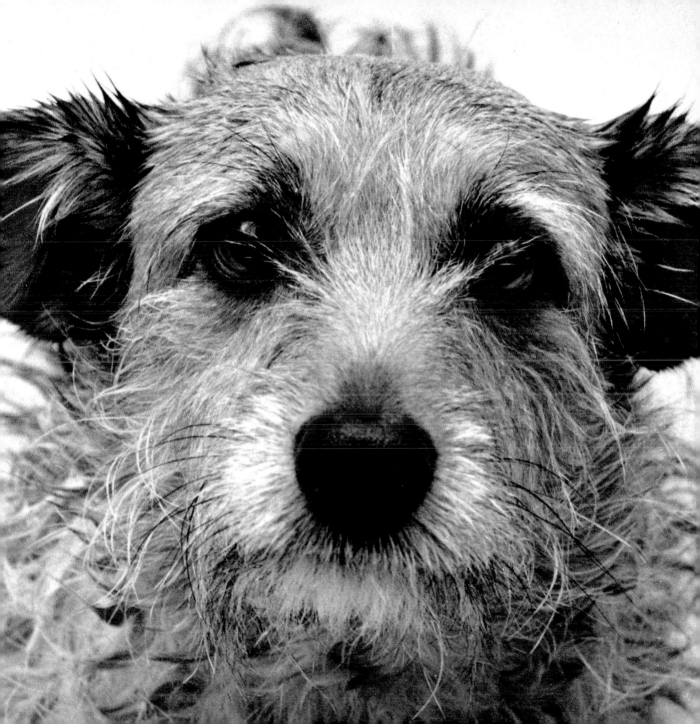

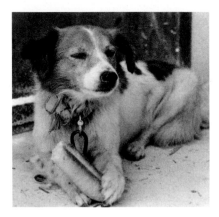

ABOVE:

**MARILAIDE GHIGLIANO**
**LANGHE, ITALY, 1992**

"This mutt lives in an isolated farmhouse in the hills of Langhe near Mondovi. He is a truffle hunter. I went there to photograph the barn animals, but the dog attracted my attention because he wanted the loaf of bread that I had for the pigs. He ate all of it. According to the farmer, the dog had never been interested in bread before; he was just trying to get his picture taken!"

RIGHT:

**MARILAIDE GHIGLIANO**
**LANGHE, ITALY, 1993**

"This dog lived in Lovera, a tiny village hidden in the hills of Langhe near Dogliani. He was chewing his bone in the town square in front of an inn. As I stopped to photograph him, another dog came near. He assumed the dog wanted his bone. But the dog just waited for him to finish his bone and then they went for a long walk together in the hills."

OVERLEAF:

**PHOTOGRAPHER UNKNOWN**
**PLACE UNKNOWN, DATE UNKNOWN**

The dog who bit off more than he could chew.

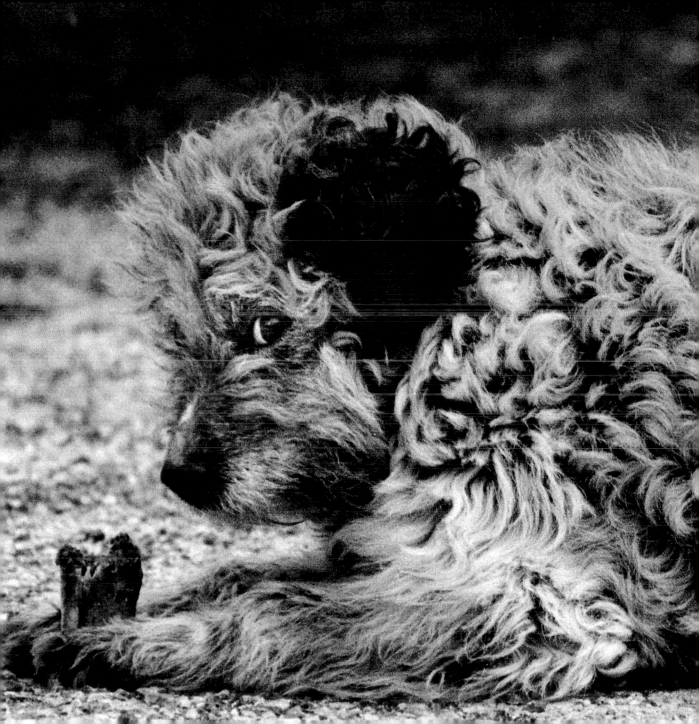

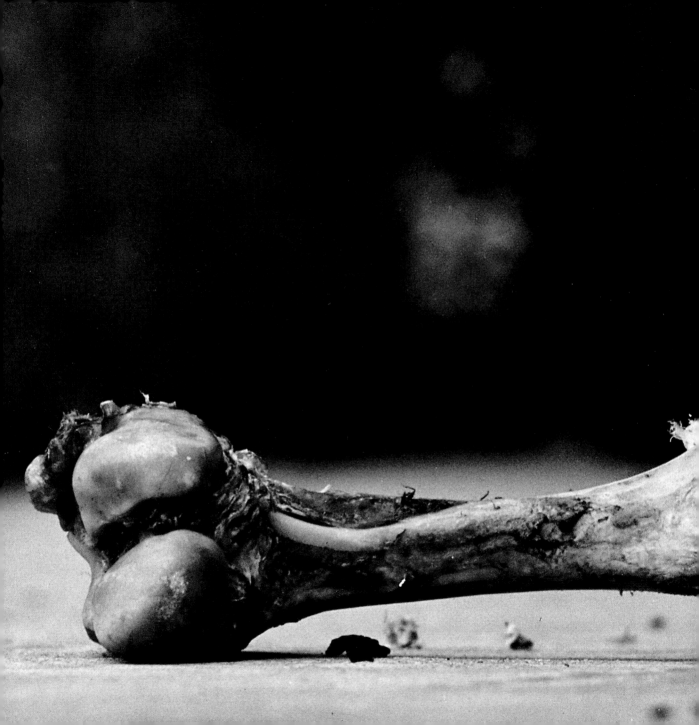

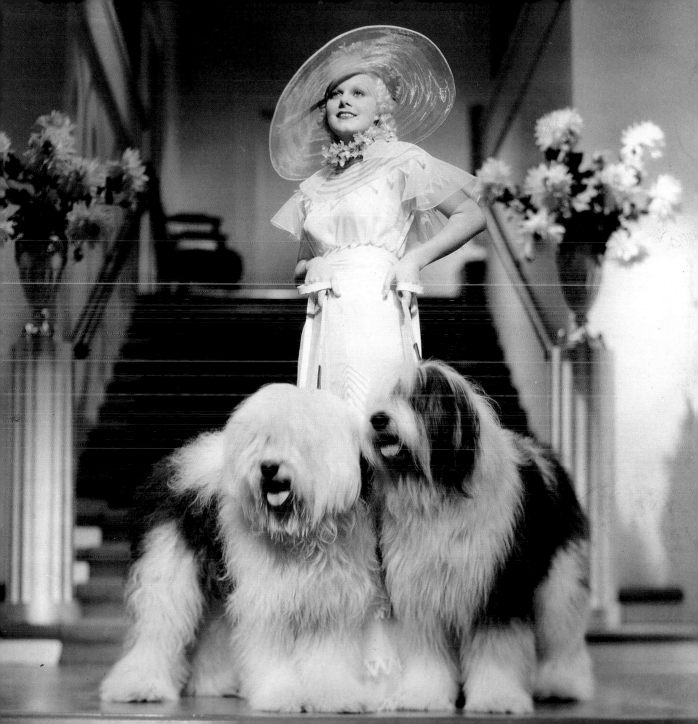

VALENTINO. 1977
*Carol Kane, as a Hollywood
starlet who befriends Valentino,
poses next to her Silver Ghost
with an elegant brace of
Borzois. Imported in very small
numbers to the United States
at the turn of the century,
Borzois were much in vogue in
the 1920s.*

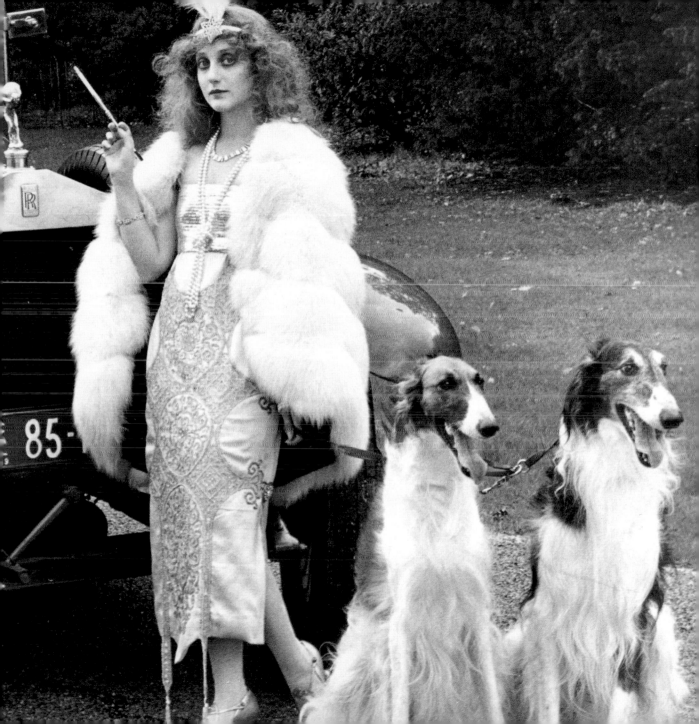

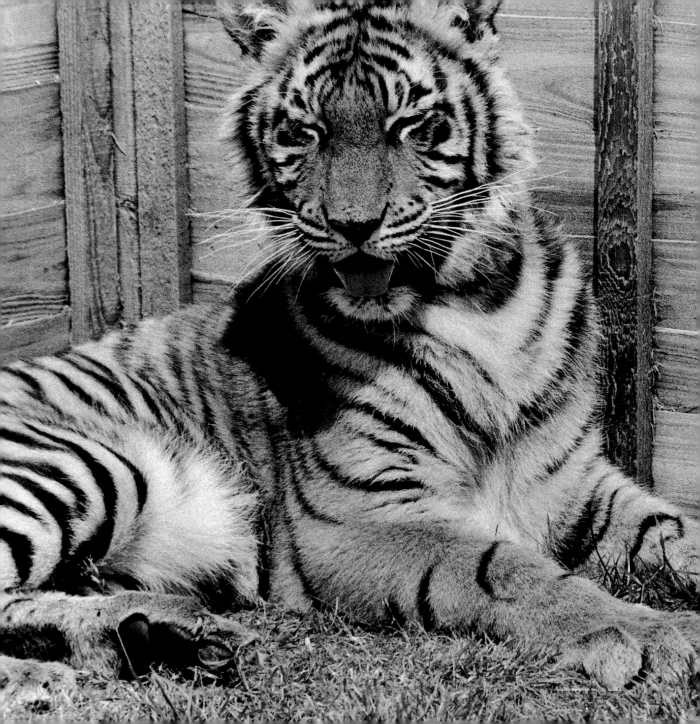

JOHN DRYSDALE
*My Powerful Friend*
Banbury, England, 1989

ABOVE:

**DONNA RUSKIN**
**DIAMOND JIM,**
**NEW YORK CITY, 1988**

"In Central Park I came across this man and his dog, a Standard Poodle
named Diamond Jim. The man was clearly very proud of the dog. I got
the sense that the two of them had rehearsed this kissing stunt before.
Perhaps they were trying to show each other off to their best advantage."

RIGHT:

**INTERNATIONAL NEWS PHOTOGRAPHER**
**PRODIGALS FROM PRAGUE,**
**NEW YORK, 1940**

Mrs. Andrew Gilchrist, the wife of the then-U.S. Vice Consul at Prague,
with her Great Dane Gollo, returning to the states on the U.S.S. *Manhattan.*

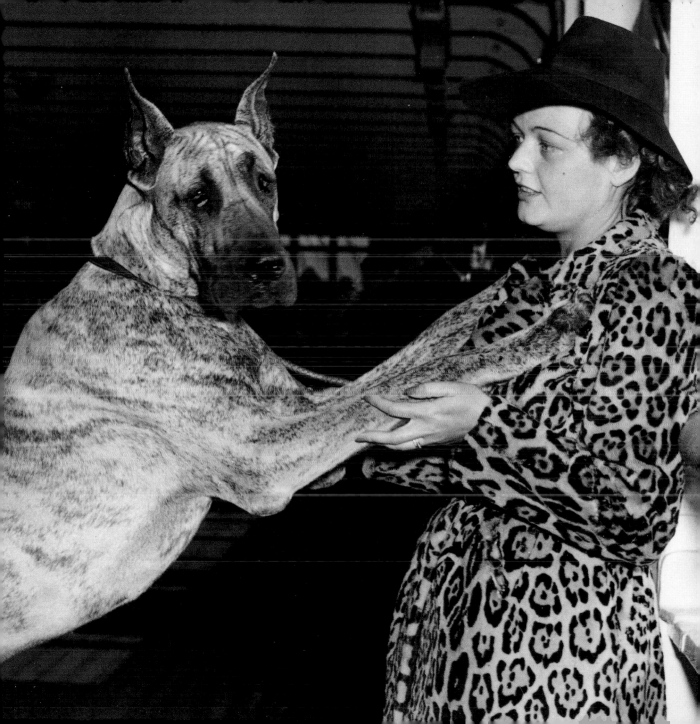

Dogs love company. They

place it first in their

short list of needs.

J. R. ACKERLEY

PHOTOGRAPHER UNKNOWN
ABOARD SHIP, OCTOBER 29, 1943

Picked up by a member of the crew of a Navy transport, Mr. Chips found himself a member of Uncle Sam's Navy before he could wag his tail and bark assent. Smuggled aboard ship by his master, Chips instantly became the mascot of the whole crew. Discovered and ordered ashore by the executive officer, Chips was "rescued" by his new-found friends whose pleas softened the exec's heart. Since then Chips has become literally an old sea dog. He participated in the grim business of the attack on Attu. When the Kiska venture began, Chips perhaps sensed the enemy had left and remained aboard ship. Like every other member of the Navy, Chips has a health record, an identification card and, of course, a dog tag.

(Original caption, circa 1943)

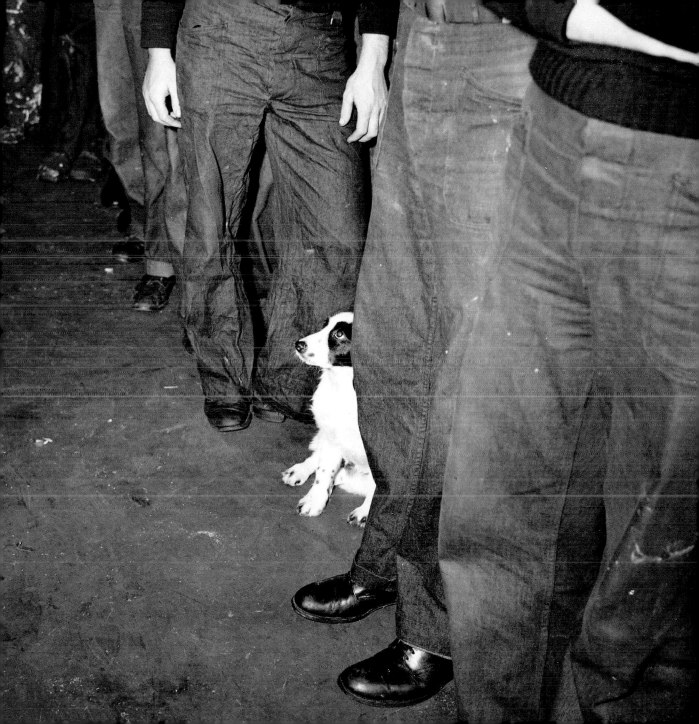

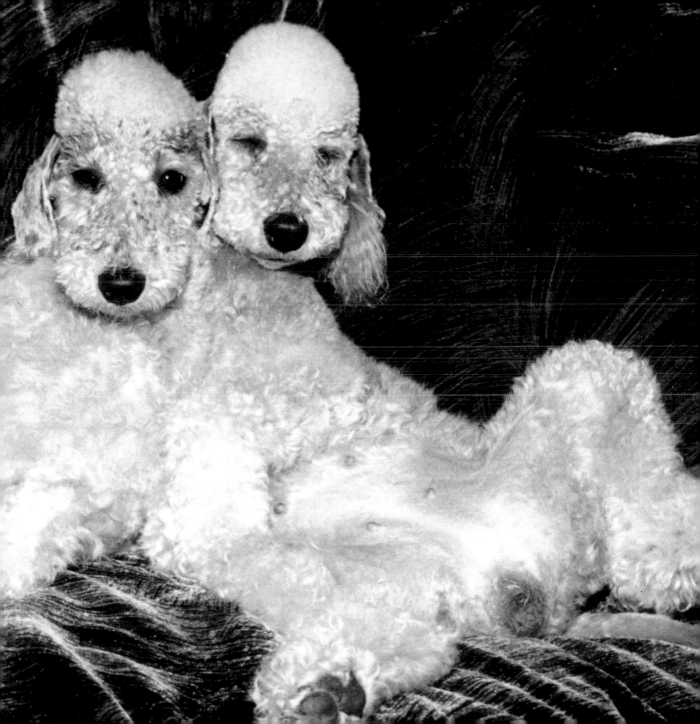

PREVIOUS PAGES:

**ROBIN SCHWARTZ**
**CAZI AND SATIN,**
**RUTHERFORD, NEW JERSEY, 1998**

"These are two Bedlington Terriers at nine-thirty in the morning, when they're usually not awake. Their owners work all week, and this was Saturday. But the dogs don't understand the difference between a Saturday morning and a workday morning, so as I was photographing them, they just fell asleep. Satin, the youngest of these two girls, is quite attached to Cazi (short for Cashmere), and really looks up to the other older dog. She follows Cazi everywhere, watching and mimicking. Younger dogs just want to be in the older dog's world."

RIGHT:

**ROBIN SCHWARTZ**
**ALPHI AND MISTY DAVENPORT,**
**FEASTERVILLE, PENNSYLVANIA, 1996**

"These two Salukis are from the same breeder, and are both very sweet dogs. Alphi, the white one, is a one-year-old male, and Misty, the cream one, is four. Here they'd just been playing like crazy and were completely exhausted."

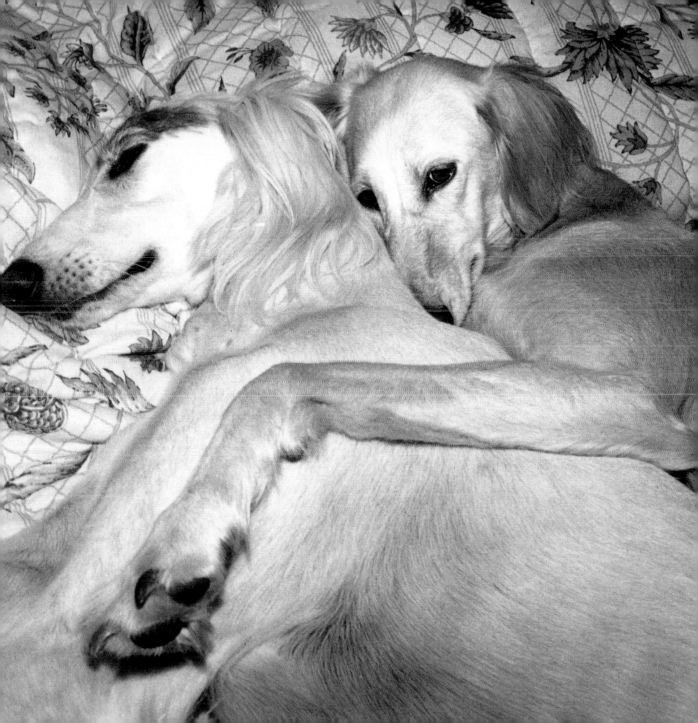

**ROBIN SCHWARTZ**
**WEDDING,**
**CONNECTICUT, 1996**

"This dog, a Boxer, was the bride's dog. Not only was he present at the wedding, he was extremely excited about it. The whole affair was held in a glass church built like a triangle. On a nice sunny day it's probably beautiful, but as it happened, the wedding took place during a nor'easter, which really added to the drama of the occasion. But the Boxer wasn't scared. He just got more and more excited the nastier it got outside. And he loved being in the middle, between the bride and groom."

**KARL BADEN**
**HARLEQUIN DANES,**
**MASSACHUSETTS, 1993**

"At a Great Dane match I came across a woman in a harlequin T-shirt, getting love from her giant."

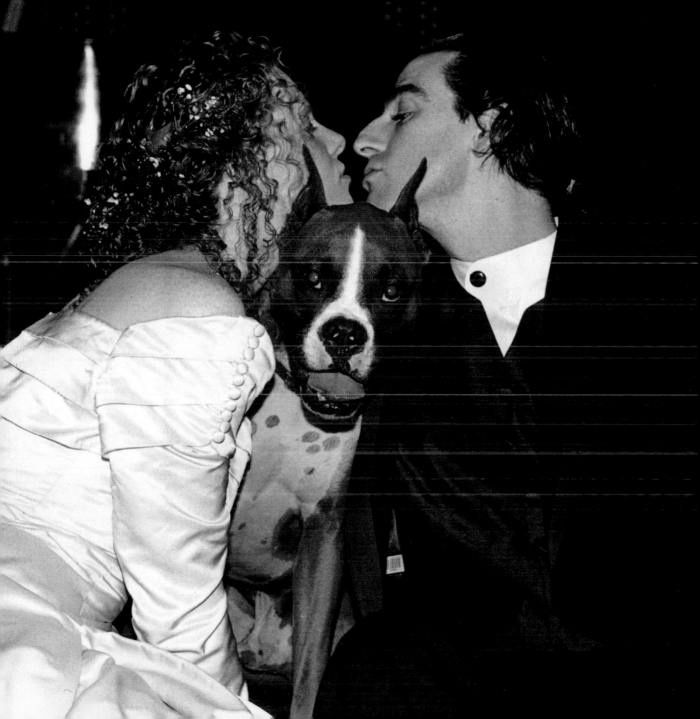

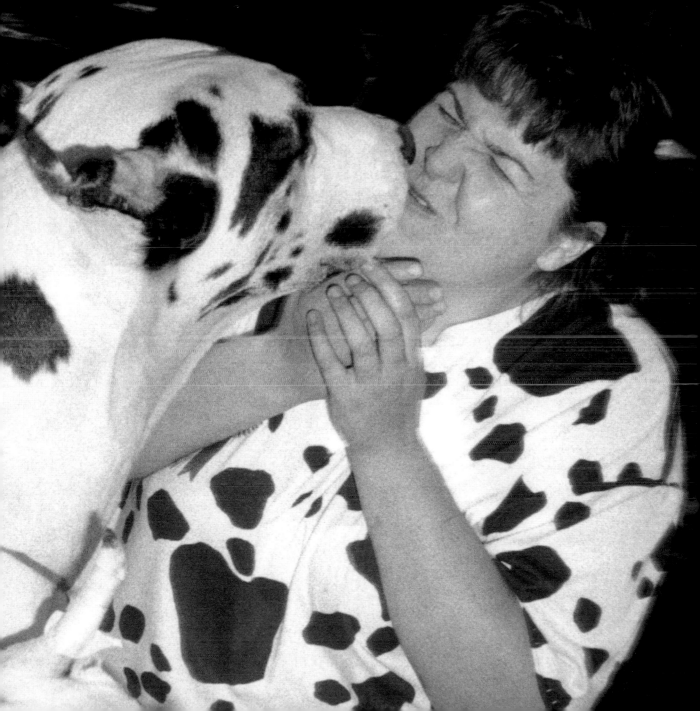

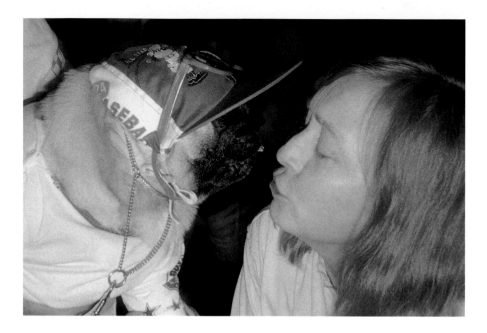

**KARL BADEN**
**RED SOX PUG,**
**MASSACHUSETTS, 1993**

"At a Pug Easter Parade, this entry wore a
uniform that was practically regulation,
ready to slug one out of the park for its owner."

**KARL BADEN**
**CHARLOTTE LICKING GIRL,**
**CAMBRIDGE, MASSACHUSETTS, 1991**

"My wife's late dog Charlotte, a shepherd mutt, was a great
dog who loved everybody. The little girl on our sofa was from
down the block, and liked Charlotte especially. In fact she
came over specifically to visit with Charlotte, not with us."

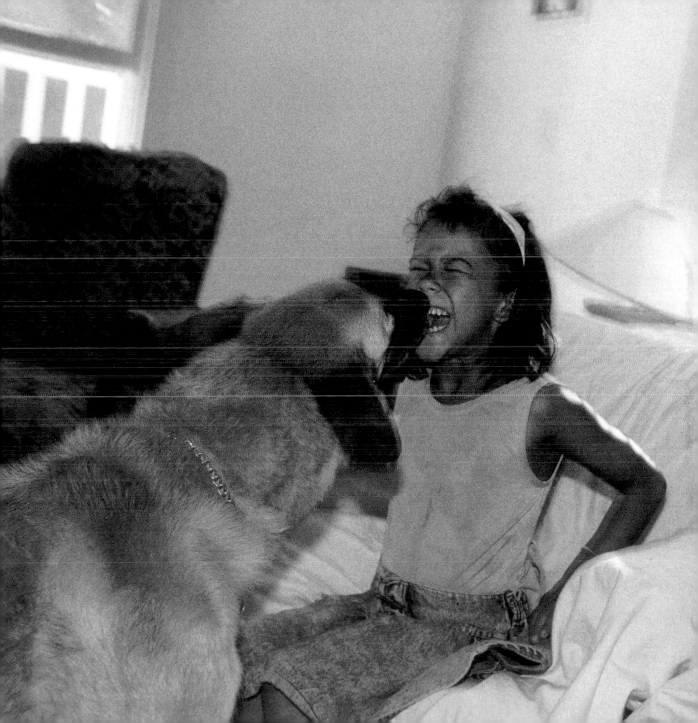

## THE NANNY

When we had our first son, Billy, I was really nervous that my dog Noodle, who is a pretty small dog, would feel threatened by the arrival of this new creature. Noodle was old and pretty set in his ways. Instead, he put me to shame. One day Billy was sick and I didn't even know it. While napping, he must have been crashing around his crib, but there wasn't any noise coming from the baby monitor. Noodle came running in to get me and wouldn't leave me alone until I followed him into Billy's room. Sure enough, Billy had a high fever. From then on, Noodle was the self-appointed nanny.

CARLA DROSNICK, MOTHER, IOWA CITY

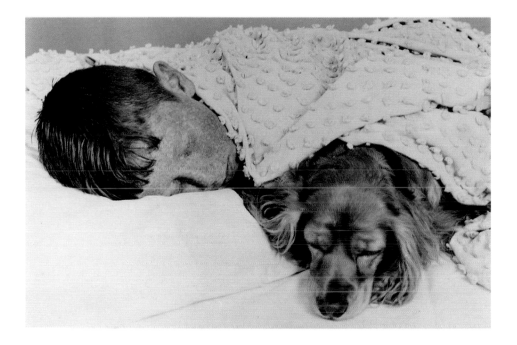

ABOVE:

**UNIDENTIFIED PHOTOGRAPHER**
**NAPTIME,**
**U.S., 1950s**

A young boy's sleep is made sweeter by the
presence of his Cocker Spaniel sharing the blanket.

# A Big Surprise

At the animal shelter my son picked out this tiny little puppy that squeaked. I thought, this dog will be easy. He'll grow up to be the size of a Cocker Spaniel at the most. Well, now he weighs a hundred pounds and eats nine times a day. And he's only ten months old.

ANNE ZHAO

ARCHITECT

LOS ANGELES

PHOTOGRAPHER UNKNOWN
*When Great Hunters Meet*
London, England, 1970

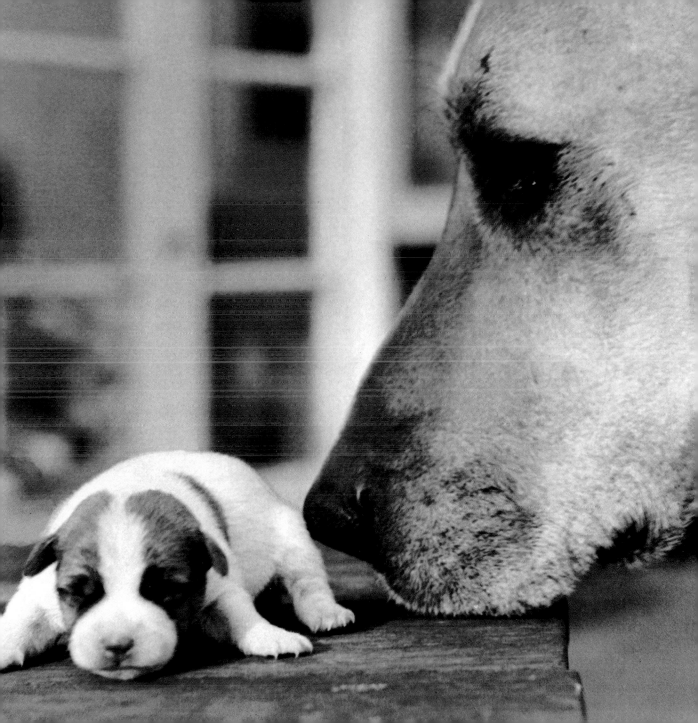

JEAN HARLOW. 1933
*The star beams in the sun, holding a Wire-haired Fox Terrier.*

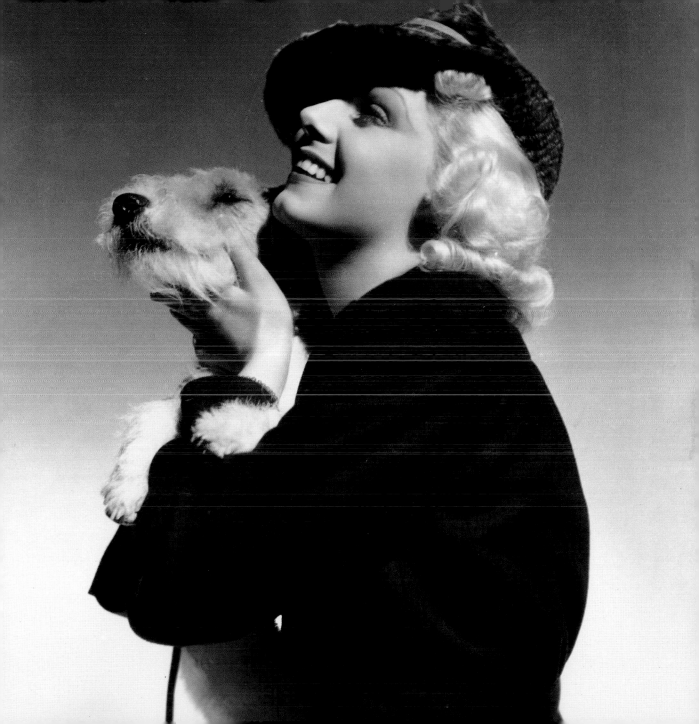

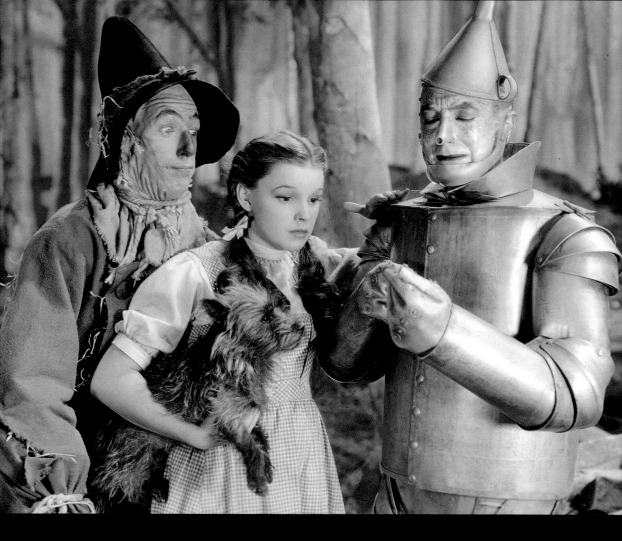

THE WIZARD OF OZ. 1939

*Terry, the Cairn Terrier who played Toto, was the lowest-paid
and, according to her trainer Carl Spitz, the hardest working of
the principal cast. During the production, it took Terry weeks to
overcome her fear of the wind machines. She finally learned to
duck behind Garland and Bolger.*

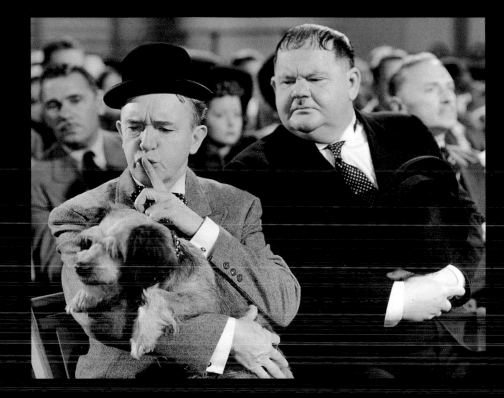

AIR RAID WARDENS. 1943
*In a typically impossible gag, Stan Laurel and Oliver Hardy*
*try to hush their whining mutt during a solemn meeting.*
*During the silents, trainers could teach a dog to whine to*
*spoken cues. With the advent of the talkies, they had to resort*
*to hand signals.*

I am called a dog because I fawn

on those who give me anything,

I yelp at those who refuse, and I

set my teeth on rascals.

DIOGENES THE CYNIC, 4TH CENTURY BC

ROBIN SCHWARTZ
*Billy, Jack Russell Terrier, at Five Months*
Montclair, New Jersey, 1995

ROBIN SCHWARTZ
CHINESE CRESTED, 1993

*This was taken at the Westminster Dog Show. Even though
the breed is Chinese, it reminds me of Mexican Hairless dogs.*

OVERLEAF: PER-OLLE STACKMAN
STOCKHOLM ARCHIPELAGO, 1980

*Lawan was one of the few expert divers in the dog kingdom.
His name in Swedish has to do with something lovely.
His owner was a professional diver. Everytime his master went
diving, Lawan would try to follow him and nearly drown
in the process. So my friend fashioned some dog-sized
equipment and taught Lawan how to dive. Lawan wore
the tank, the mask—everything. He wore boots here so
he wouldn't scratch our wetsuits accidentally when we were
all underwater. He was crazy about diving.*

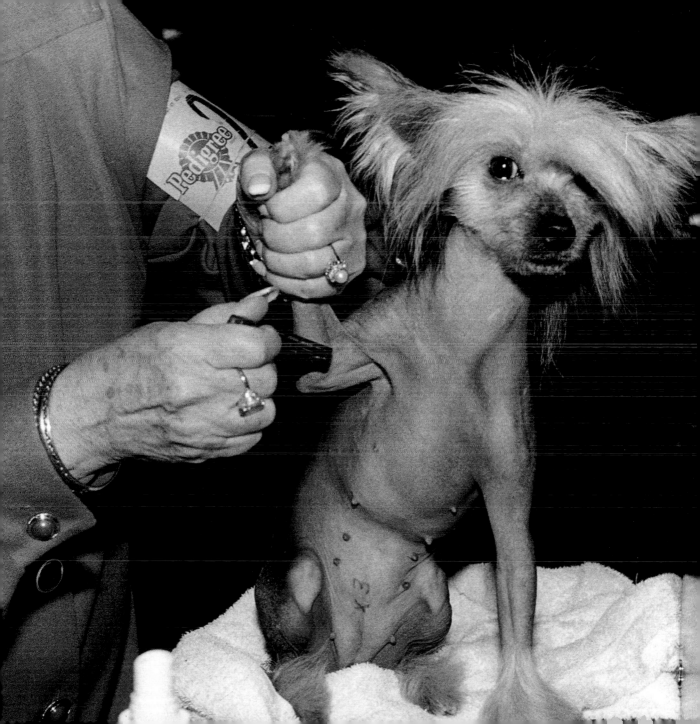

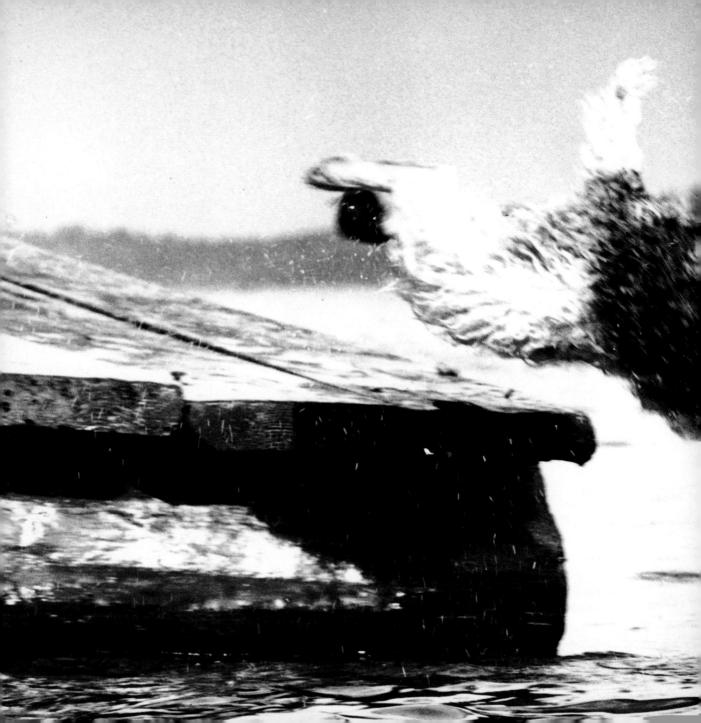

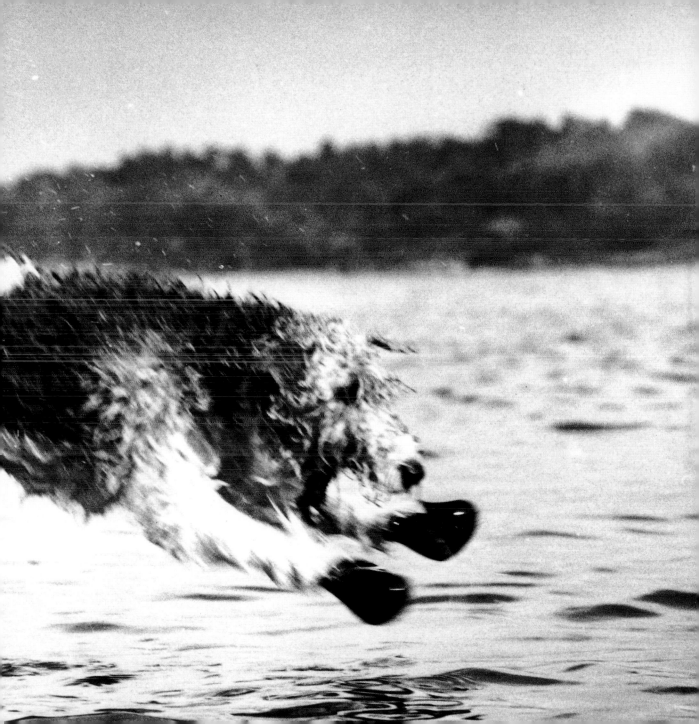

This dog is going to learn your every desire. He'll
learn to work from heel and retrieve on command
whether it be land or water. He'll learn to follow your
whistle and hand signals. He'll learn when to do the
retrieving job on his own and when to depend on
you. I think the bond between dog and man is
stronger in the retriever breeds than in any of the
other hunting dogs because of the basic requirement
of the teamwork necessary to get the job done.

**RICHARD A. WOLTERS**
WATER DOG

RIGHT:
**TONY MENDOZA**
**GRAYTON BEACH, FL, 1990**
A classic combination, a dog and his ball
photographed in the surf at Grayton Beach, Florida,
for a photography project called *Dogs On Vacation*.

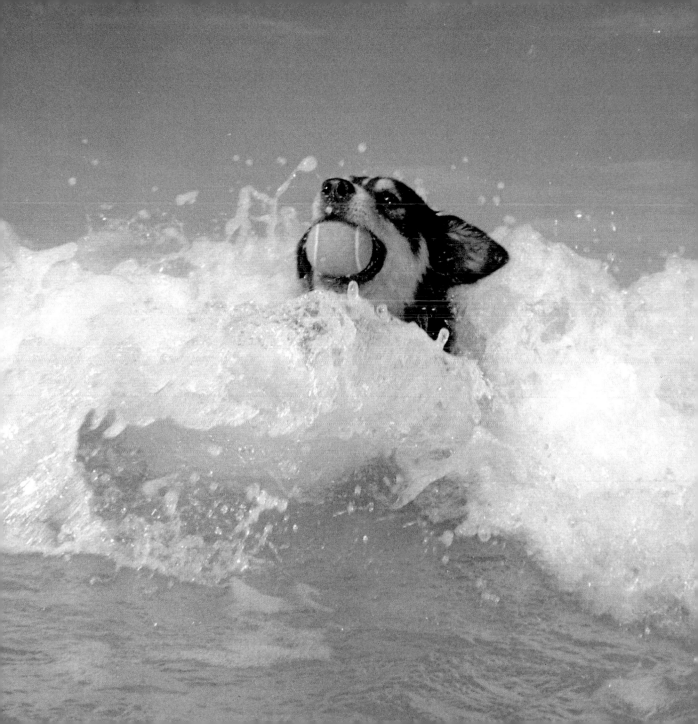

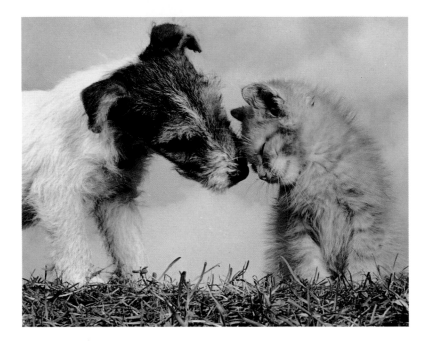

ABOVE:

**YLLA**
**UNTITLED, NEW YORK, 1950**

In the photographer's studio, a Wire-haired
Fox Terrier puppy nuzzles a tabby kitten.

RIGHT:

**JOHN DRYSDALE**
**CARPETBAGGERS, ANDOVER, ENGLAND, 1996**

"After a lion cub wandered away from its mother at a lion reserve
near Andover, none of the other nursing lionesses would show signs
of maternal possession. Instead, the cub was raised on a bottle in
the secretary's house, in the company of the house's Golden
Retriever. The two spent most of the day on the carpet in the
reception office, forcing visitors to shuffle around them. Of course
no one with even half a heart would have told them to move."

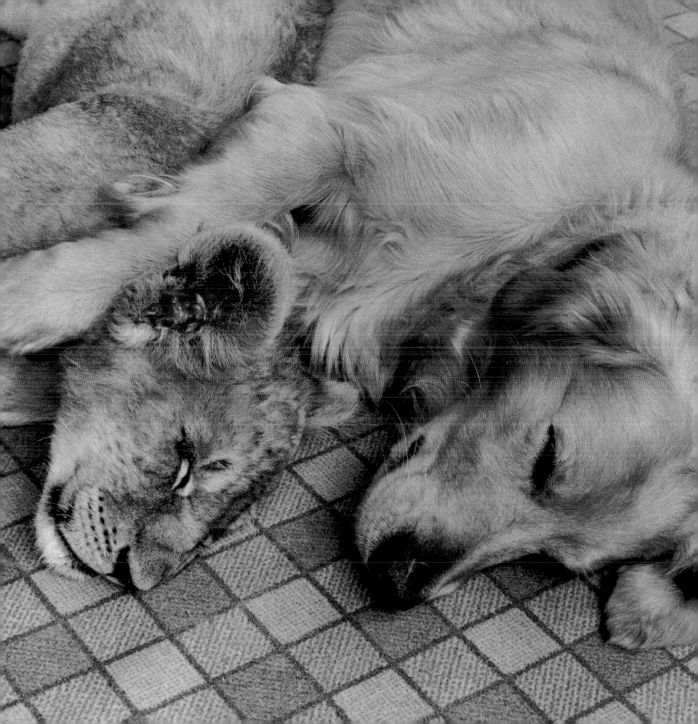

# Definition

They are I think called Chihuahuas because they chew on everything including my toys.

JESSIE ROSE

KINDERGARTNER

SYRACUSE

PAUL van DRIEL/ERIK ALBLAS
*Two Together: Chihuahua Puppies*
Amsterdam, 1993

overleaf:
ALLAN and SANDY CAREY
*Bloodhound Mother and Child*
Montana, 1994

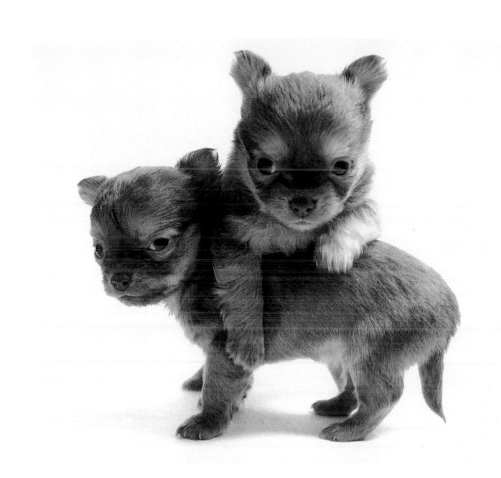

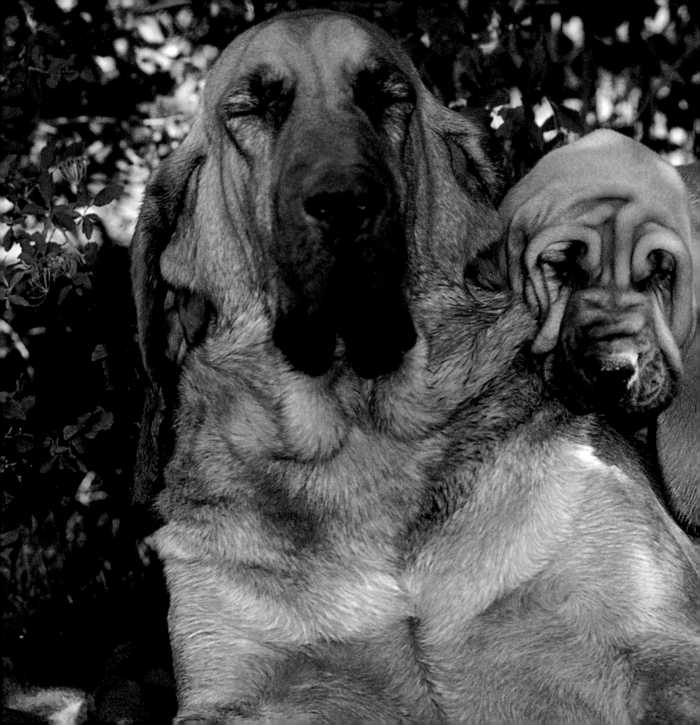

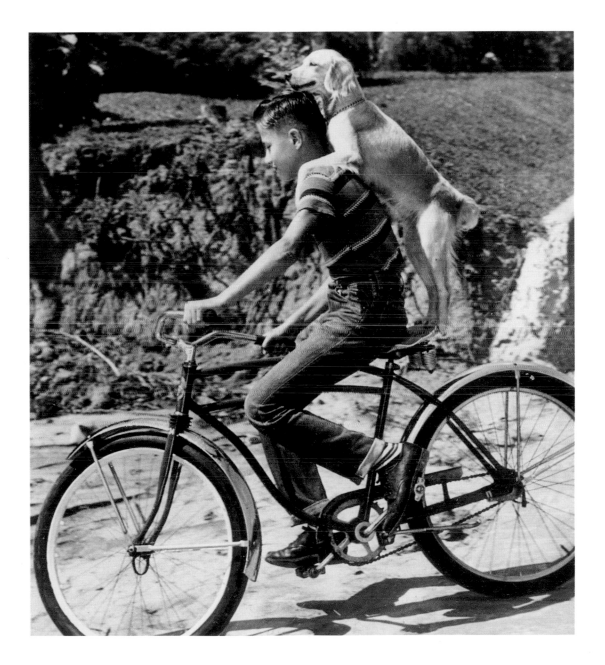

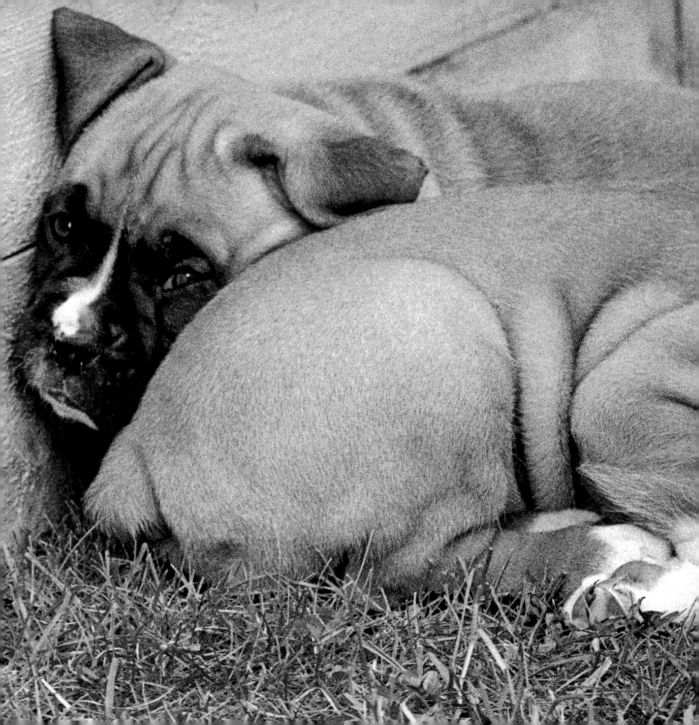

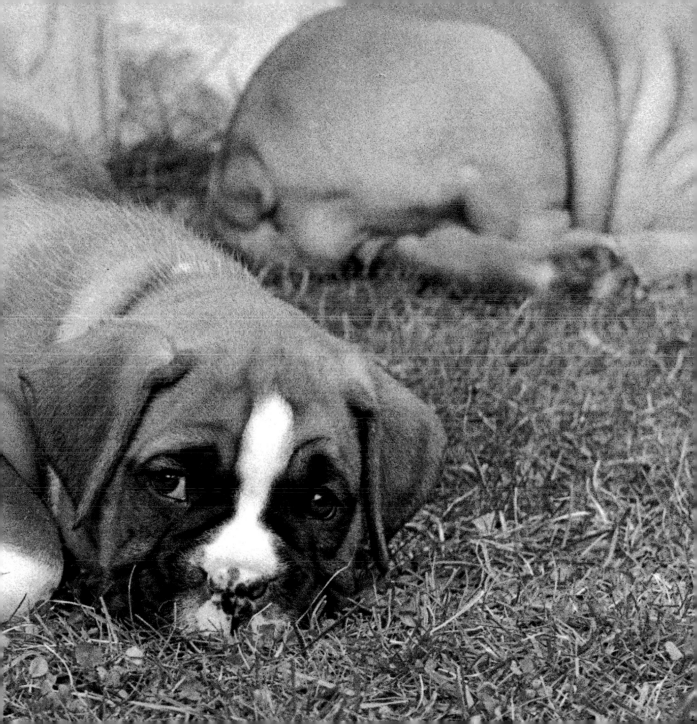

**JOHN DRYSDALE
ODD FRIENDS,
ANDOVER, ENGLAND, 1991**

"The puma cub, starring in a movie, was given the
company of a friendly English Pointer when it wasn't
on the set. The two became so close that the dog
adopted the puma and moved it into the house."

**H.D. BARLOW
UNCONDITIONAL LOVE,
U.S., 1940s**

No matter what Freddie does, Karl the
Dachshund is always there. And if Freddie
begins to cry, Karl responds with an almost
motherly show of concern, putting a reassuring
paw on the baby's arm and licking his tears away.

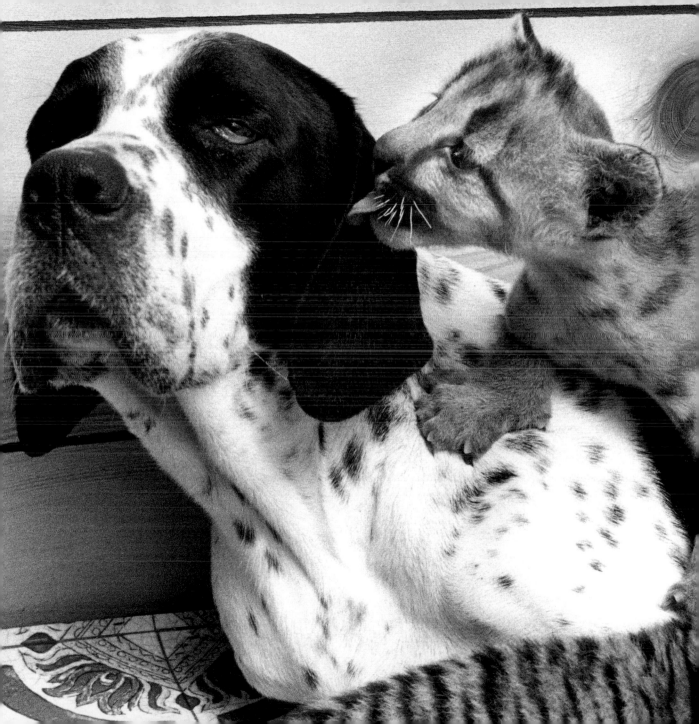

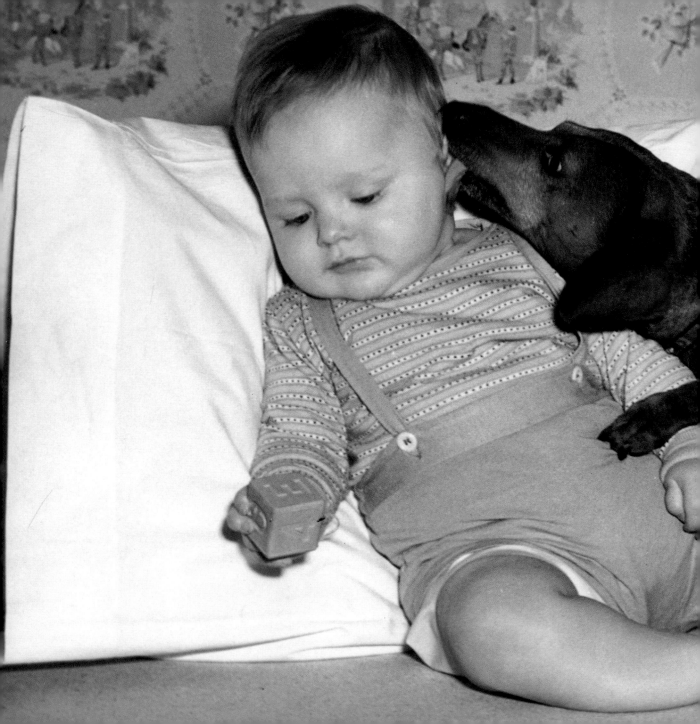

Sheba was a malnourished wreck when I found her under a dumpster.
Aside from a broken leg, she had snaggly fangs, stick-out ribs, and
enormous ears. Coyote-dog crosses are common in the Southwest,
and I figured, either she's wild or not. But I didn't exactly trust her.
Naturally my irresponsible neighbors skipped town and left their
rabbit behind. I was frantic Sheba would kill it, so I had to take it
in. I kept them separated for weeks, though Sheba really wanted to
get to this rabbit, and this dumb rabbit seemed to want to get to
her. Then the day came when I got home and found the bedroom
door open, the rabbit cage open, and the rabbit gone. I was frantic,
imagining the worst. But instead I found them nestled together on
the couch in the den, which is where they sleep to this day.

TERRY CARERRA, SEDONA, ARIZONA

RIGHT:
**JOHN DRYSDALE
STAND-IN PUP,
NORFOLK, ENGLAND, 1975**

"Having just had her pups sold, the bulldog was feeling rather
forlorn, and needed something else to mother. Her owner, a
farmer, found an abandoned baby squirrel a few days later and
decided to try it with the dog. Acceptance was instant,
and the squirrel became an honorary pup."

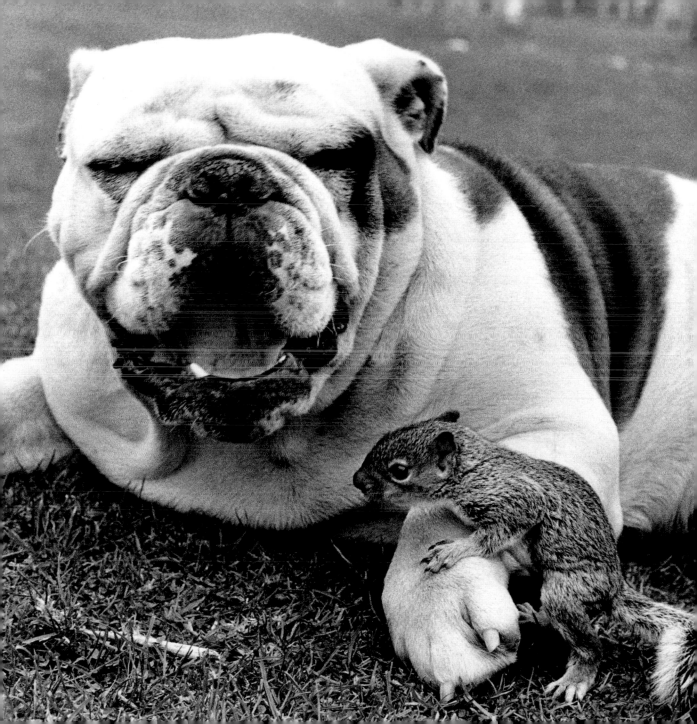

MARY BLOOM
NEW YORK CITY STREET, 1992

*In Chelsea, I ran into a woman who had three*
*English Bulldogs, and the one I wanted to shoot was*
*the one who would have nothing to do with me.*
*But the woman was thrilled and proud.*

## The Snake Terriers

JOHN DRYSDALE
*Bush Baby (Marmoset)*
*Getting a Ride on a Black*
*Labrador,*
*London, 1990*

The U.S. Department of Agriculture has a very special problem on Guam—snakes. And we have a very special group of dogs to deal with it. Our dogs are mostly Jack Russell Terriers and Fox Terrier mixes, which were originally bred to hunt varmint like rats and moles. But our team has been trained to hunt snakes. And no one hates snakes more than my dogs. This is a fairly new operation, but the problem really began after World War II, when a seemingly benign serpent called a "Brown Tree Snake" was introduced to Guam via military cargo from other islands in the South Pacific. Unfortunately, the snakes had no natural predators on the island. Once biologists noticed that some eight of the island's dozen or so bird species had suddenly become extinct, the USDA began to act. My main job right now is containment. Most planes that leave Guam stop off in Hawaii. If these snakes ever got onto Hawaii, it would be an ecological disaster. Not to mention the mainland. And the snakes are tricky. We've even found them in the wheel compartments of airplanes!

I train my dogs in San Francisco, and then we transport them to Guam. Nothing leaves the island without our dogs doing a thorough search first. And these terriers are tenacious—if there's a snake coiled up somewhere they'll find it. These dogs might not seem heroic to some people, but once one species is extinct, others are sure to follow. And that ultimately means Man, too.

MEL ROBLES, CANINE COORDINATOR-TRAINER, USDA, WESTERN REGION

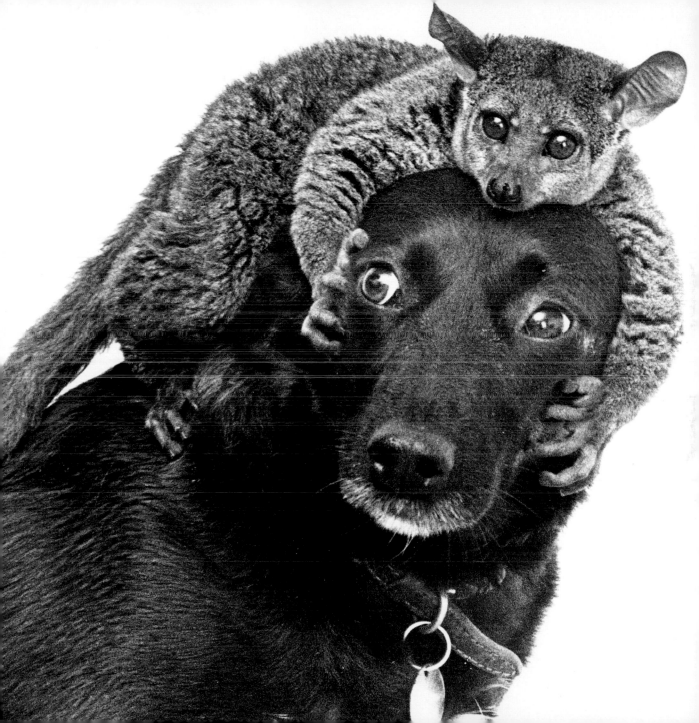

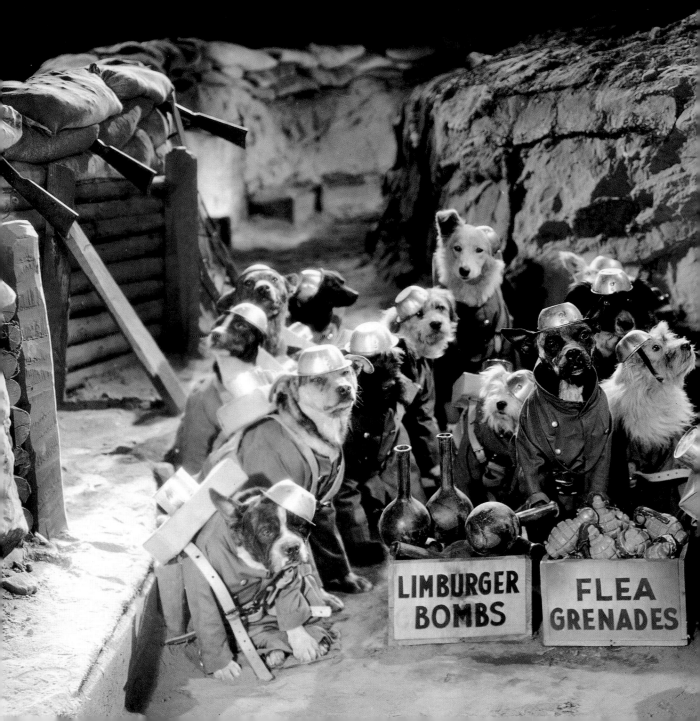

LIMBURGER
BOMBS

FLEA
GRENADES

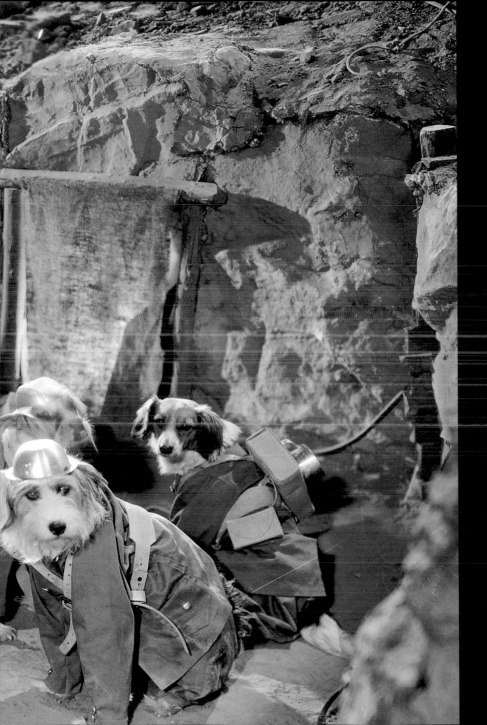

DOGS IN THE TRENCHES
1930s
*Dogs brave WWI trenches in the* Bugsy Malone *of dog movies.*

PHOTOGRAPHER UNKNOWN
THE GARGOYLES STAND GUARD
U.S., c. 1970

OVERLEAF:

ROBIN SCHWARTZ
THE USCHI VON JENS ENGLISH BULL DOGS:
BART, HOMER, WINSTON,
BELLA, MAGGIE, AND SARAH
TENEFLY, NEW JERSEY, 1996

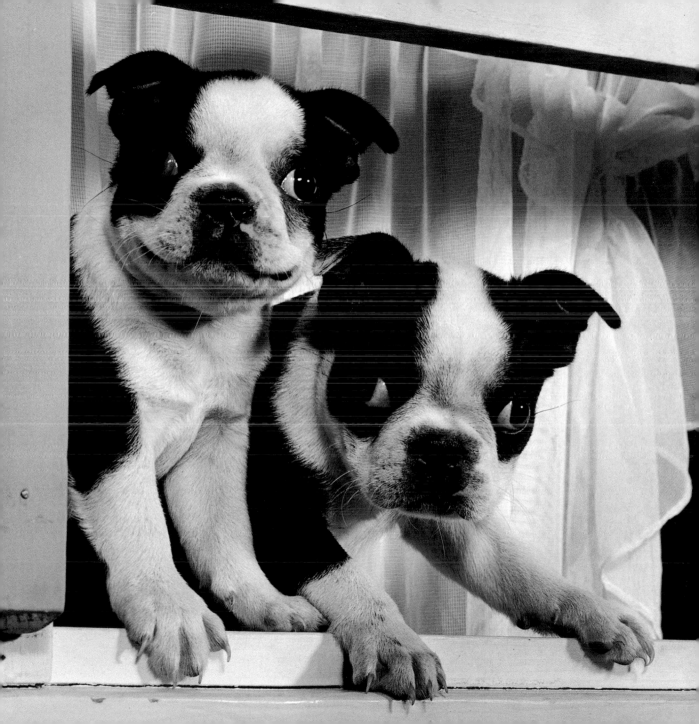

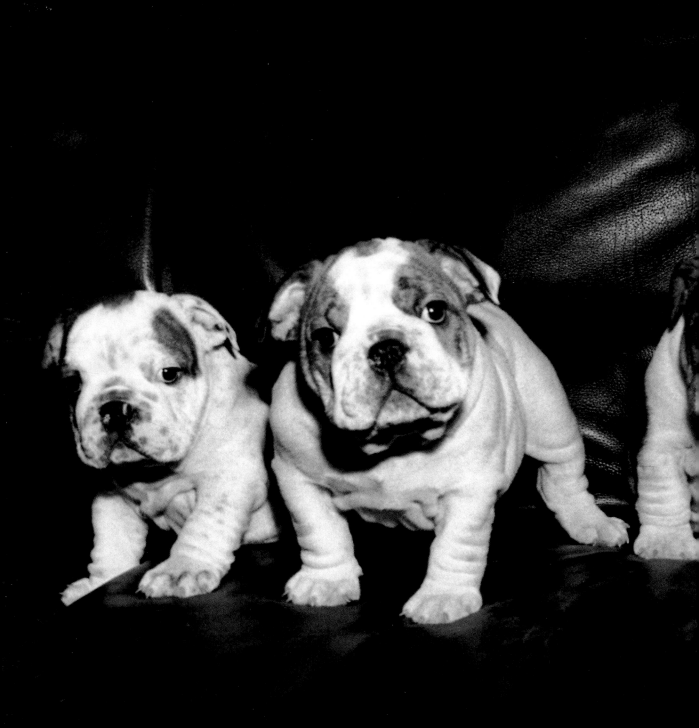

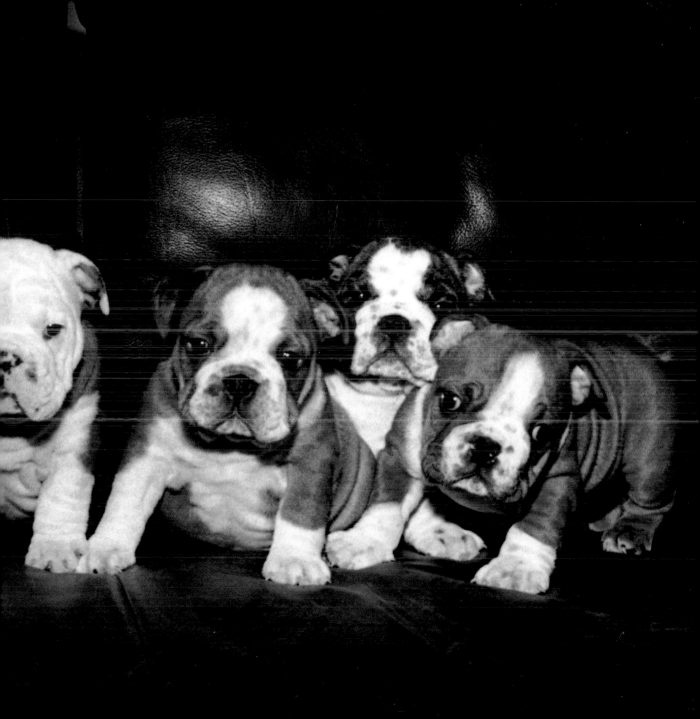

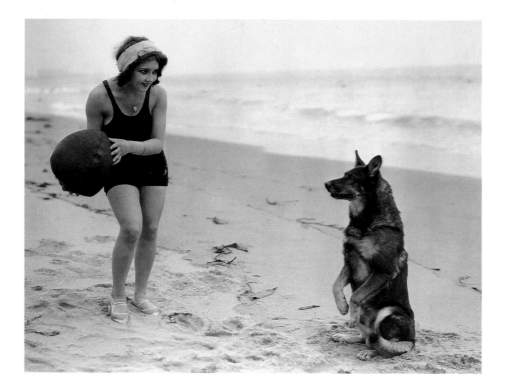

RIN TIN TIN. 1920s
Above: *Audrey Ferris plays ball with Hollywood's foremost
German Shepherd.*

JOAN CRAWFORD AND DOUGLAS FAIRBANKS, JR.
WITH BOXER. 1929
Right: *A honeymoon photograph of Hollywood royalty
at Catalina Beach. Crawford was fresh from filming*
Our Dancing Daughters *and Fairbanks had just finished*
A Woman of Affairs.

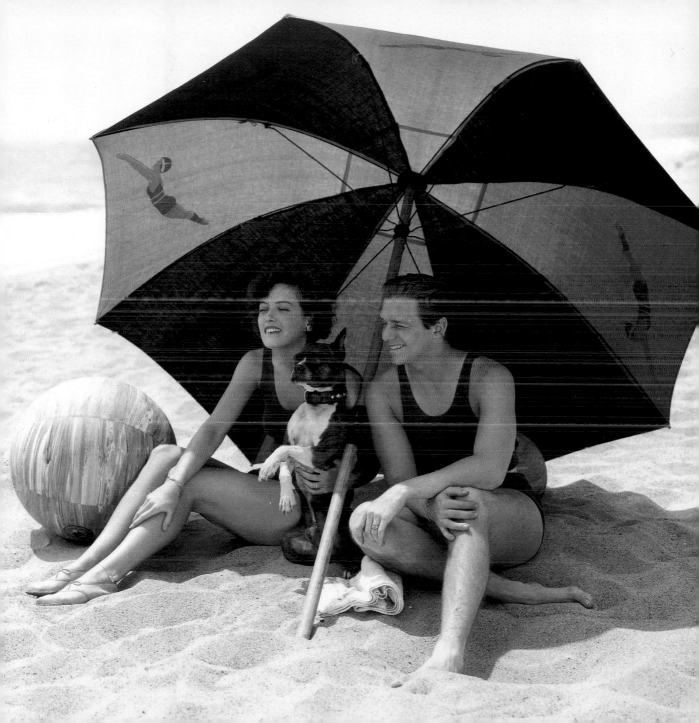

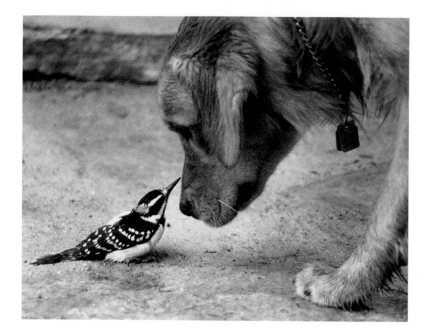

A R C H I E   L I E B E R M A N
J U N I O R   A N D   T H E   B I R D ,   1 9 8 8

*This is a true story. I came out the door onto the patio and Junior, my Golden Retriever,*
*was standing nose to beak with a bird. So I called out, "Junior! Stay! Don't move!" and rushed*
*into the house to get a camera. When I came back, my pal was still there, and so was the bird.*
*Which was not such a good thing for the bird, as the next moment a cat rushed up, caught the*
*bird and ran off. Junior ran after her, caught her and shook her until he released his*
*new friend. But the bird, who had wised up, flew away.*

J O H N   D R Y S D A L E
L L A M A   L O V E ,   1 9 6 9

*The llama, a four-week-old orphan at Longleaf Safari Park near Warminster, England,*
*had formed a remarkably close relationship with this English Pointer. The dog was a veteran of*
*surrogate parenting, having proved his mettle with lion and tiger cubs already.*
*He seemed happy to lend an ear.*

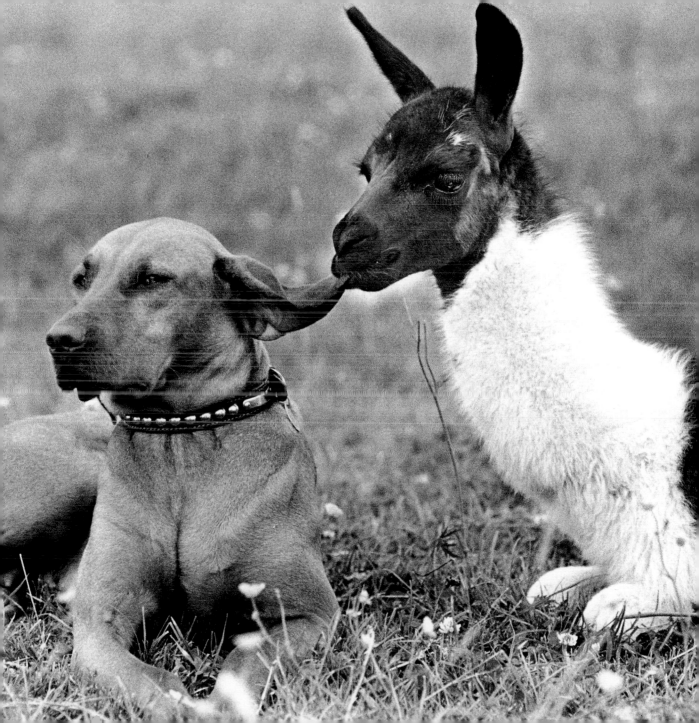

Caramel, my Viszla male, got into the habit of jumping onto the couch and pressing his nose against the window every day at three o'clock. He'd give a little yap, then race around to the front door. Then he'd sit there gallantly, waiting for me to open it. When I did, he'd walk, with all the dignity he could muster, up to the edge of the driveway, and sit there like a statue. A minute later the love of his life, a female Viszla, would come trotting up with her owner. I knew Caramel wanted to bust out with joy, but he didn't. He'd wait for her to come up, and then they'd politely touch noses. As she'd prance away, he'd turn around and maintain his composure until he got back inside. Then he'd fall into crazy spasms of joy and knock over the furniture.

LILA CARROLL, ILLUSTRATOR, CHICAGO

RIGHT:
**DONNA RUSKIN**
**TOMBSTONE TILLIE AND CALAMITY JANE,**
**PENLAND, NORTH CAROLINA, 1992**

"These two characters, mutts with a lot of Labrador Retriever in them, are lounging in the side yard of Suzanne Ford's bed-and-breakfast in Penland. Suzanne told me that they were strays and had just showed up one day. Being the hospitable type, she took them in, and they never left."

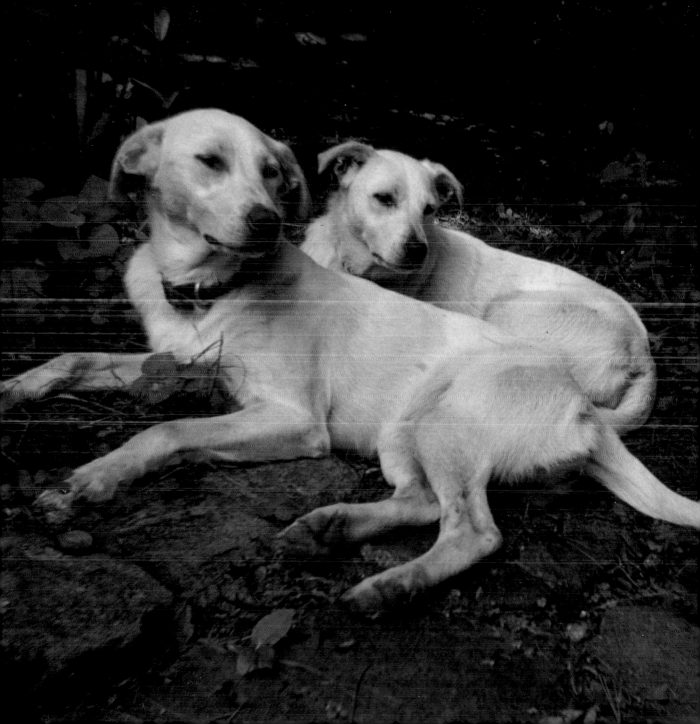

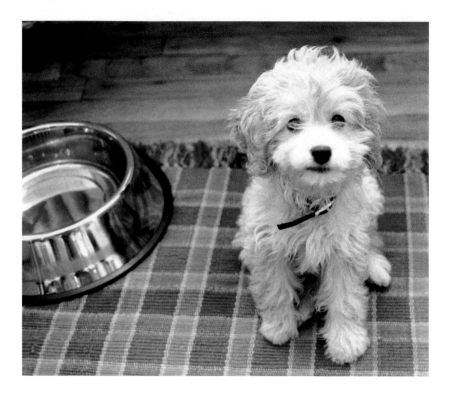

GREGORY WAKABAYASHI
*Yogi and Bowl*
New York City, 1999

right:
WALTER CHANDOHA
*Sweetie with Bottle*
Annadale, New Jersey, 1970

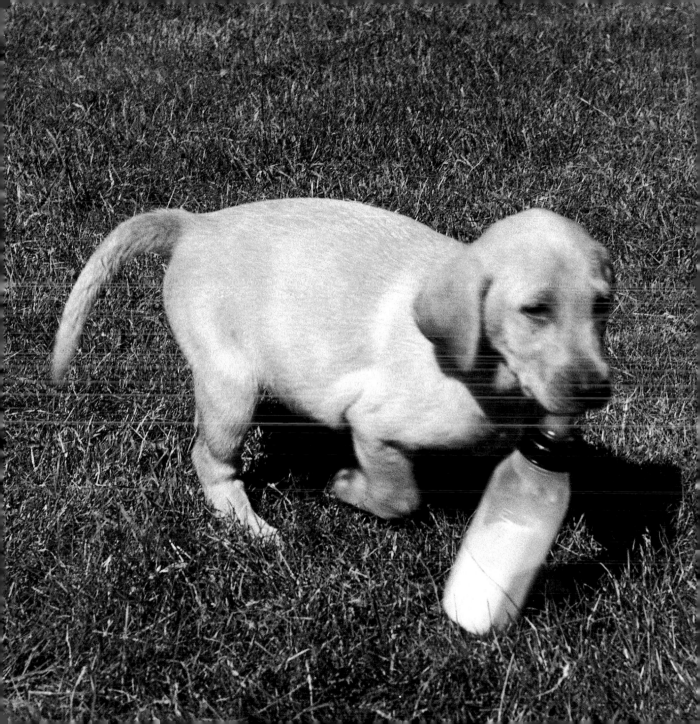

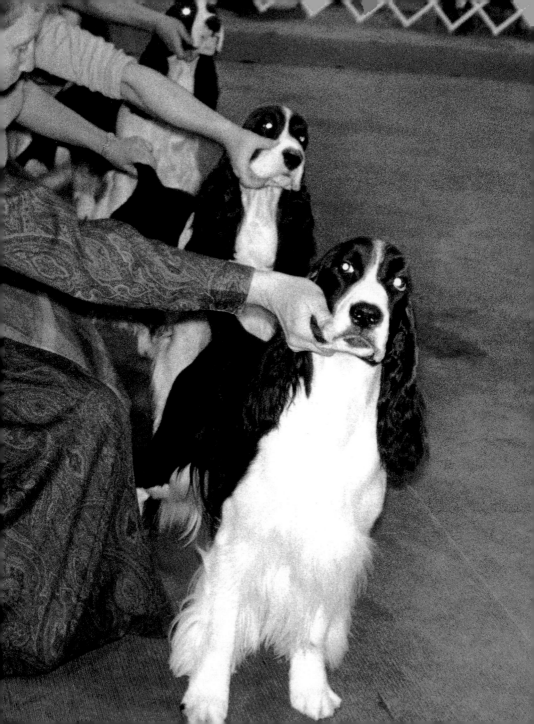

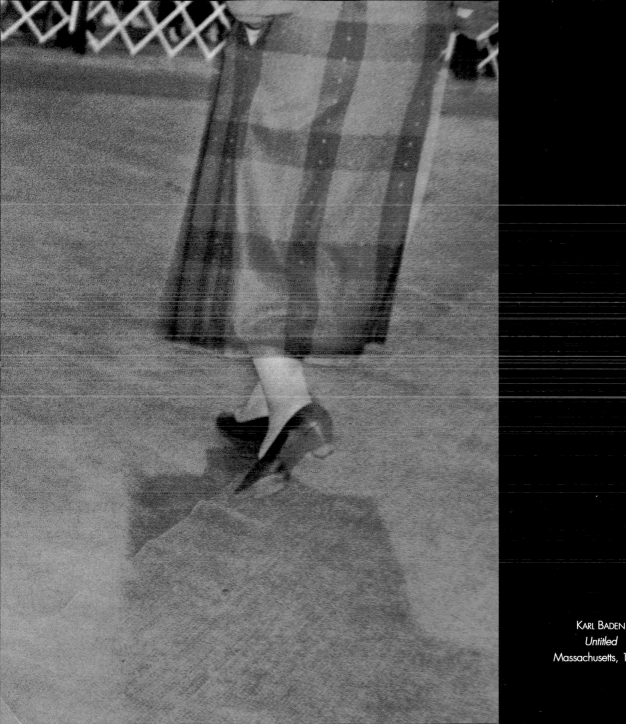

KARL BADEN
*Untitled*
Massachusetts, 1

RIGHT AND OVERLEAF:

**ROBIN SCHWARTZ**
**KIRAN AND FOSTER,**
**HOBOKEN, NEW JERSEY, 1997**

"Kiran is a white German Shepherd who weighs about a hundred pounds, and Foster's a female Pug. They live downstairs from me — Kiran in the apartment above Foster—and they're about the same age. A lot of dogs are afraid of Kiran, but not Foster. They really like each other, and play together as much as they can."

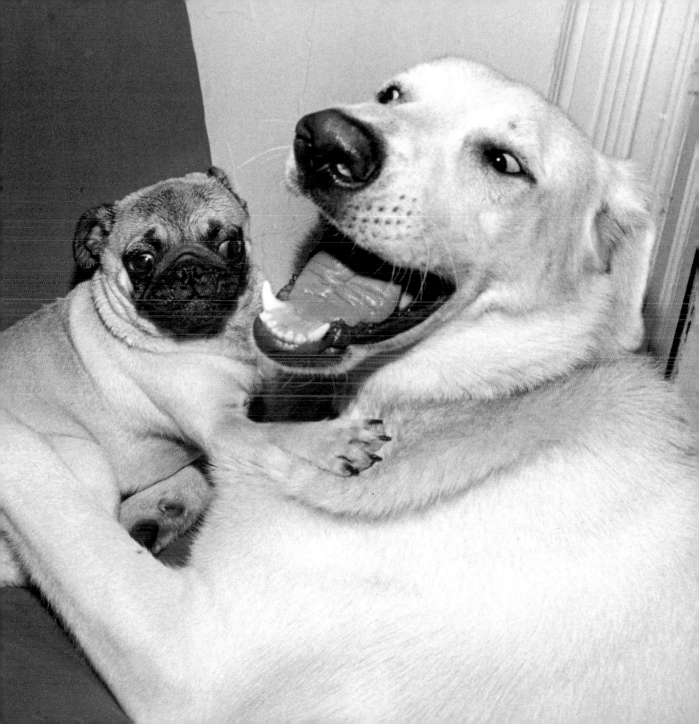

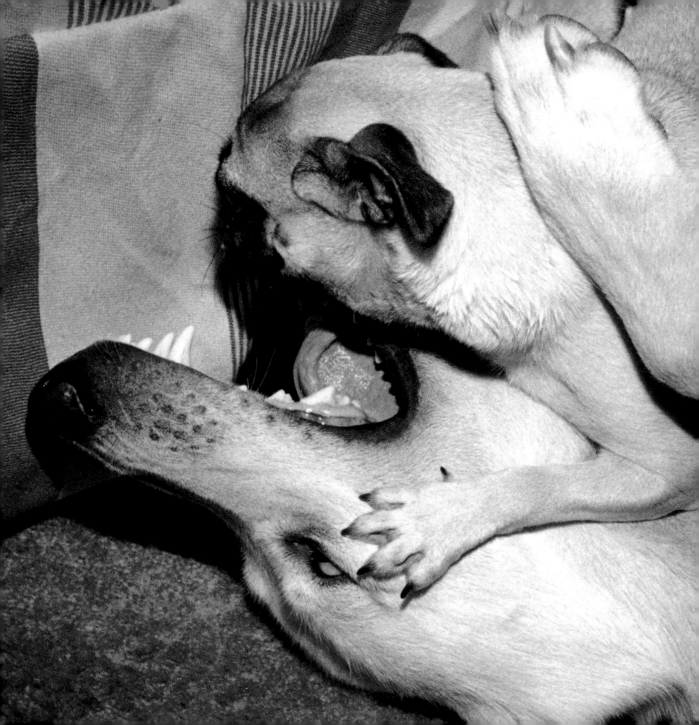

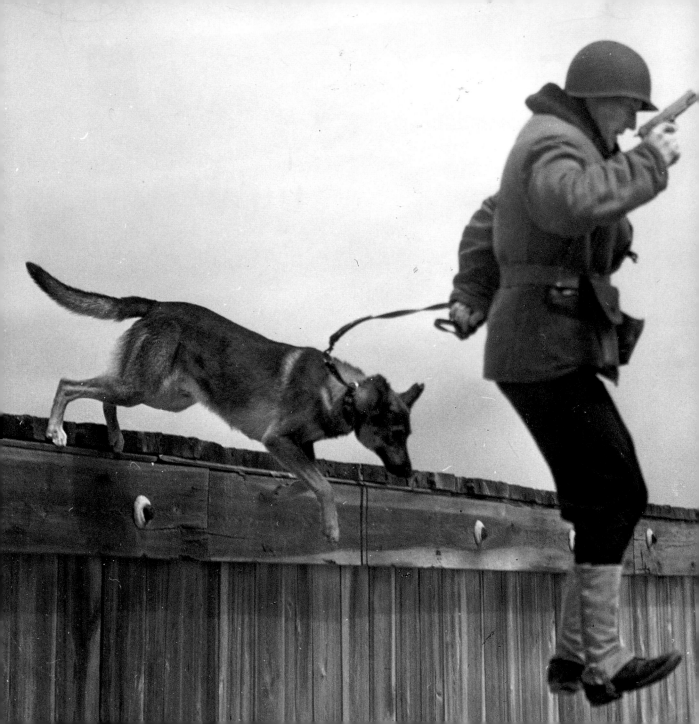

Irving Haberman
*Beach Patrol*
*U.S. Coast Guard*
*n.l., c. 1943*

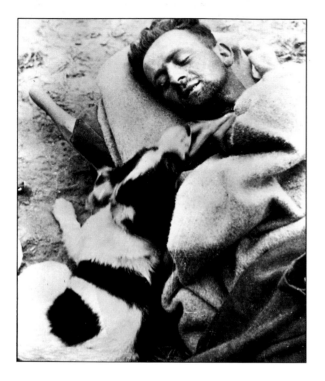

UPI PHOTOGRAPHER
*Comforted at the Beachhead*
*France, 1944*

Opposite:
U.S. MARINE CORPS
PHOTOGRAPHER
*Butch Guards over Private*
*Rez Hester's Nap*
*Iwo Jima, 1945*

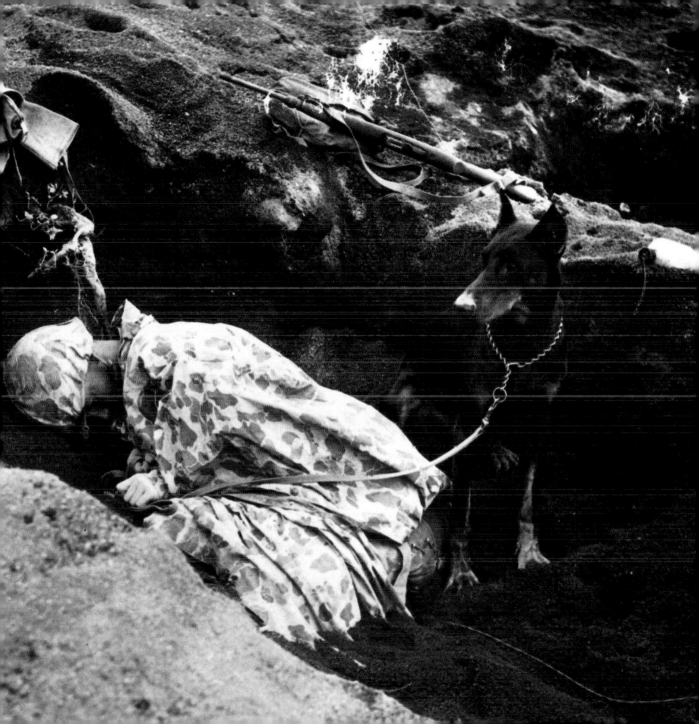

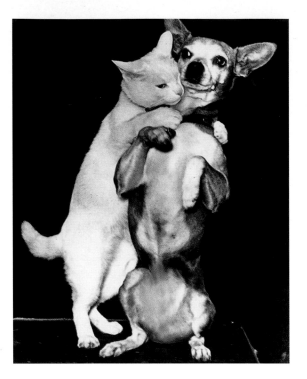

ABOVE:

**CHARLES G. SNYDER
IN THE HOLIDAY SPIRIT,
BOSTON, MASSACHUSETTS, 1946**

Brimming over with Christmas spirit, Lee the cat forgets his innate antipathy
for anything canine long enough to give Frisco the Chihuahua a huge hug.

RIGHT:

**ABBY HODES
UNTITLED, NEW YORK, 1997**

"At a sidewalk cafe one spring night, everything felt very French:
the conversation, the menu, even the dogs. One of them had been
standing around like it owned the place. When the other dog came up, the
two greeted each other like Parisians, kissing each other on both cheeks."

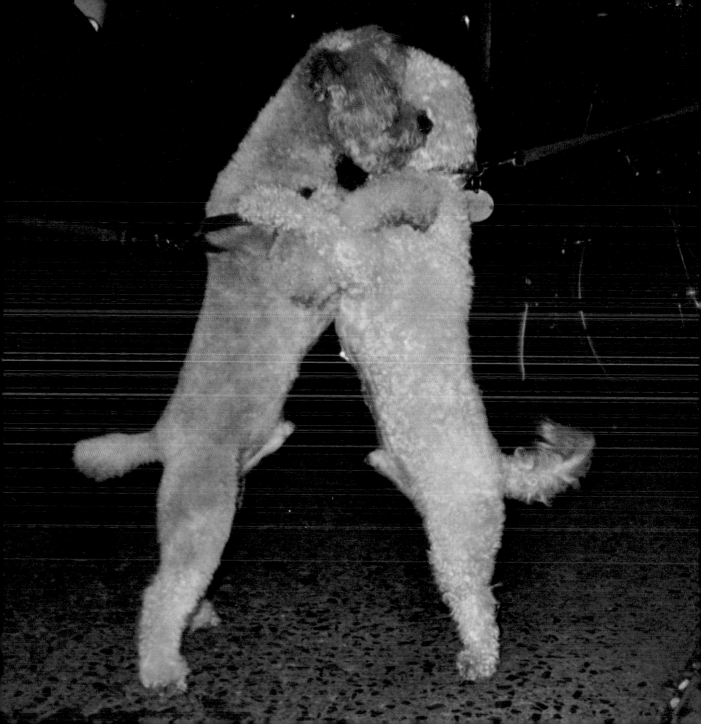

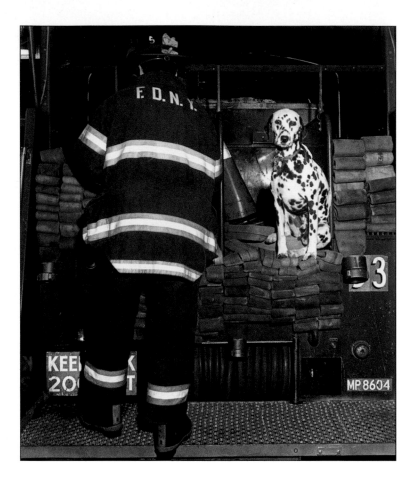

ARMEN KACHATURIAN
*Blaze with Firefighter*
*Tom Condon of Engine*
*53/Ladder 43*
*New York City, 1996*

Opposite:
GEORGE WOODRUFF
*Sussex Finds the Injured*
*Fire Fighter*
*n.l., 1942*

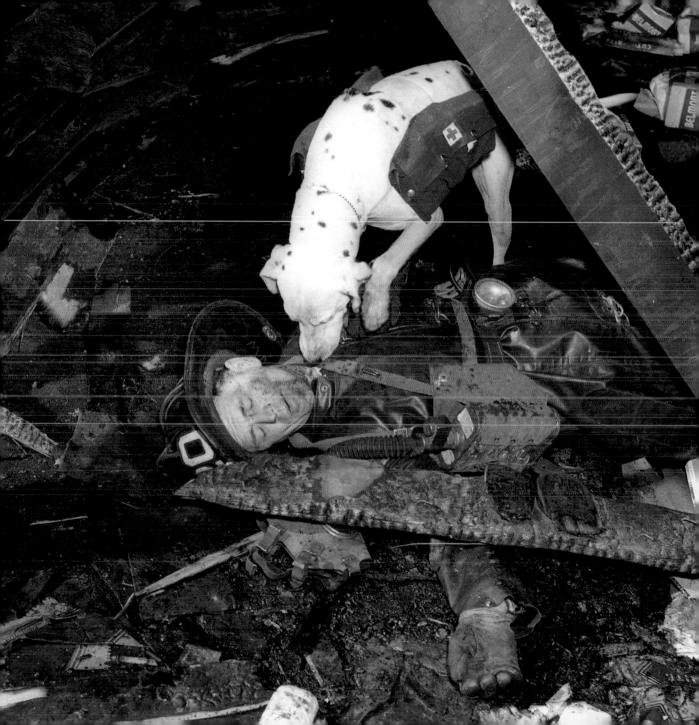

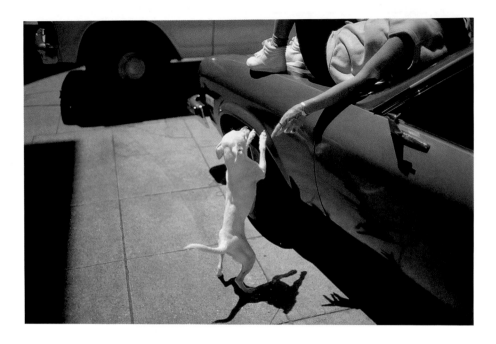

ANDREW J. HATHAWAY
*White Dog Outside my Front Door*
San Francisco, 1992
"My neighbor was sunning herself on her car when
I came outside. I think her dog was scared of me.
He reached up to her for reassurance, she reached down
to pet him, and there it was—
the hand of God from the Sistine Chapel."

*Opposite:*
ROBIN SCHWARTZ
*Mural*
New York, 1982

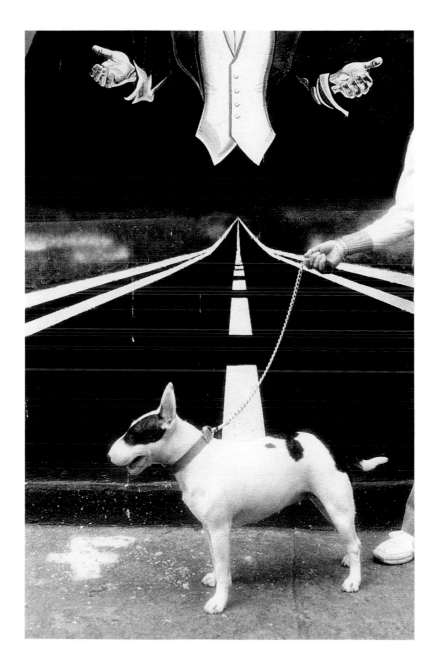

**UPI PHOTOGRAPHER**
**WOODSTOCK AND BONITA,**
**SAN DIEGO, CALIFORNIA, 1975**

According to thirteen-year-old Penny Adams, owner
of both Woodstock the mouse and Bonita the Great
Dane, Woodstock walks all over Bonita, and Bonita
doesn't mind a bit. It all started when Woodstock
jumped out of Penny's hand one day and landed on
the dog's head. Bonita, a gentle giant, just stood still.

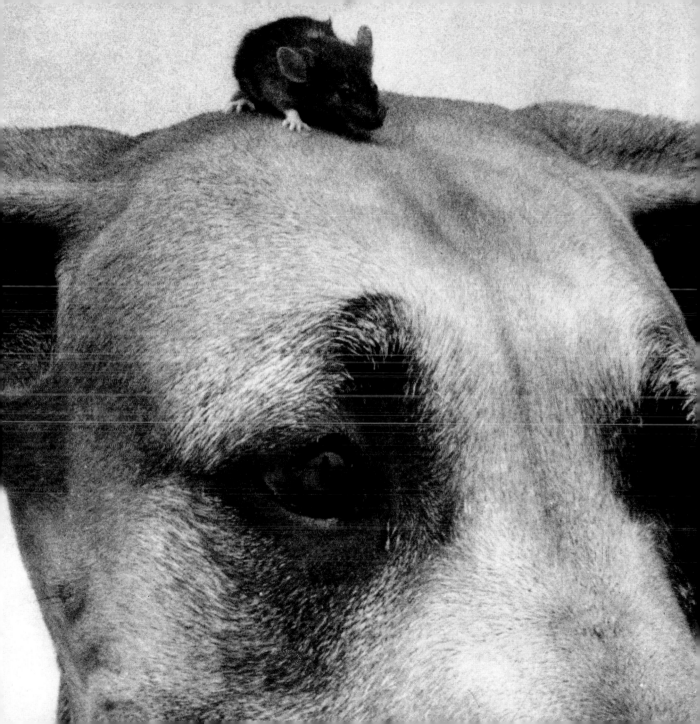

LEFT:

**UPI PHOTOGRAPHER
UNITED FRONT,
KENT, ENGLAND, 1962**

Jess, a mutt, stands under the high-slung chassis of her Great Dane pal Ramah. According to owner Mrs. Olive Tate of Upton Road, if you combine one's size and the other's barking, you've got a terrific watchdog.

RIGHT:

**ACME PHOTOGRAPHER
THE LONG AND THE SHORT OF IT,
CHELSEA, ENGLAND, 1947**

During the Allied Forces Memorial Fund Show at the People's Dispensary for Sick Animals in Chelsea, a giant St. Bernard named She stands protectively over her best friend, a Miniature Dachshund named Mitzi.

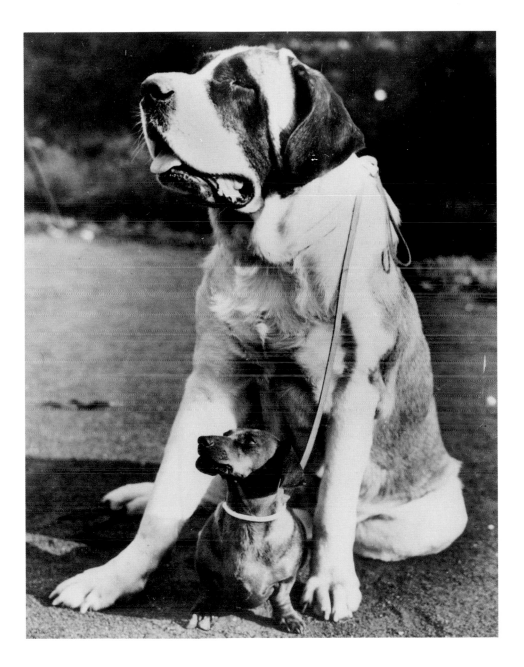

## The Bomb Squad

Our unit may be smaller than the other canine-enforcement units at Miami International Airport, but our dogs are in the business of thwarting terrorists—and that's a pretty big job in my book. And our dogs have to be really smart. That's why we use mostly Labradors and German Shepherds—and even Poodles, which many people don't realize are among the very brightest dogs. Our dogs and their handlers are trained to find explosives, but how they actually do so has to remain a secret, for obvious reasons. Of course, all these dogs have finely honed noses. It's not an easy job. The dogs and their handlers have to spend three months training at Lackland Air Force Base in Texas —it's a pretty rigorous course. Then we continue to train them three to five days a week here at the airport. We have a "Bomb Search Building" set up for just that purpose. Because it's such a serious task to sniff out a bomb, our dogs are never cross-trained with narcotics dogs or the dogs used for detecting illegal plant and animal matter. We don't want them to find anything but explosives—and luckily they never do! Besides sterilizing areas for presidential visits or visits by heads of state, we keep the airport safe for the average traveler. That's the most important thing. It's a great team effort.

SGT. JOSEPH RESCHETAR, CANINE EXPLOSIVE ORDNANCE DETECTION (EOD), METRO-DADE POLICE DEPARTMENT, MIAMI

UPI PHOTOGRAPHER
*Lancer, Marijuana-sniffing German Shepherd Dog,*
and Handler Jack Grinham,
State Trooper
*Logan International Airport, Boston, 1973*

Overleaf:
PHOTOGRAPHER UNKNOWN
*Rin-Tin-Tin in*
Dog of the Regiment
*Los Angeles, California, 1927*

188

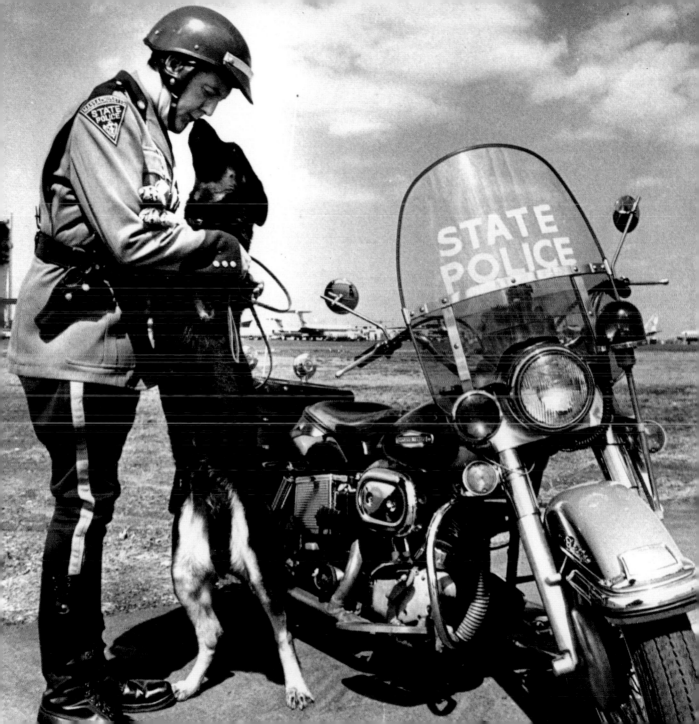

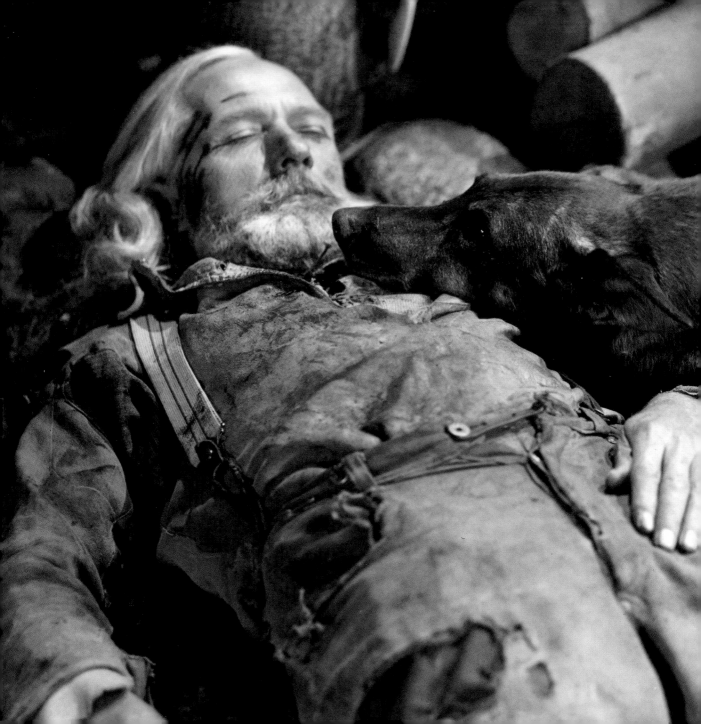

Few quadrupeds are less

delicate in their food.

OLIVER GOLDSMITH, 1774

YLLA
*Collie Puppy and Siamese Kitten in My Studio*
New York City, 1947

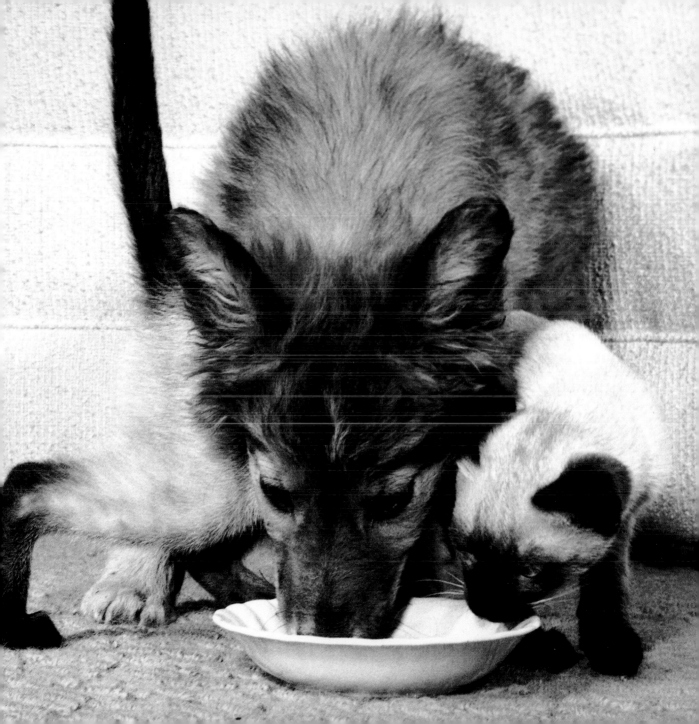

## Dugan's Race

RON KIMBALL
*The Leaders*
*Chester, California, 1995*

The Iditarod is the biggest sled-dog event in the world. It is also the most dangerous. A grueling 1,049-mile trek across the mountains and frozen tundra of Alaska, the marathon event takes anywhere from nine days to a couple of weeks to complete. And not everybody—or every dog—finishes the race. One athlete who has is Libby Riddles. A sixteen-year veteran of the sport and the author of *Race Across Alaska*, she had the honor in 1985 of being the first woman ever to win the competition. Today she admits she was lucky to finish the race—much less win it. "My lead dog that year was Dugan, an exceptional Alaskan husky I had raised myself. His good genes and training really came in handy towards the end of the race when a blinding Arctic ground storm threatened to delay the event by days. I had just reached a checkpoint and had the option of waiting the storm out or continuing on. I decided to go for it." It was a risky move. "There are markers along the trail—about three to a mile—and at one point neither the dogs nor I could see them anymore. I had to leave my dogs to find them first and then go back to them and mush them on. Many dogs would have turned back had their musher walked ahead without them—but not Dugan! He knew how much this meant to me. Had he run off, I might have died. Taking on the storm that year was pretty gutsy, I guess, and it won me the race. But it was my incredible team of dogs—especially Dugan—who saved the day . . . and me!"

ED.

Overleaf:
PER WICHMANN
*Winter Race*
*Sweden, 1995*

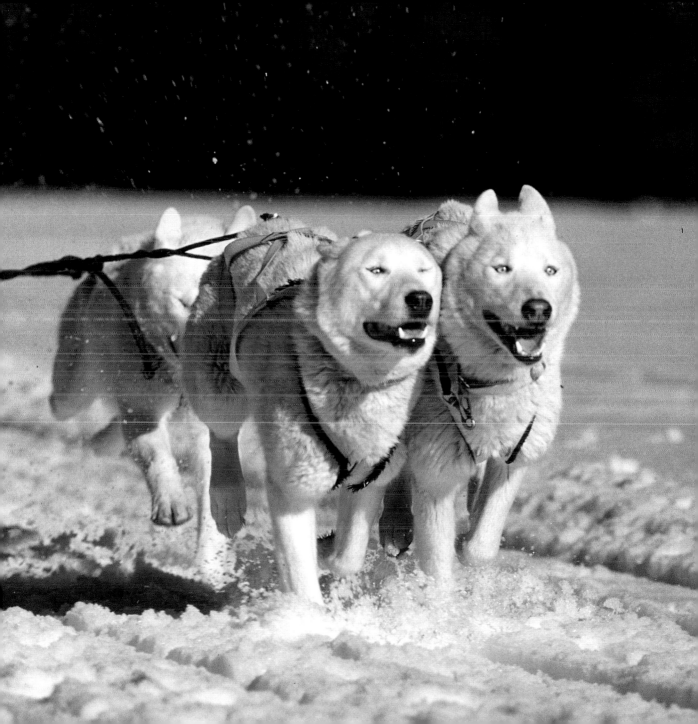

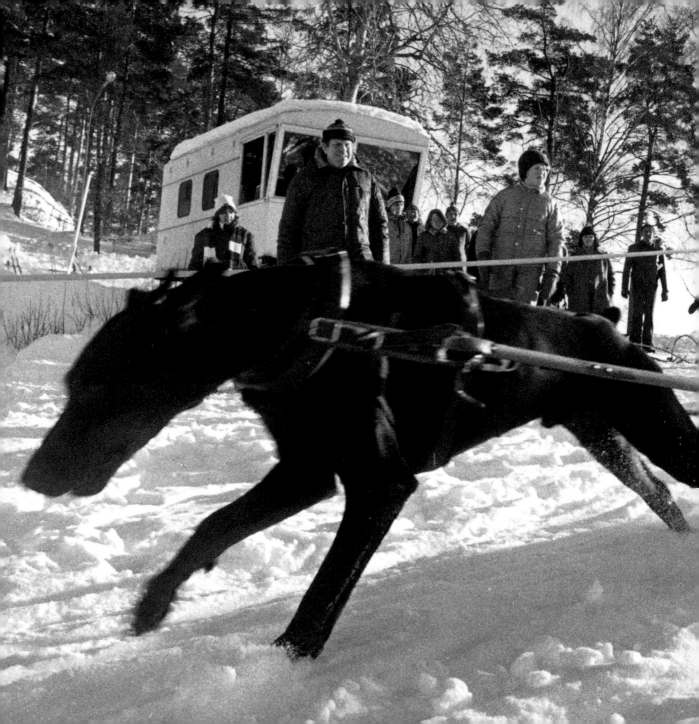

Nowadays you get all this bad press about the Pit Bull. How they eat other dogs and cats and kids and all this. Well, I think maybe it's the owners who put them up to it. Because when I was a kid, I had a dog who looked just like Petey the Pup, and she was the sweetest creature on earth. Her name was Melva, a made-up name, but it sounded right to me. Melva was like a four-legged angel sent down to cheer everyone up. Our cat had kittens, and Melva would lie very still while they crawled all over her. One even fell asleep laying across her paw, so she couldn't get up without disturbing it. For hours, even through dinner time, she wouldn't move. I think she loved the way that kitten felt.

HAROLD SPARKLEY, RETIRED, KANSAS CITY

RIGHT:

**UNIDENTIFIED PHOTOGRAPHER**
**I'LL TAKE CARE OF YOU, U.S., 1940s**

A basketful of orphaned kittens arouses the
maternal instinct in a spotted Pit Bull Terrier.

OVERLEAF:

**ROBIN SCHWARTZ**
**NATHANIEL AND REBECCA,**
**HOBOKEN, NEW JERSEY, 1996**

"These are my kids. Nathaniel is a Cornish Rex
cat, and Rebecca's a Whippet and was just
three or four months old when I took this picture.
She loves that cat. She really loves that cat.
My husband thinks they look alike."

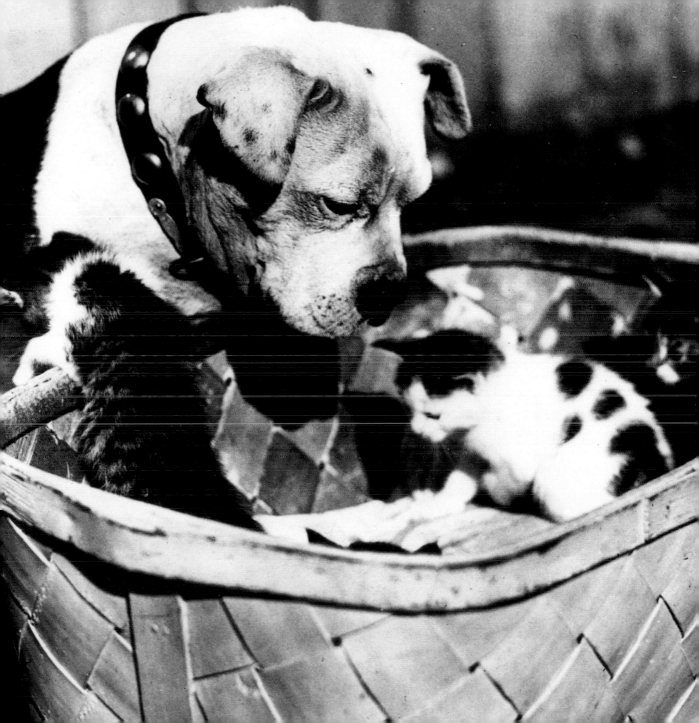

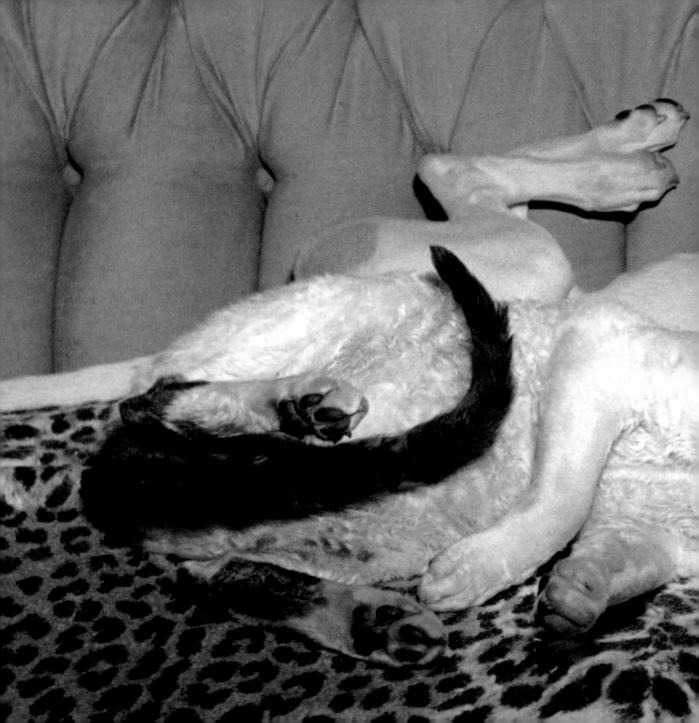

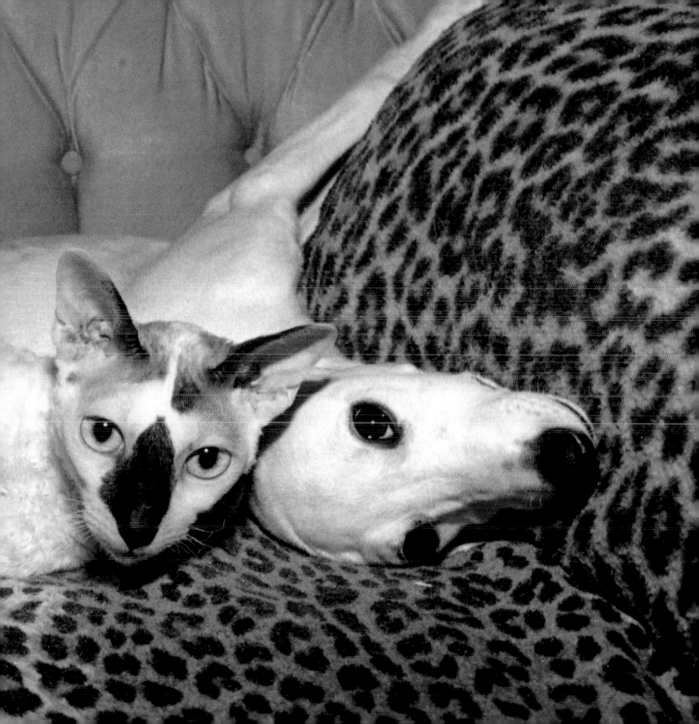

## Saving Duke

On my tenth birthday I was presented with Duke, a six-week-old, bright-eyed, and big-pawed pup. What a beauty! Duke was part–German Shepherd, part–Alaskan husky with handsome black and tan markings. Everywhere we went people commented on what a good looking dog he was. We were inseparable. That Christmas I got a new hockey stick. Never mind that I didn't have a pair of skates or the foggiest notion of how to play the game—I had Duke as a teammate and some giant Sweethearts candy for pucks. What else did I need? We set out on a cold, late December day to find some ice. Behind the county fairgrounds were some deserted irrigation ponds that were frozen over—perfect for playing boy vs. dog hockey. Just as I was about to run onto the ice, Duke began barking at me. Not to be outdone, I yelled back and kept running closer to the center of the pond. I'm not quite sure exactly what happened next. I remember seeing Duke airborne in what seemed to be a ten-foot-high leap, arcing through the air and then landing, crashing through the ice. The next thing I saw was Duke's cold and wet face looking up at me from the frigid water. Crying hysterically, I tried to hand him my hockey stick, afraid he would drown. Duke couldn't swim—he had never been taught! He had never even been in the water before. But by some miracle he didn't drown. He could swim! Not only that, he instinctively and bravely saved me from falling through the ice. Duke died tragically about a year later, and even as an adult I miss him. However, his courage and self-sacrificing loyalty lives on every day in my memory and in my heart.

John Curtis-Michael,
entertainer, New York City

UPI Photographer
*Fixing a Barrel to a St. Bernard's Collar*
*St. Bernard Hospice, Switzerland, 1927*

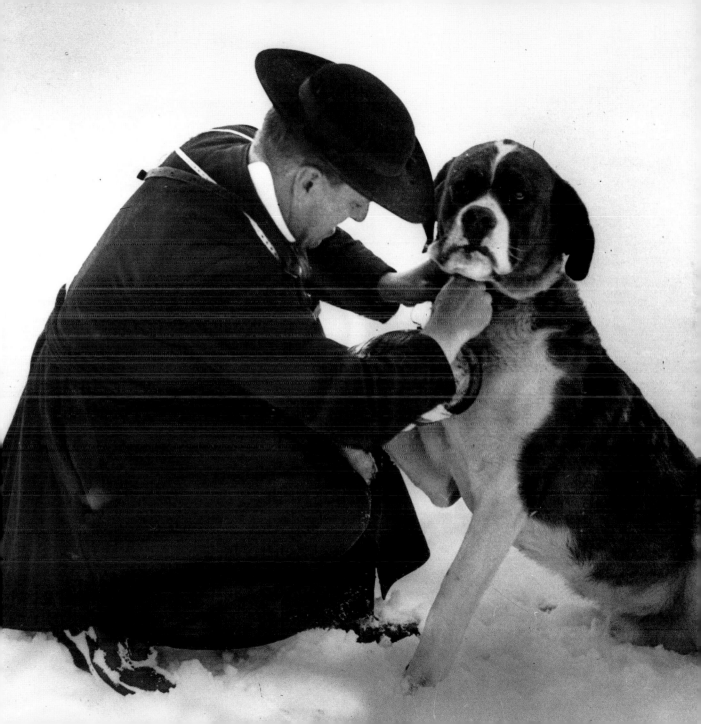

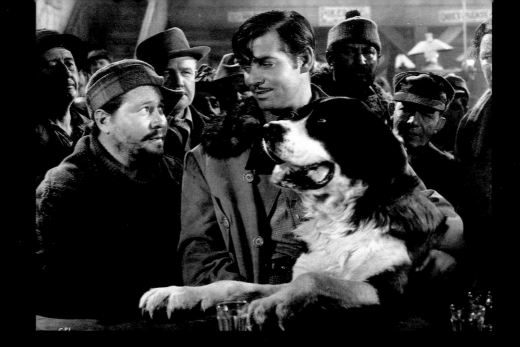

THE CALL OF THE WILD, 1935
Above and right: *Clark Gable's co-star was a St. Bernard named Buck. The precocious giant made his trainer, Carl Spitz, famous. Four years later Spitz was called upon for* The Wizard of Oz.

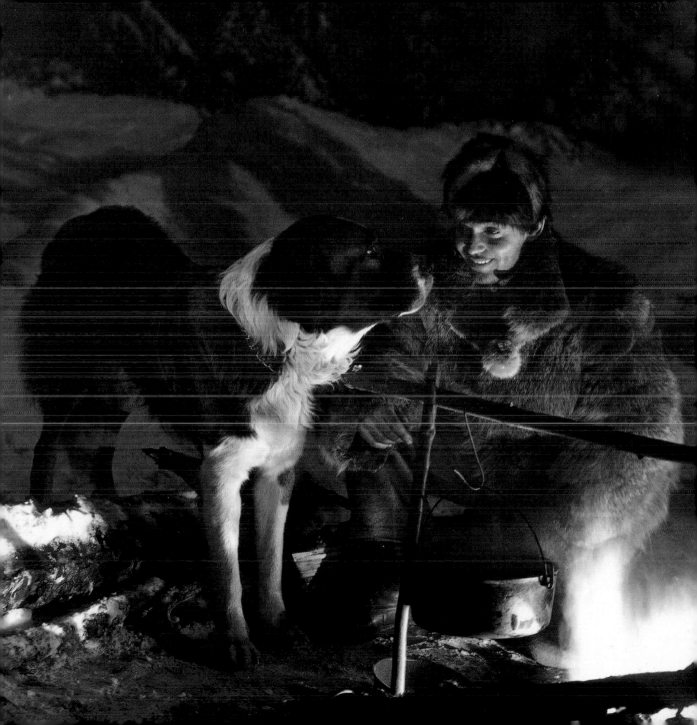

## The Wives of Beep-Beep

PHOTOGRAPHER UNKNOWN
*Pete the Pup Nursing a Goat
Hollywood, c. 1930*

When I moved to New York, the first dog I got was Lulu—a Yorkshire Terrier puppy. Later, I got another Yorkie named Beep-Beep. Lulu made it quite clear from the beginning that she didn't like poor Beep-Beep. In fact, she hated Beep-Beep, and for a long time Beep-Beep just worshipped Lulu. They were like a married couple— a married couple in an arranged marriage. I mean, Cupid had shot his arrow into Beep-Beep, but Cupid had not shot his arrow into Lulu. But the years went on and they had a certain relationship. Finally, at age eleven, Lulu died. After her death, Beep-Beep just lost it. He stopped eating and got weaker and weaker. I didn't think he would live much longer. Eventually, I decided to get a new puppy. I brought home Minky, a Chinese Crested, and she was very young and just worshipped Beep-Beep. Of course, Beep-Beep had no use for her and would beat her up all the time. It was like he had taken on the personality of his beloved Lulu. Nevertheless, Minky absolutely adored Beep-Beep. And slowly Beep-Beep came out of his depression. He began to eat again and was soon back to his old self, barking and bossing me around. Then I got another Chinese Crested puppy, Lily, and she worshipped Beep-Beep, too. So even though Beep-Beep never loved both of them like he loved Lulu, he grew old having two young wives who really saved his life. Now he's fourteen years old and his wives are three—and he looks like he's going to keep going for a long time.

TAMA JANOWITZ, DOG LOVER AND AUTHOR, *SLAVES OF NEW YORK* AND *BY THE SHORES OF GITCHI GUMEE*

206

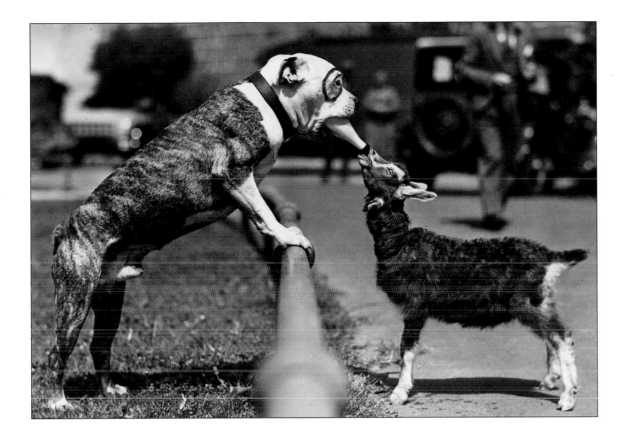

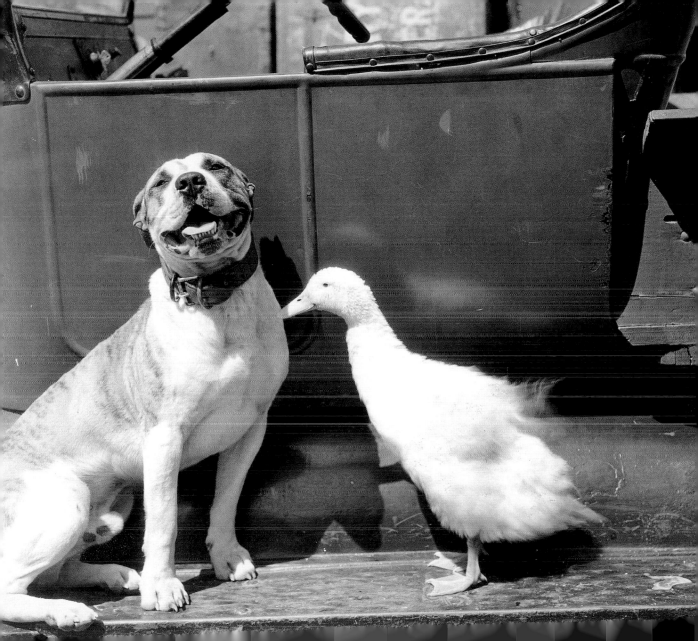

ALICE WINGWALL
*Discussion in the Galeries Vivienne*
Paris, 1990 (detail)
"The dog had been sitting there for a while. A lot of people
looked at him as they passed, but this woman
started a conversation. She was telling him he was
beautiful and well-behaved and so on."

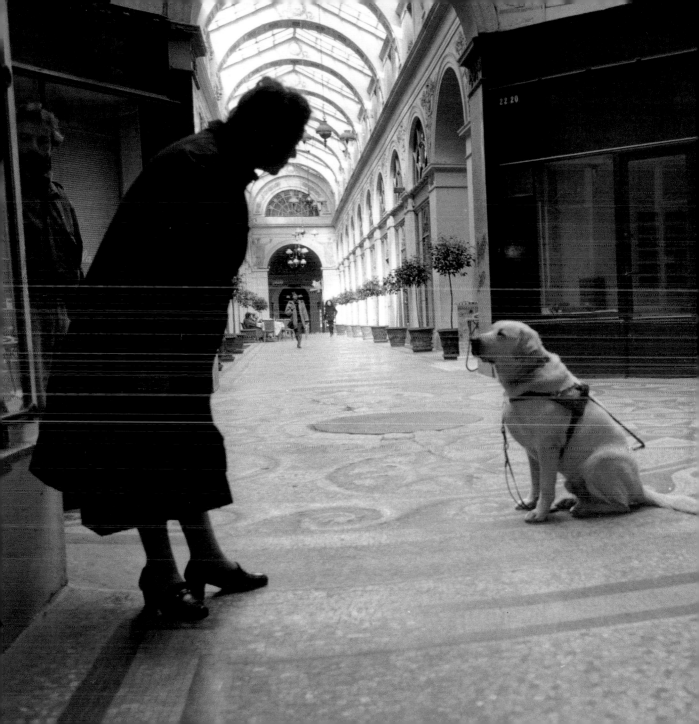

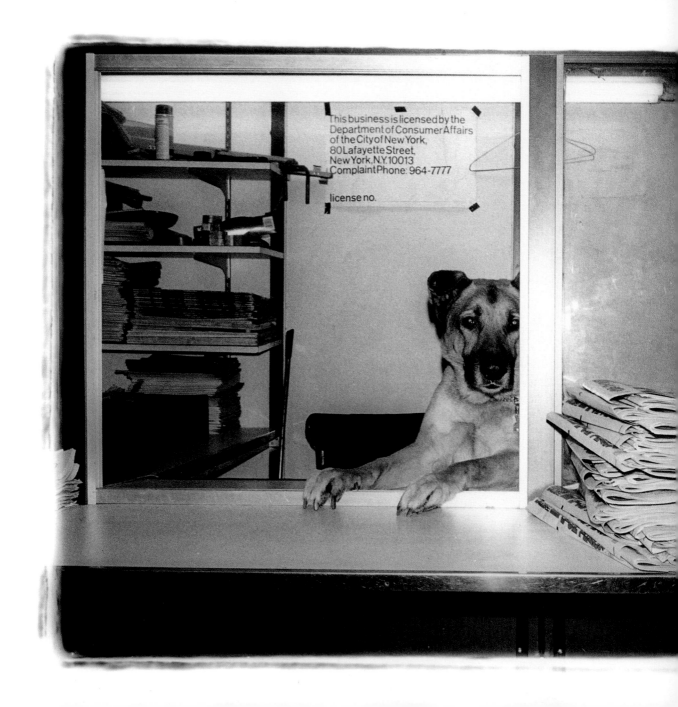

JOYCE RAVID
DOG SELLING NEWSPAPERS, NEW YORK, 1980

*I don't know anything about him. He was just there.*

JAYNE MANSFIELD AND PEKINGESE. 1960
*Rained out from filming* Too Hot to Handle, *Jayne Mansfield
poses with Powder Puff.*

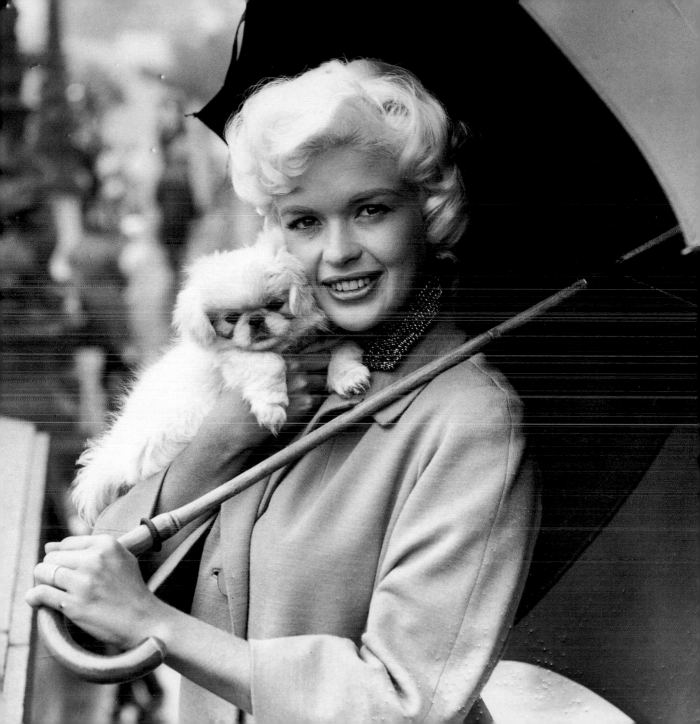

SON OF LASSIE. 1945
*Peter Lawford holds an impeccably groomed Collie still as they hide from a patrolling Nazi guard.*

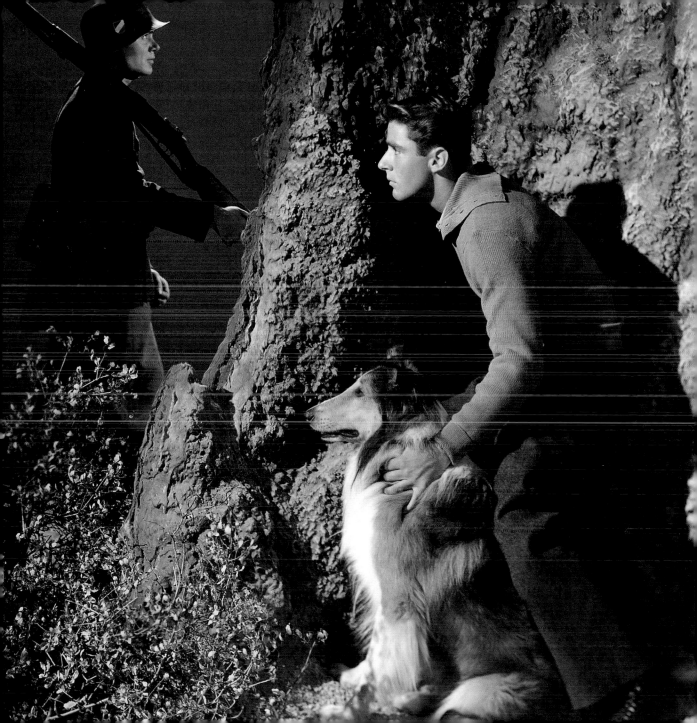

*When a doting person gets down on all fours and plays with*

*his dog's rubber mouse, it only confuses the puppy and gives him a sense*

*of insecurity. He gets the impression that the world is unstable,*

*and wonders whether he is supposed to walk on his hind legs*

*and learn to smoke cigars.*

COREY FORD

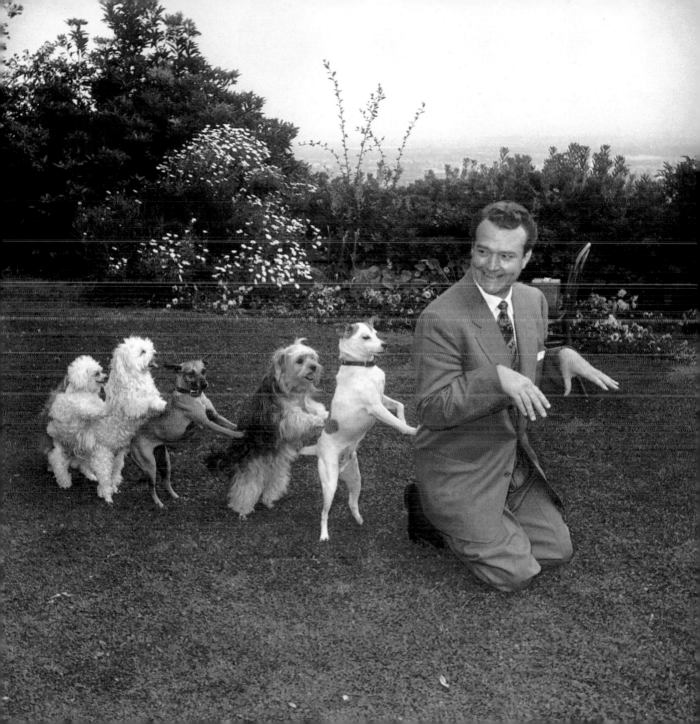

## Minnie the Mutt

MARTIN HARRIS
*John Robert Williams and
His Boston Terrier, Peggy,
at the Boy's Club Pet Show
New York City, c. 1942*

Every dog has his day. And for a homeless Rottweiler-spaniel mix from Hayward, California, a day that began as usual ended in an act of heroism that saved a two-year-old's life.

On a quiet Sunday stroll to church last winter, David Bruce and his wife, Pauline, noticed a friendly stray dog walking ahead of them. So did their two-year-old son, David Jr., who demanded to be let out of his stroller to pet the dog. No sooner was the energetic toddler on his feet than he dashed behind a parked car and began heading into the street. His parents watched in horror as a blue sedan sped down the road toward the parked car, which blocked the driver's view of the child. In an instant, the mutt came out of nowhere, darted right in front of David, turned, jumped up and knocked him backwards—out of the path of the car. The dog then sat down next to the child, her tongue hanging out and her tail wagging happily.

It was a miracle. And the grateful couple, who weren't able to adopt the stray because they lived in a pet-free apartment house, were heartbroken when they discovered that the local animal shelter was scheduled to put the homeless heroine to sleep. At the last minute, the Bruces told the local newspaper about the dog's act of bravery and were soon flooded with calls to adopt her.

Christened "Minnie the Mutt," the courageous canine now has a home, and is typically down-to-earth about her heroism. "Any mutt would have done the same thing," she tells one and all.

ED.

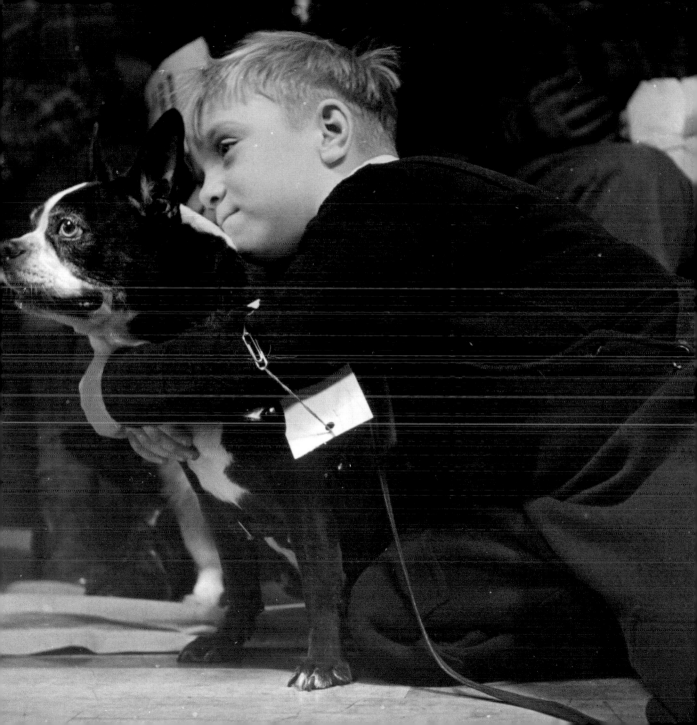

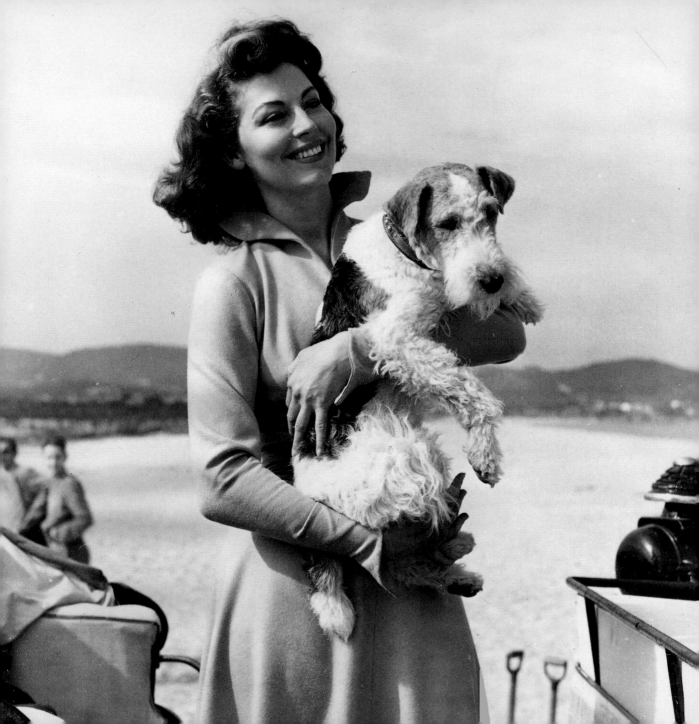

I saw a dog reunite with its owner. It was the best demonstration of joy I've ever seen. I'd found the dog, a retriever cross, wandering around lost on a Friday night. I didn't find its owner until Monday. The dog spent the weekend curled up in a miserable ball in my shop as I worked. Friends came in and out; it didn't stir. I brought it food; it didn't eat a thing. Monday morning, it suddenly began crying like a puppy and scratching at the front door. It must have sensed the owner coming. When she walked in the door, the dog leaped straight into her arms, yowling hysterically. It seemed to be saying, "My love, my love, I'll never leave you again."

KURI SAWAI, SURFBOARD DESIGNER, HILO, HAWAII

RIGHT:
**UNIDENTIFIED PHOTOGRAPHER**
**A DOG AND HIS BOY, U.S., 1930s**
Silhouetted against an afternoon sky, boy and dog—
a young shepherd-retriever mix—stand face to face.

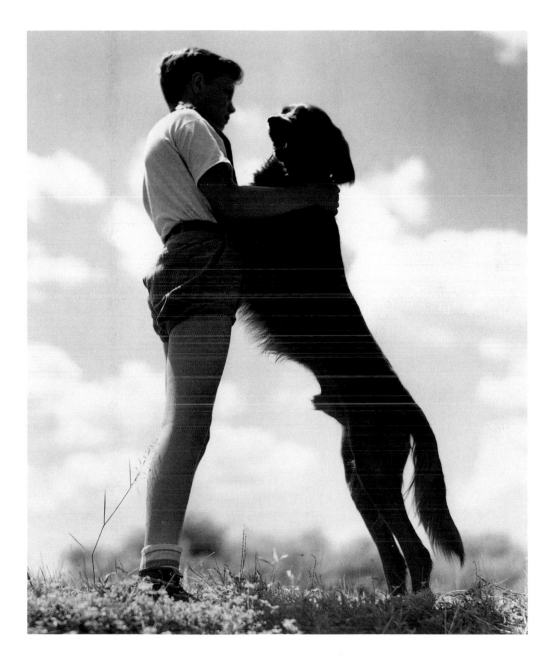

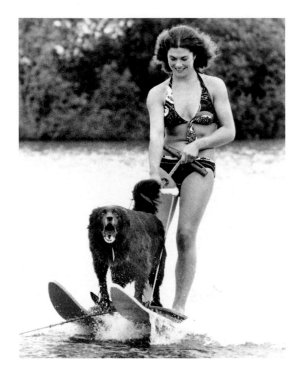

**JOHN DRYSDALE**
**RUTLAND, ENGLAND, 1984**

"Whenever her owner went waterskiing, Merry, a collie-labrador
mutt, would swim out to her mistress and tow her skis back in her
mouth. On successive ski runs, she would try to climb aboard too.
Later on a board especially adapted for her, she got her wish to
ski and would bark and wag her tail enthusiastically during the
whole ride. Then she took to riding on her owner's skis and grew
to prefer waterskiing to walking in the summertime."

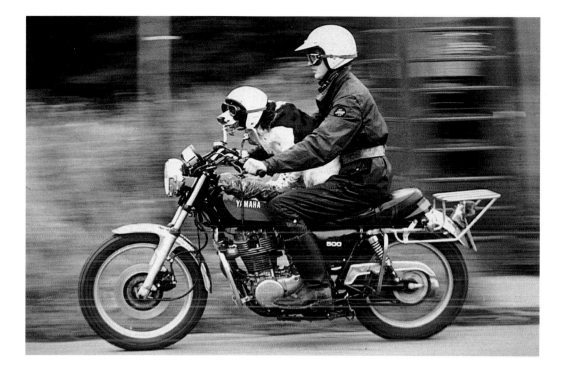

A motorcycling mutt with his own small
helmet and goggles takes to the road.

227

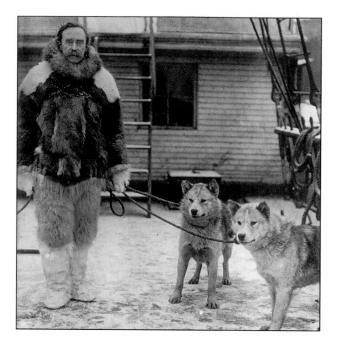

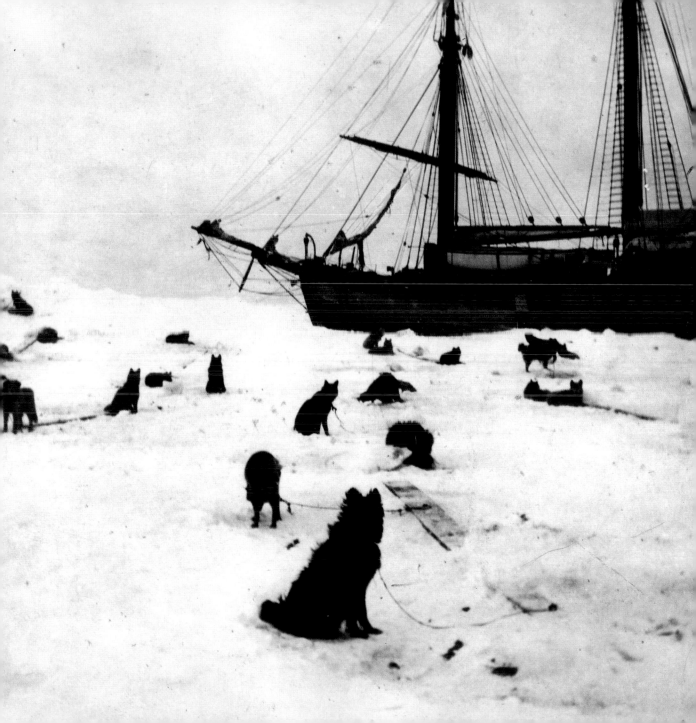

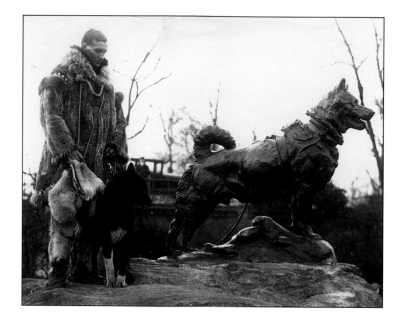

UPI PHOTOGRAPHER
*Gunnar Kasson and Balto
at the Unveiling of Balto's
Statue in Central Park
New York City, 1925*

Opposite:
UPI PHOTOGRAPHER
*Gunnar Kasson and His
Dog, Balto, Leader of the
Sled Team that Brought
Medicine to Diptheria-
Stricken Nome, Alaska
n.l., 1925*

Overleaf:
REUTERS PHOTOGRAPHER
*Lining Up before Minstrel the
Cat at the Metropolitan
Police Dog Training School
Keston, England, 1987*

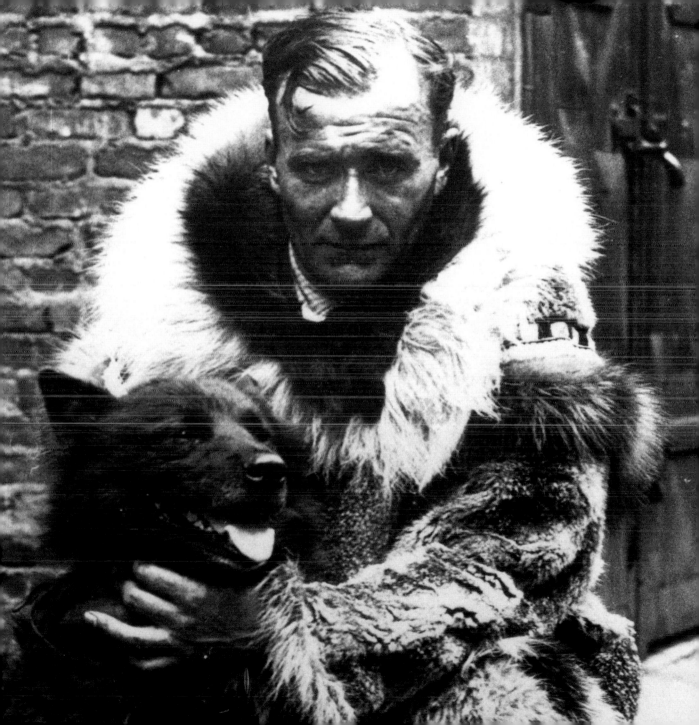

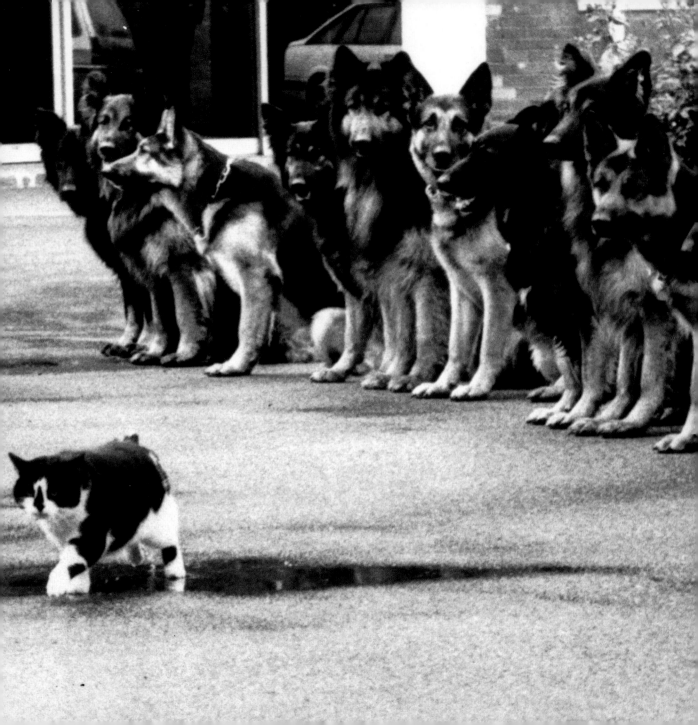

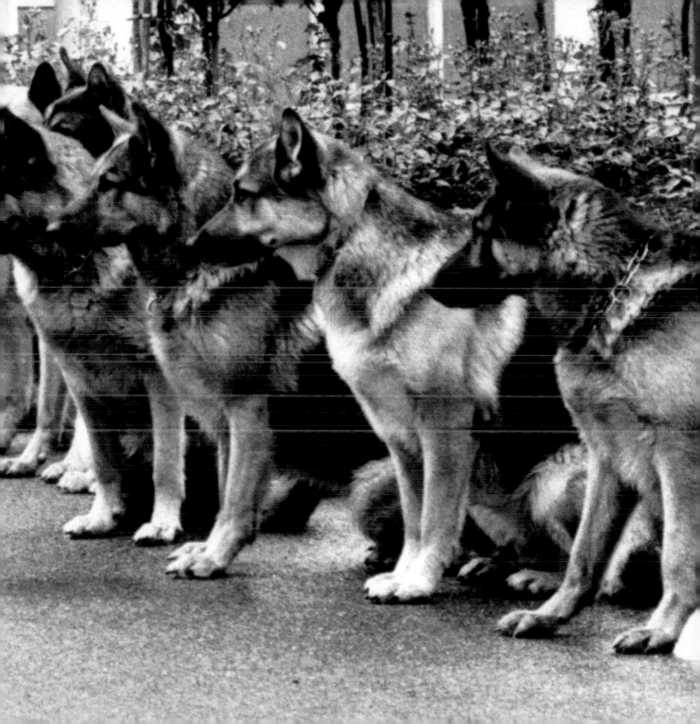

ANTONIN MALY
UNTITLED, 1989

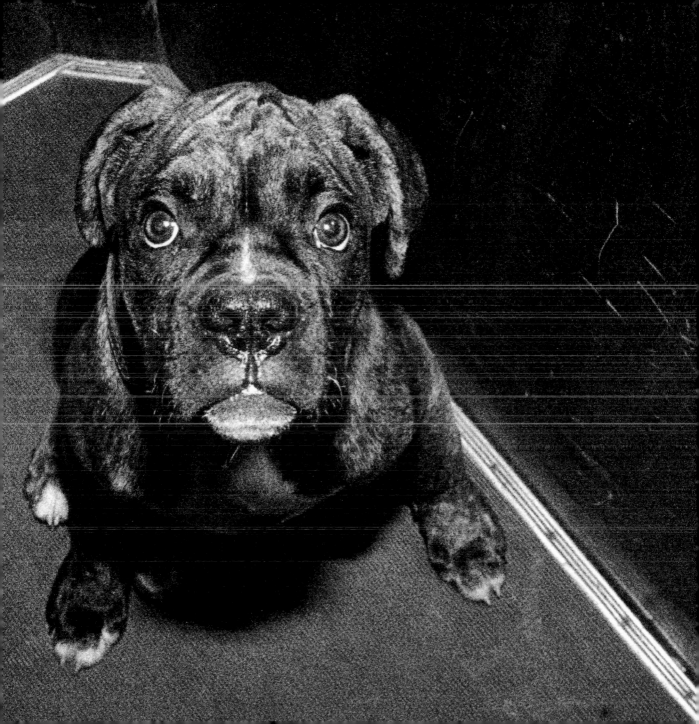

I'd rather have an inch of dog

than miles of pedigree.

**DANA BURNET**
MUTTS

**JOHN DRYSDALE**
**LONDON, ENGLAND, 1955**
"On a London street closed to traffic, this mutt was engrossed in a football game with a small group of boys who treated him as an equal player. When I took this picture, the dog was acting as goalkeeper. He was so skilled, none of the boys managed to score."

236

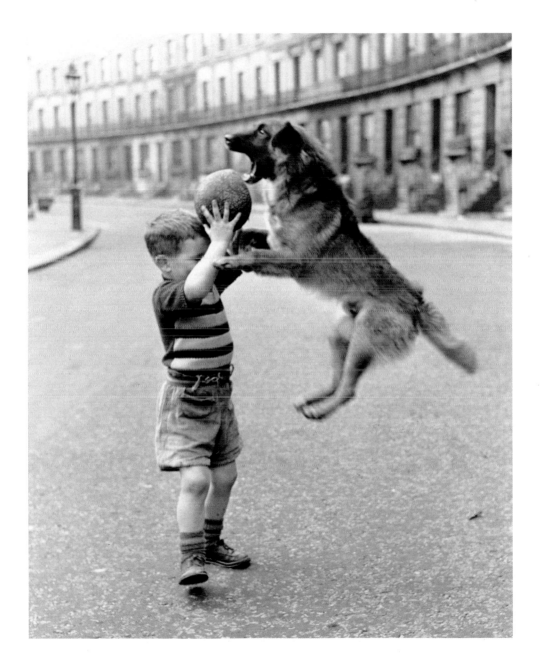

When I was a kid, maybe nine or ten years old, I was walking with some of my friends on the beach, and we saw a pack of homeless dogs. They weren't vicious, just playful, but while we were watching them, the dogcatcher's van pulled up, and the dogcatcher went after them. He nabbed a few of them and shoved them into the back of his van. Then he took off after the others. As soon as he was out of sight, my pals and I went to work. We got the back of the van open, and all the dogs spilled out and ran away—not only the beach dogs, but others he had rounded up too. We didn't do it to be mischievous; we did it to help the jailed dogs.

PHILIP GONZALEZ AND LEONORE FLEISCHER
THE DOG WHO RESCUES CATS:
THE TRUE STORY OF GINNY

KURT HUTTON
ASCOT, ENGLAND, 1949

The Stevenson family has been training circus dogs for three generations. In their winter quarters at Ascot, Asta, who is part terrier, stays in shape by jumping over the vacuum cleaner.

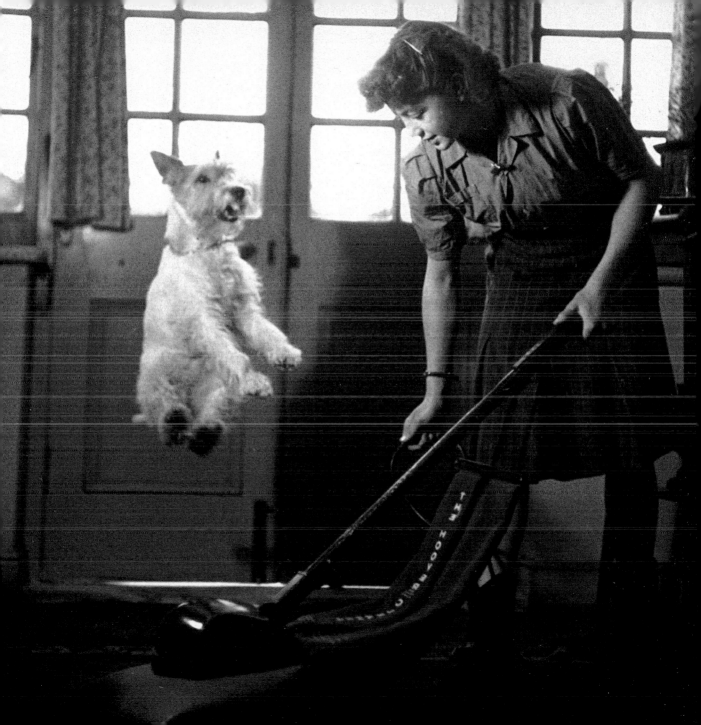

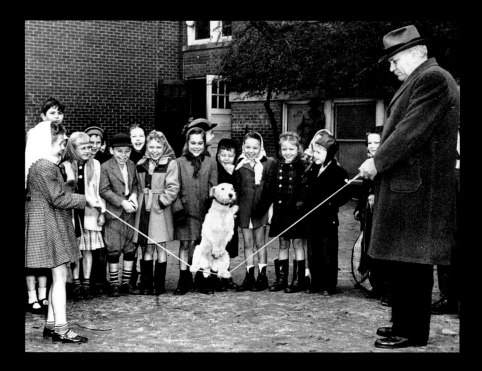

PHOTOGRAPHER UNKNOWN
*The Governor Lends a Hand*
Charlotte, North Carolina, March 28, 1948
North Carolina's Governor Cherry and Elmer the performing dog
give a traffic safety lecture to schoolchildren. Elmer, owned along
with six other trained dogs by Ernest E. Presley of the Charlotte
Police Force, played a lead role in the two-year safety campaign.

*Opposite:*
PHOTOGRAPHER UNKNOWN
*Beastly Affairs*
New York, 1908
From a series of Victorian animal postcards produced by
the Rotograph Company of New York.

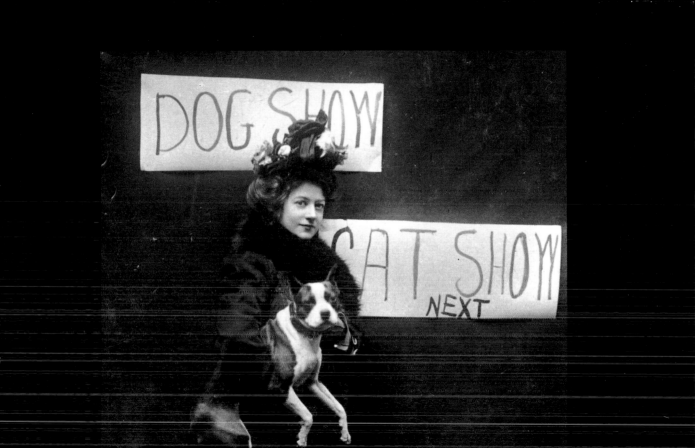

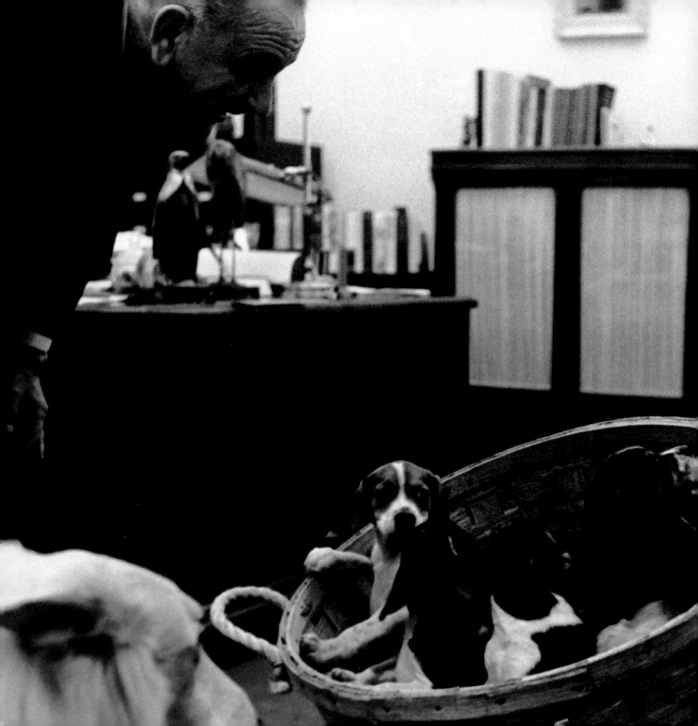

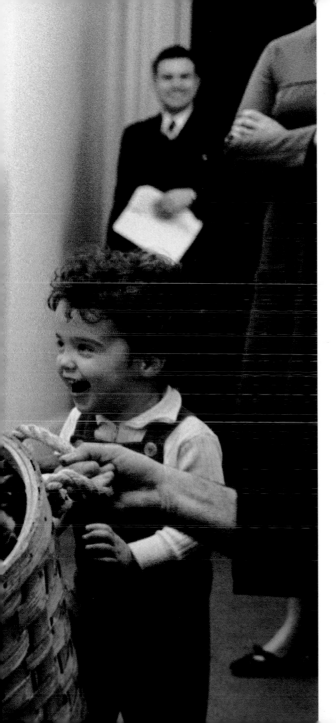

YOICHI R. OKAMOTO
*A Basket Full of Beagles*
The White House, Washington, D.C., 1966

PLAYING CUPID

I taught my dog Geraldo (a Bouvier) to hold a flower in his

mouth and bring it to my wife, in an effort to show my wife that

I actually do have the capacity for silly little romantic gestures.

But the result is that my wife gives the dog all the credit.

BOB ROSS, TEACHER, MIAMI

RIGHT:
**KARL BADEN**
**PUG WITH GOWN AND FEET,**
**WORCESTER, MASSACHUSETTS, 1993**
"For Halloween the Pug wore butterfly wings, and the
girl wore a diaphanous robe with angel's wings to match."

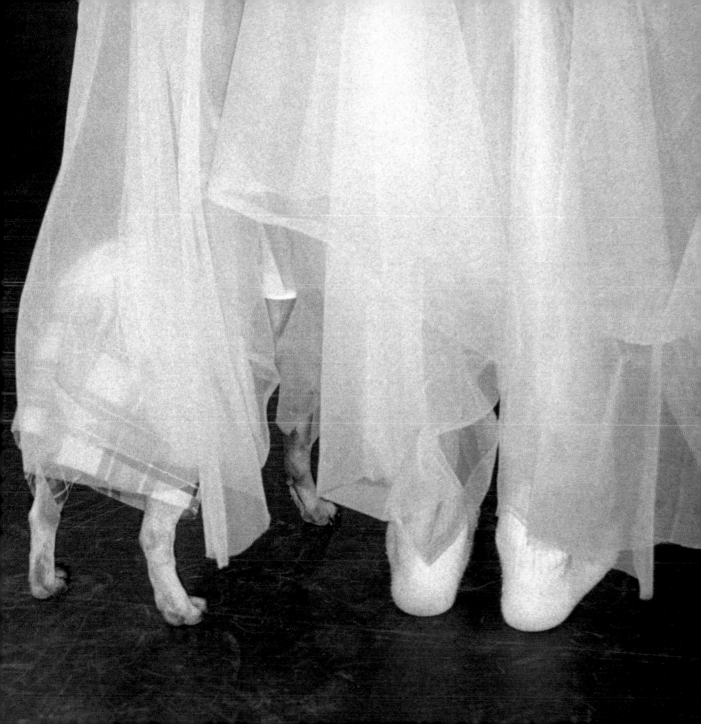

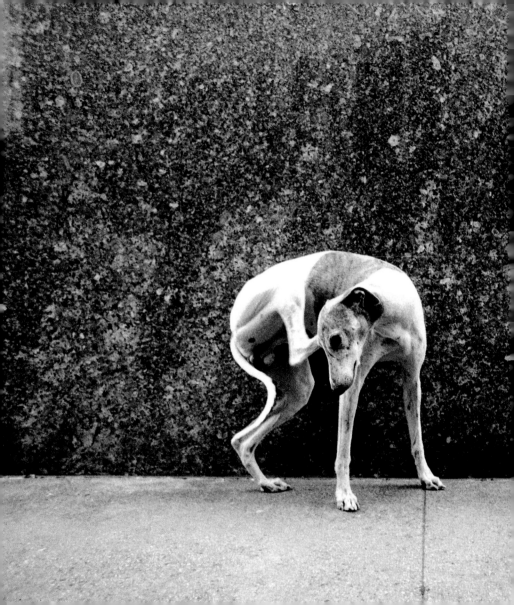

LAURA BAKER STANTON
*Baroque Takes a Break*
New York, 1991
"We'd been shooting for the *AKC Gazette*
and my Whippet Baroque, a very serious model,
suddenly decided it was time for a break.
I was so exasperated I took the picture
anyway. People have told me he's got a
criminal mind. For a while he lived in Dallas,
where he wound up racing a police car.
They said they were going thirty-five,
and he was going faster."

*Charley is a born diplomat. He prefers negotiation to fighting,*

*and properly so, since he is very bad at fighting. Only once in his ten*

*years has he been in trouble—when he met a dog who refused to*

*negotiate. Charley lost a piece of his right ear that time.*

*But he is a good watchdog—has a roar like a lion, designed to*

*conceal from night-wandering strangers that fact that he couldn't*

*bite his way out of a cornet du papier. . . .*

....................................................

**JOHN STEINBECK**
**Travels with Charley**

CHAIM KANNER
HONFLEUR, FRANCE, 1968

*Now this is an interesting story. I was near Paris, taking lots of pictures. I saw the Boxer
in the window and naturally pointed my camera up. But at the same time, Elliott Erwitt was
there, pointing his camera at me. So if this were his picture, taken from down the street,
what you'd see would be me, photographing this dog.*

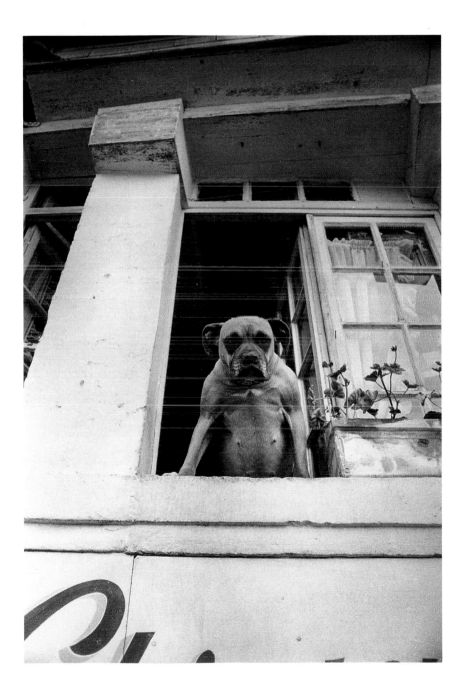

R ICHARD  K ALVAR
P ARIS ,  1974

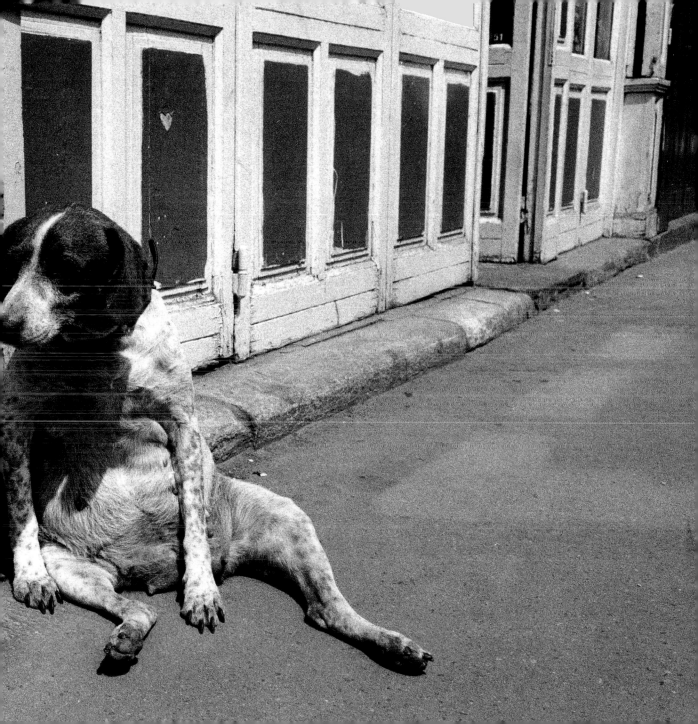

## Angels of Mercy

KENT AND DONNA
DANNEN
*Tundra, Samoyed,*
*on Caribou Pass*
*Arapaho National Forest,*
*Colorado, 1981*

One of the largest searches for a missing person in recent memory took place in one of the smallest communities in America. Galena Hollow, Missouri, a tiny hamlet in the middle of the Ozarks, became the focus of national attention for three long days in March of 1996 with the disappearance of Joshua Carlisle Coffey, a ten-year-old with Down's syndrome who had wandered away from his home late one afternoon.

After having been lost for seventy-two hours in freezing temperatures and rough terrain, the youngster was presumed by many to be dead. But the parents of the child and the tenacious local sheriff's department —not to mention 350 volunteers from six states—never gave up hope. And neither did two stray dogs. Later nicknamed "Baby" and "Angel," a homeless brown Dachs-hund-Beagle mix and his companion, a mixed-breed Blue Heeler, led searchers to the boy after the sheriff department's team of rescue dogs had finally closed in on an area where they believed the child would be found. Reclining face-down in a gully about a mile and a quarter north of his home, little Josh had been kept alive by the two strays, who had slept on top of the child to keep him warm and even fetched food for him from the provisions of local rescue workers. Quickly dubbed "Missouri's Little Miracle," Joshua Coffey had suffered from over-exposure but otherwise was in amazingly good shape.

As for the miracle mutts themselves, they finally found a home with the relieved and grateful Coffey family. "The angels just slipped in beside Josh," Mrs. Coffey said. "Those dogs had wings for sure."

ED.

252

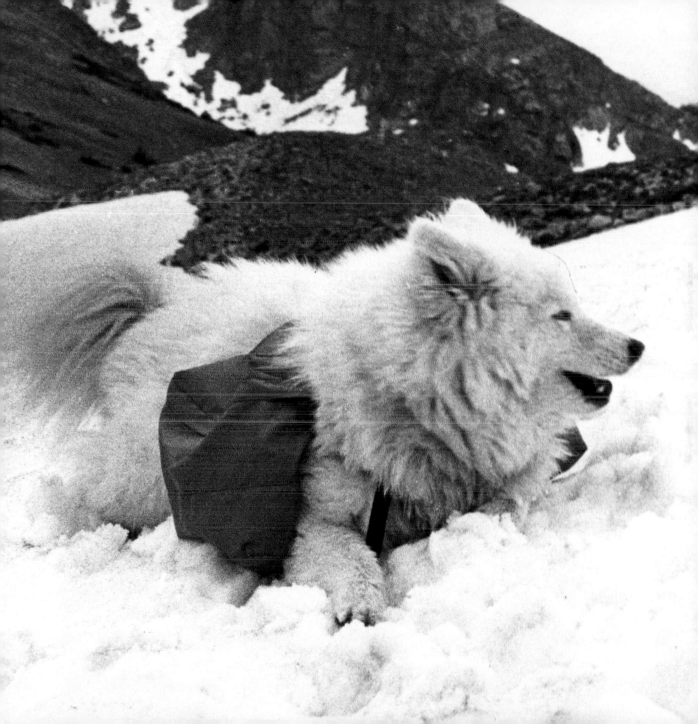

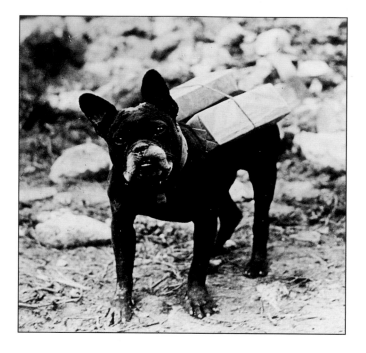

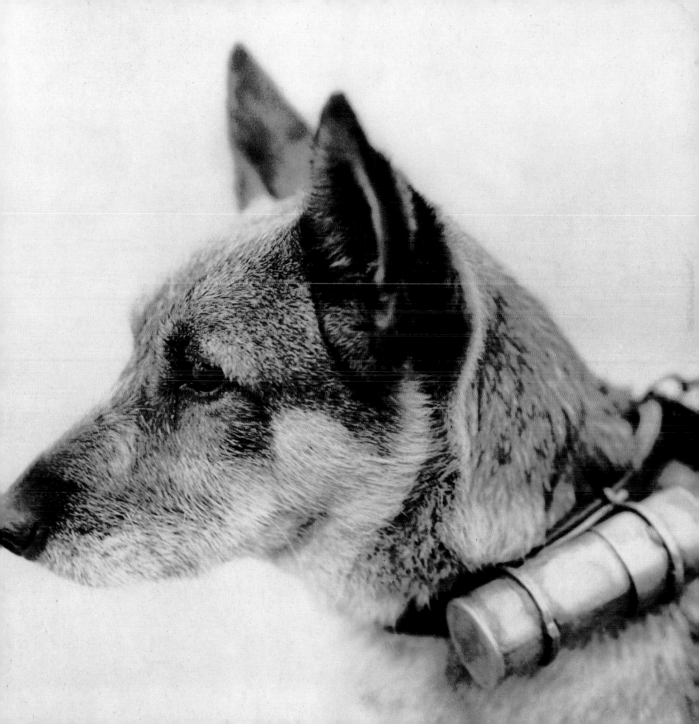

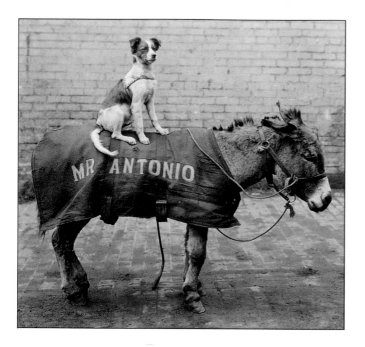

ABEL & CO.
*On Top of Mr. Antonio*
*Washington, DC, c. 1922*

Opposite:
ROBIN SCHWARTZ
*Jake and Mugs*
*Ohio, 1990*

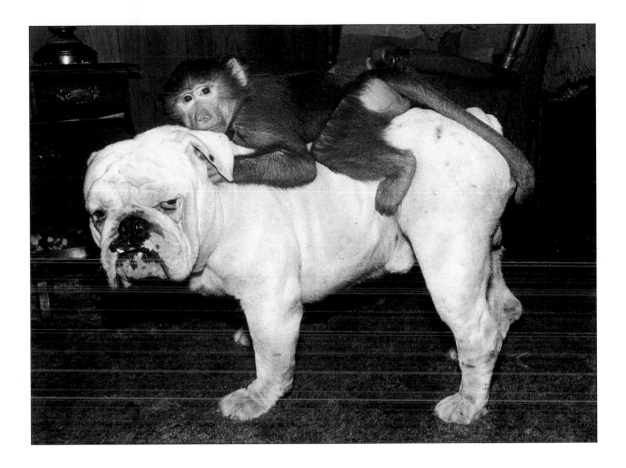

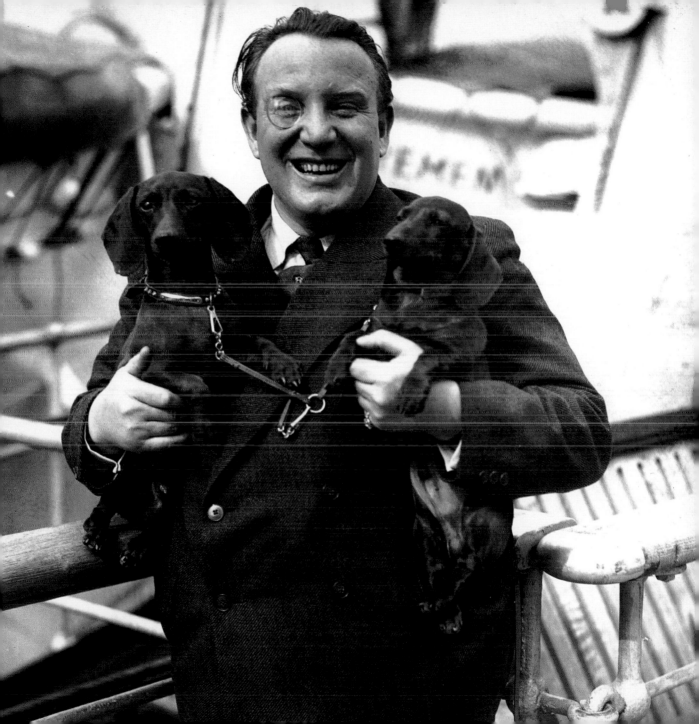

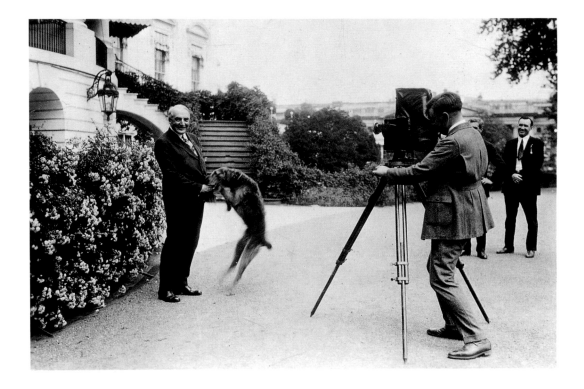

Photographer Unknown
*President Harding and his Dog*
Washington, D.C., 1922
The loyal pair photographed in the White House garden.

*Opposite:*
Photographer Unknown
*Winston Churchill*
February 23, 1950
The statesman and his Bulldog in an election-day portrait.

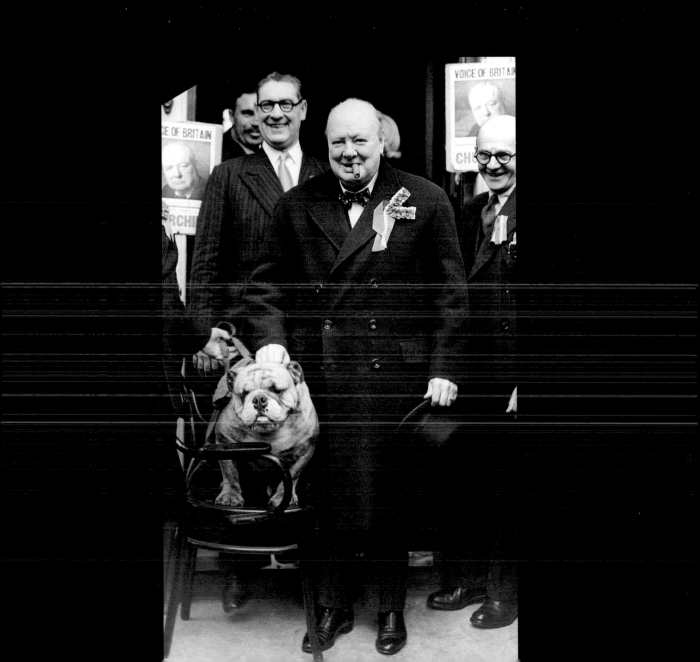

If you pick up a starving dog and make him

prosperous, he will not bite you. This is the

principal difference between a dog and a man.

MARK TWAIN

**PELLE WICHMANN**
**PARIS, FRANCE, 1980**
"I was strolling around Montmartre in Paris off-season
and suddenly a little black dog came walking toward
me. He stopped outside the bakery. He seemed to
know it well; he sniffed and wagged his tail very fast.
I think the dog knew the owner of the shop."

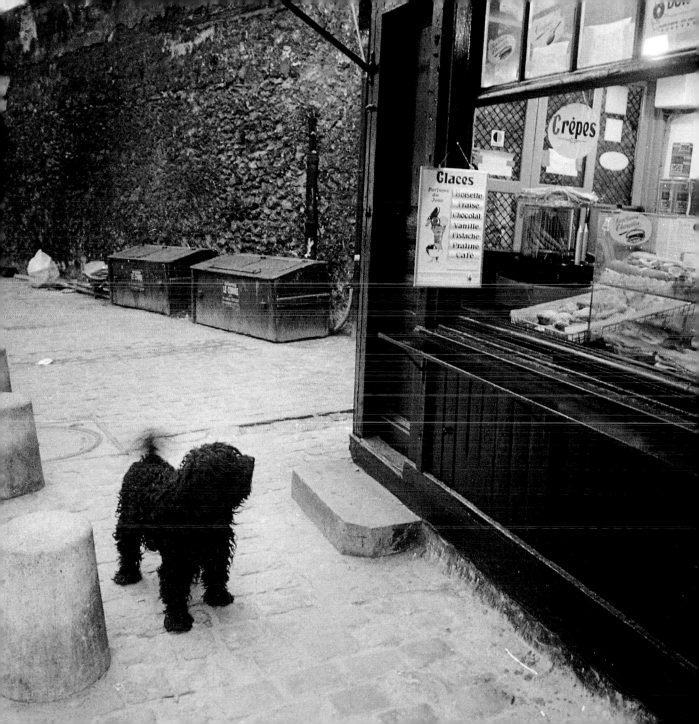

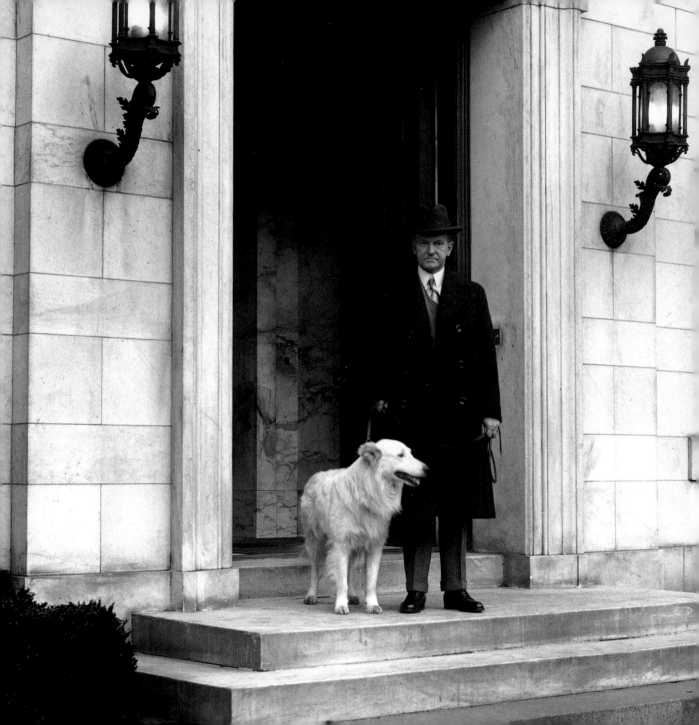

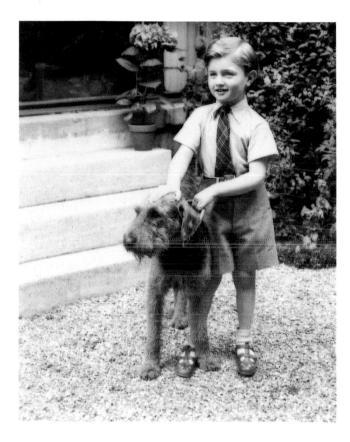

*Opposite:*
PHOTOGRAPHER UNKNOWN
*Calvin Coolidge and His Collie at the Temporary White House*
Washington, D.C., March 3, 1927
While the White House roof was being repaired,
the Coolidge household—including Collies—
moved into the nearby Patterson Mansion on Dupont Circle.

JOSEF BREITENBACH
*Boy with an Airedale*
Paris, c. 1935

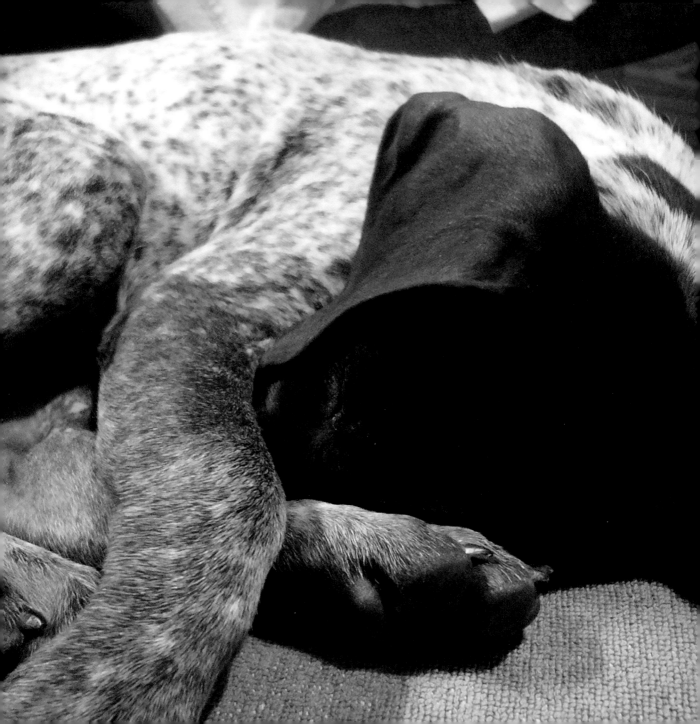

NAOMI IRIE

CLEVELAND, OHIO, 2003

*This is Hana-chan, my mother & stepfather's German Short-Haired Pointer puppy, at 3 months.*
*It never seems to matter where she is or what her surroundings are, as soon as*
*she curls up in someone's lap or on a warm surface, she instantly falls into a deep slumber.*

Buffy, my dog, was with me for eighteen years. She was your basic medium brown mutt, looked a little like a Basenji with her pointy ears, and weighed no more than forty pounds. But she was an amazing dog. Once she even got me out of a legal jam. I was on trial on campus in Buffalo, falsely charged with the stabbing of the head of campus security. Those were, after all, radical times. For a character reference, my physics professor wrote a letter about how Buffy was always a fixture on campus, following me everywhere, and how someone with such a great dog couldn't possibly be an evil or violent person. As this letter was being read in the courtroom, my friends stood outside the doors with my dog. When the reader got to the part about Buffy, they opened the doors and let Buffy in. She came trotting through the courtroom right up to me, and curled up at my feet. It was a very Norman Rockwell moment, and all the proof they needed to drop the charges.

ELIOT SHARP, COMPOSER, NEW YORK CITY

RIGHT:
**UNIDENTIFIED PHOTOGRAPHER**
**MON AMI, PARIS, 1960s**
In a café at the Beat Hotel, a ever-watchful terrier-mix named Biquette assumes his customary place atop the shoulders of owner Madame Madeleine, a concierge from Place St. Michel.

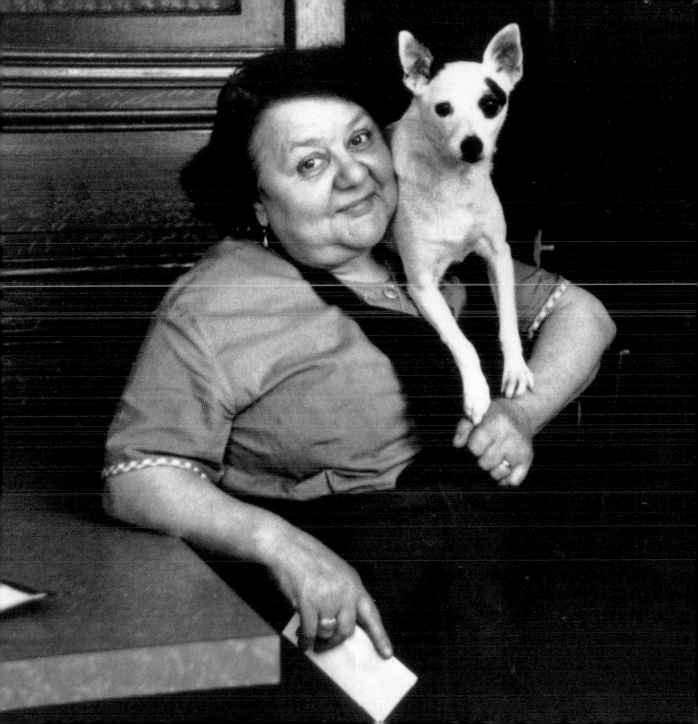

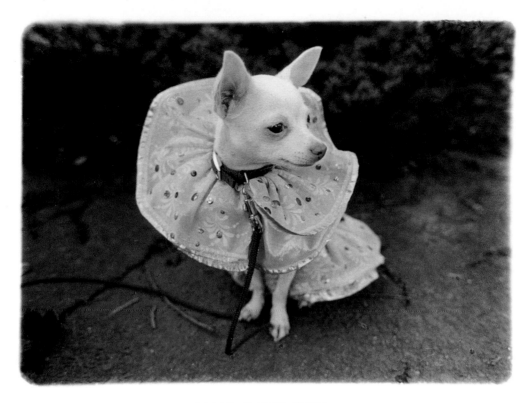

SUSAN COPEN OKEN
DOG WITH ATTITUDE, 1985

*She's just so feminine, the way she's striking the pose.
There was a performance piece going on in Central Park and the Chihuahua was just
sitting there, waiting for her owner to be finished.*

HANS OLA ERICSON
MONTPARNASSE, 1987

*This was at a café. I lived for many years in Paris, and this was a common scene.
The Parisians love dogs and cats. I like them too. It's wonderful to be in a restaurant
and watch the animals.*

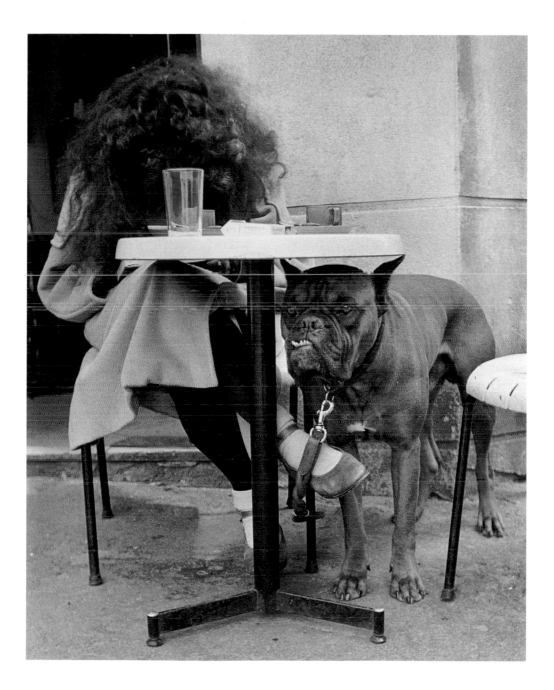

SIX OF A KIND. 1934
Right: *George Burns, Gracie Allen, and a Great Dane in this
zany comedy about traveling west, directed by Leo McCarey.*

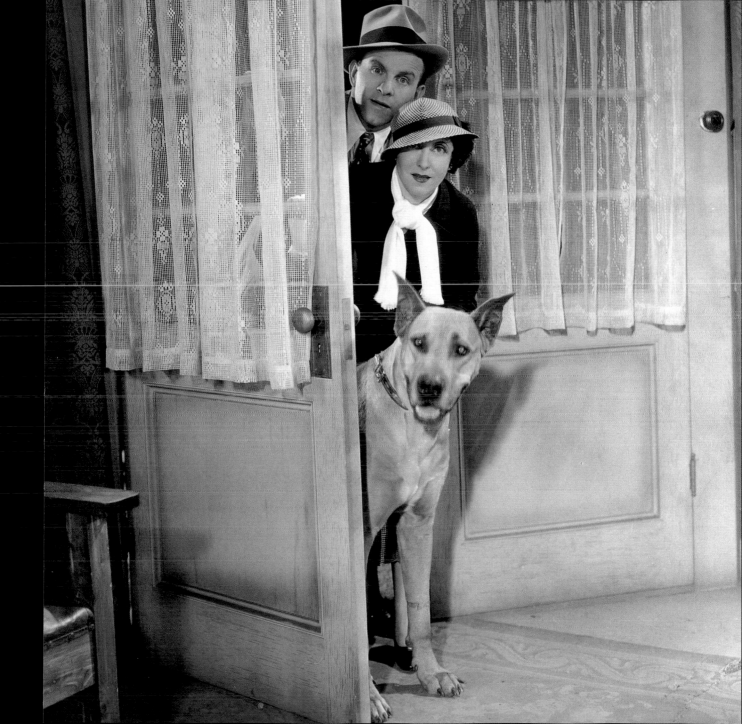

AFTER THE THIN MAN. 1936
*Three-way chemistry gave the series consistent appeal. Asta
the Fox Terrier leads the way for William Powell and Myrna
Loy on the search for a midnight snack.*

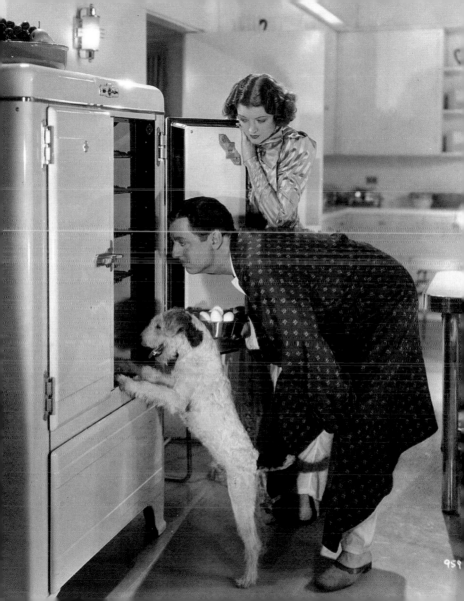

959

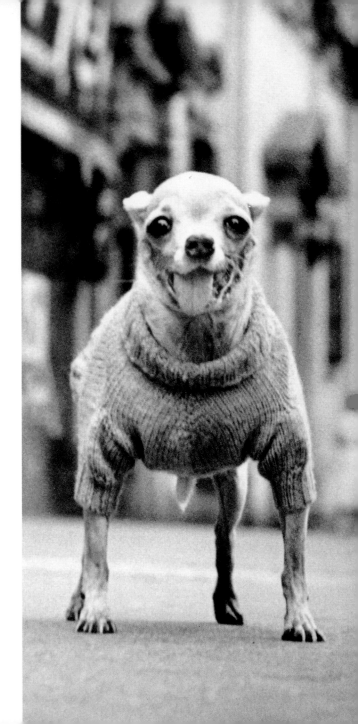

ELLIOTT ERWITT
NEW YORK CITY, 1946

*People like to point out that the photograph is taken
from the dog's point of view, but the dog, of course,
isn't surprised by that, as you can see. He's completely
ignoring the person next to him, and her point of view.*

*It is not so much that I acquire dogs as it is that dogs acquire me.*

*Maybe they even shop for me, I don't know.*

*If they do, I assume they have many problems, because they certainly*

*arrive with plenty, which they turn over to me.*

..............................................

**E.B. WHITE**
**The Care and Training of a Dog**

CHAIM KANNER
MUGGY DAY, 1976

*This was shot on Third Avenue and around 20th Street in Manhattan, during the years*
*when I used to spend the summer months in New York. The dog was not a lonely dog.*
*Its owner was in the supermarket and it was just waiting outside.*
*To me it looked very well taken care of. I think it was, mostly, a very hot dog.*

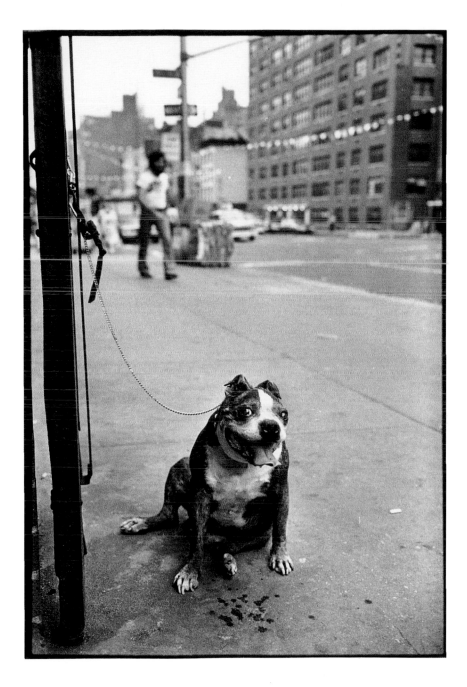

HEEL!

THIS PAGE: MAUD FRIZON METALLIC
LEATHER PUMP WITH A HIGH, THICK
HEEL, ABOUT $295. THE DOG, A SHIH
TZU; PRADA LEASH, ABOUT $190.
OPPOSITE: GUESS METALLIC LEATHER
SHOE-BOOT, COWBOY STYLE, ABOUT
$165. THE DOG, A WEIMARANER.
MORE INFO, LAST PAGES.

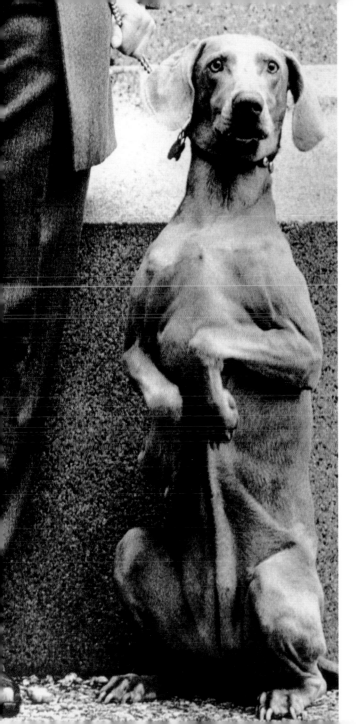

ELLIOTT ERWITT
NEW YORK CITY, 1989

*These professional dogs have several advantages.*
*For one, they come cheaper than humans.*

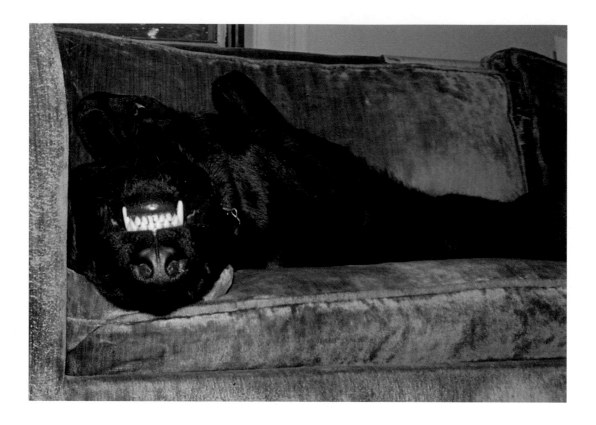

**TONY MENDOZA**
**BOSTON, MA, 1979**

One of a series of photos called *The Leila Pictures*. In
Hebrew, *leila* means "night"; a perfect name for this mutt.

282

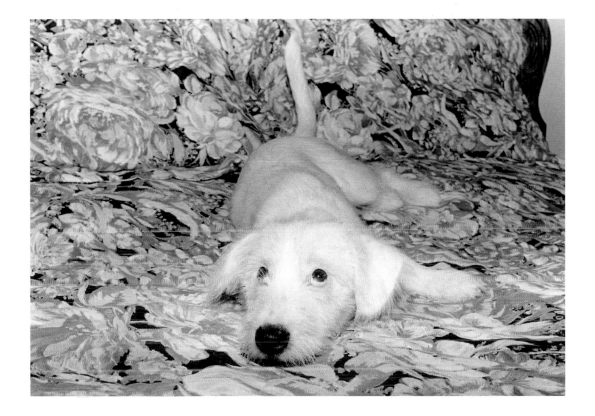

**ROBIN SCHWARTZ**
**HOBOKEN, NJ, 1995**

Someone brought Copper from Pueblo, Mexico. Now
he lives with a family in a house with a backyard.

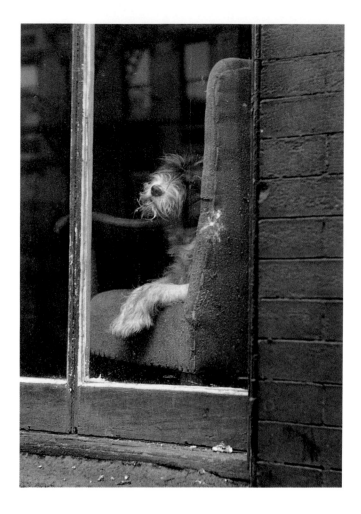

SID KAPLAN
*New York City, 1955*

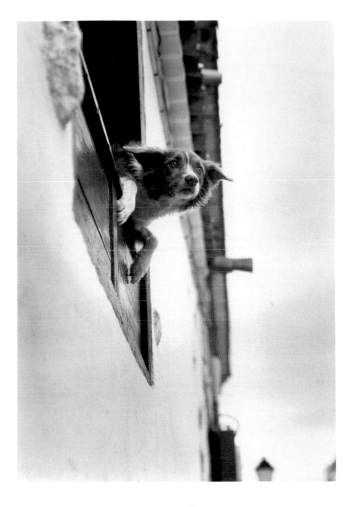

Mark McQueen
*Street Dog*
Tenerife, Canary Islands, 1990
"Like most of the dogs I photograph, I saw this one
once and never again. But he was my first dog of the 1990s.
It was New Year's Day in Los Christianos, a port town of Tenerife,
and though the dog had a nice view of the ocean he was
more interested in the goings-on in the street."

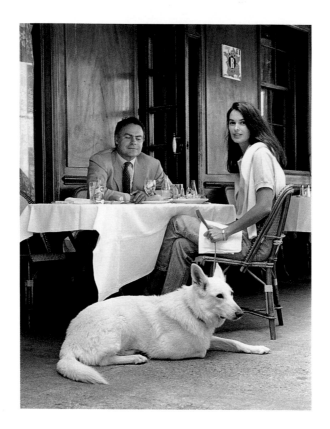

PRISCILLA RATTAZZI
*Jean et Diane De Noyer and Sugar*
New York, 1988

*Opposite:*
HAROLD FEINSTEIN
*It's a Deal*
Paris, 1988
"Most of the time the dog looked away but every once in a while
he'd look up, as if he were following the conversation."

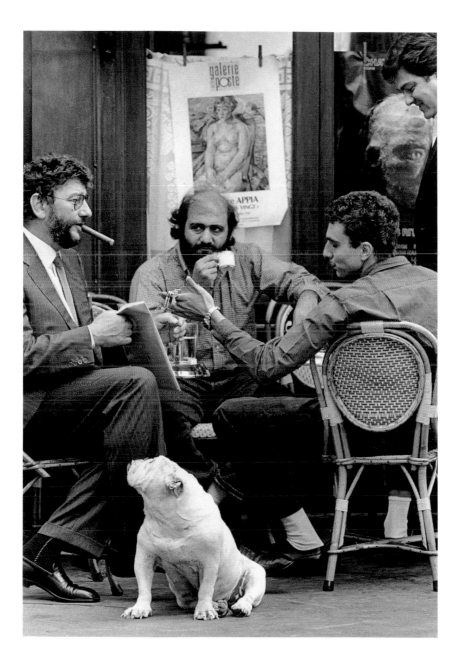

When the Man waked up he said,

"What is Wild Dog doing here?"

And the Woman said,

"His name is not Wild Dog any

more but the First Friend,

because he will be our friend

for always and always and always.

RUDYARD KIPLING

**MARILAIDE GHIGLIANO**
**CASTIGLIA DEL NORD, SPAIN, 1985**

"I was in the town of Moarves to photograph a beautiful
Romanesque church. At one point I heard barking and turned
to see this puppy peeking out of the beaded curtains of the bar
near the church. While I photographed him he darted in and
out of the curtains, turning our meeting into a game."

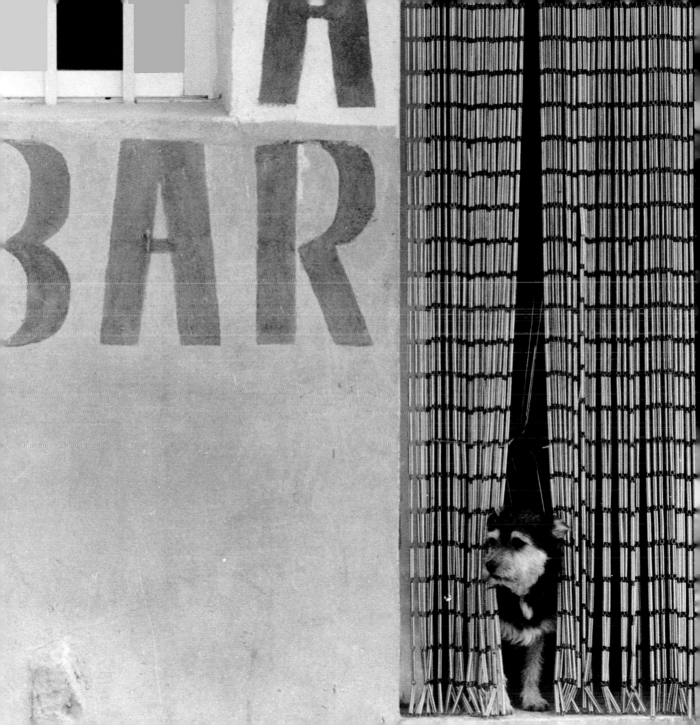

Don't make the mistake

of treating your dogs like

humans, or they'll treat

you like dogs.

MARTHA SCOTT
Dogs

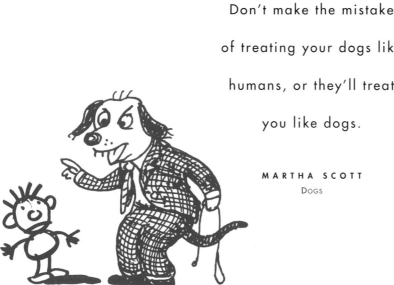

**MARILAIDE GHIGLIANO**
**ROME, ITALY, 1990**

"One day at a busy intersection at the Piazza Venezia in front
of the Vittorio Emanuele II monument, I saw two tourists with this
darling little puppy. I think they may have rescued him because
they were well-dressed while he had no collar or tag, only a mere
cord around his neck. They didn't notice me on the ground taking
pictures between their legs. If someone had photographed me at that
moment, who knows what they would have thought I was doing."

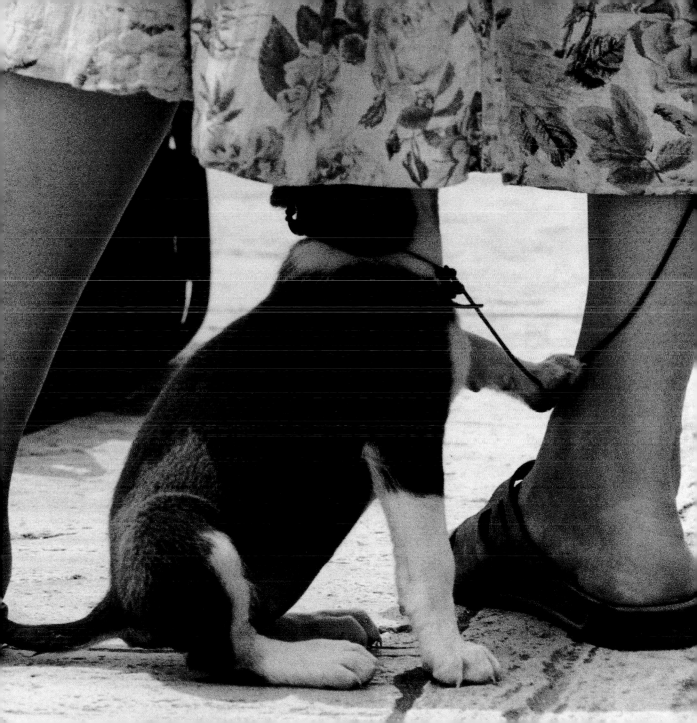

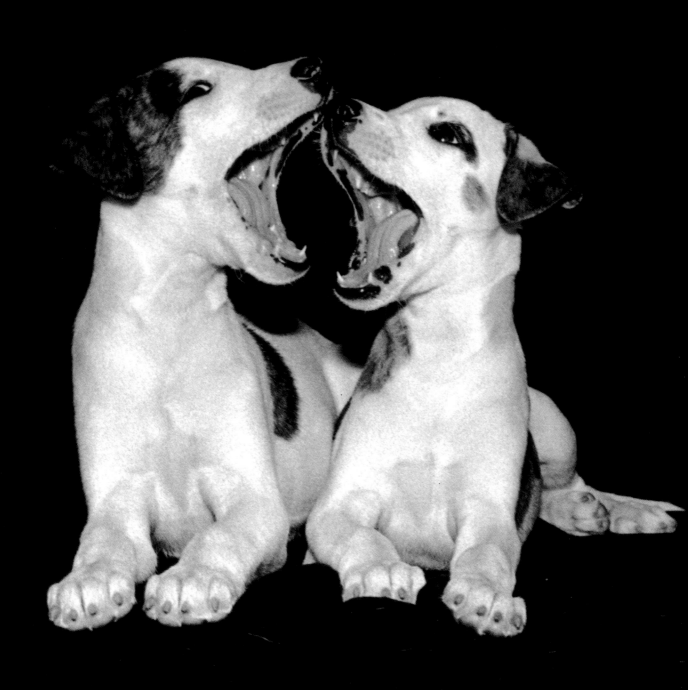

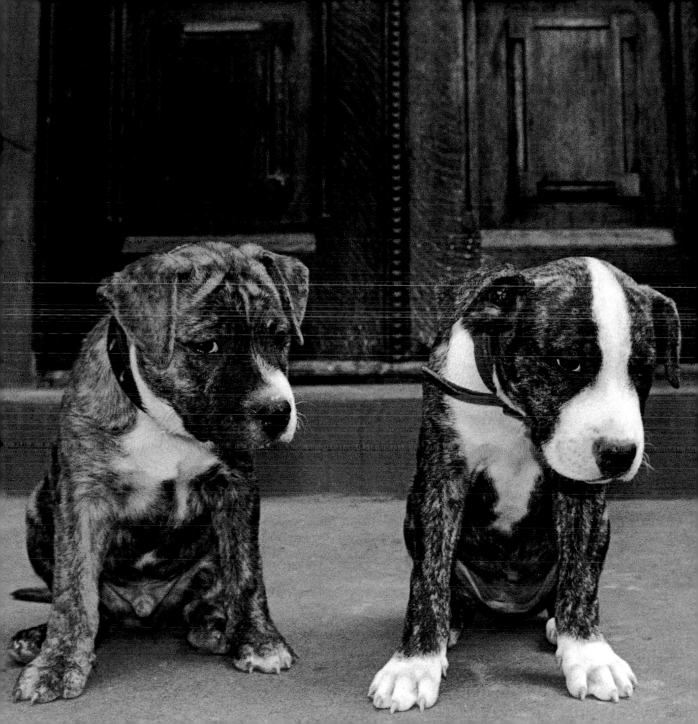

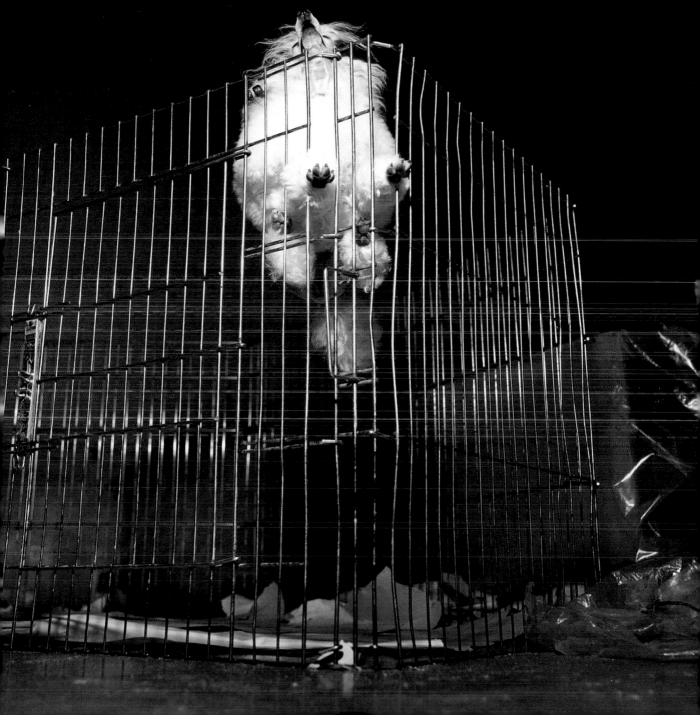

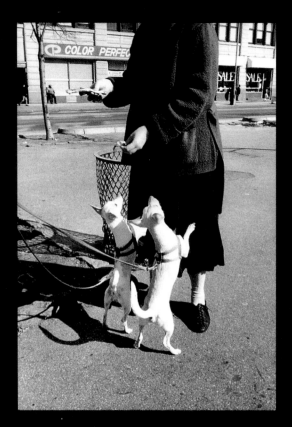

LIZZIE HIMMEL
*Union Square Park*
New York, 1991
"This woman took her two Jack Russell Terriers for an afternoon
constitutional in the park every day. They loved pizza and
kept begging her for some until she finally relented."

*Opposite:*
DAN WEINER
*East End Avenue*
New York, 1950

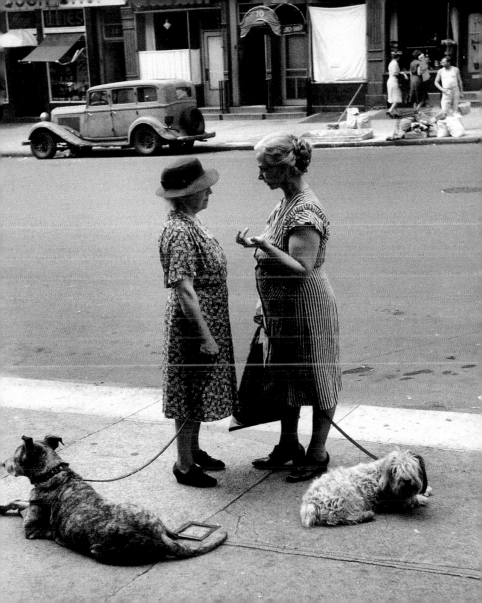

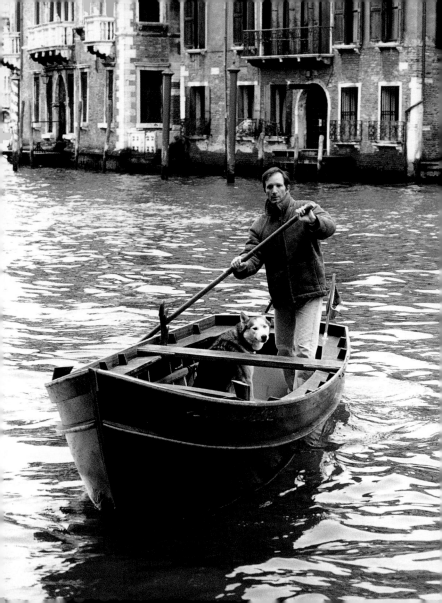

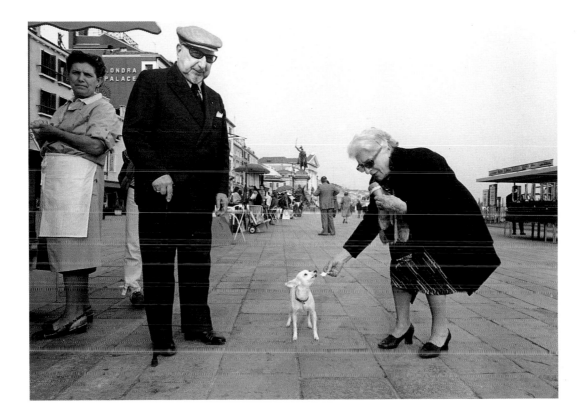

*Opposite:*
PRISCILLA RATTAZZI
*Brandino Brandolini and Lev*
Venice, 1988

JON FISHER
*Venice*
Italy, 1991
"I was walking near the Piazza San Marco
along the promenade of the Grand Canal
when I came across this gelato-eating Chihuahua."

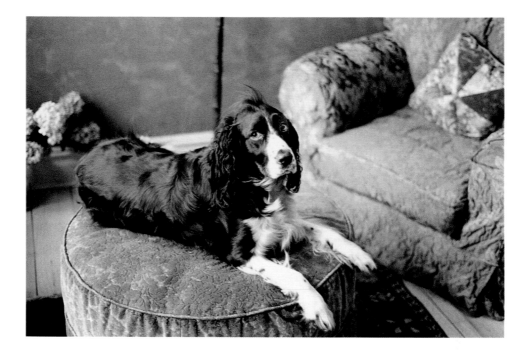

LAURA BAKER STANTON
*Ralph Kletter-Renee*
New York, 1993
"His hyphenated name is for his two owners,
who've been best friends for fifteen years.
He goes back and forth between their apartments."

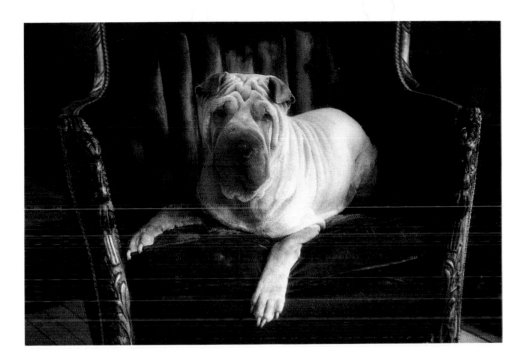

RICHARD ELKINS
*Oscar*
New York, 1990
"Oscar's a young Chinese Shar-Pei owned by Craig Lucas,
a playwright who was posing for me in his library.
I was really interested in that chair, which seemed perfect for an
old-fashioned portrait. And Oscar, who was running around
and being very likable, seemed like an old-fashioned dog."

ELLIOTT ERWITT
NEW YORK, NY, 1977

Sandy (on counter), the star of the musical *Annie,* and
her understudy in their dressing room at the theater.

OVERLEAF LEFT:
ROBIN SCHWARTZ
BANDIT AND LONI,
CONNECTICUT, 1997

"These two Smooth-coated Fox Terriers are
half-sisters from the same breeder, and everything
about them is very sweet. Even their names are sweet.
Bandit, the younger one, bears the full name
Rapidan Heartstrings, and Loni, the dog with the
darker mask, is known as Ch. Heart's Desire. You
could say it's in their blood to be this sweet, since
their mother's name is Ch. Foxmoore Tess Trueheart."

OVERLEAF RIGHT:
ROBIN SCHWARTZ
CUTTER AND ROCKY,
COLTS NECK, NEW JERSEY, 1994

"I take my own dogs lure coursing, and these
Borzois were there to race that day too.
They were hanging out in the back of a car,
waiting out the rain. They were from the same litter,
which helps explain why they were so connected.
They had the same personality, though I found out
recently that one still races, and the other doesn't."

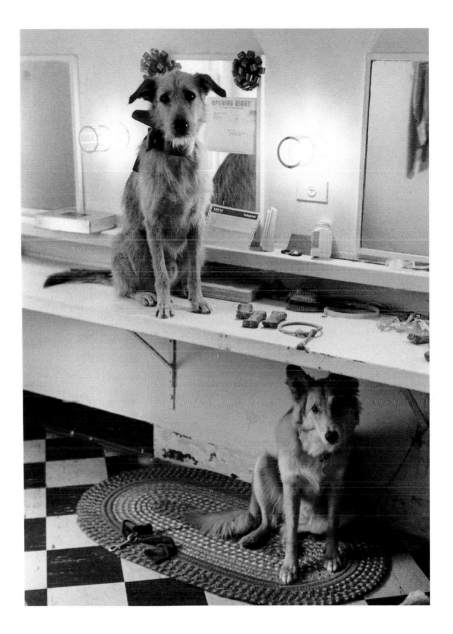

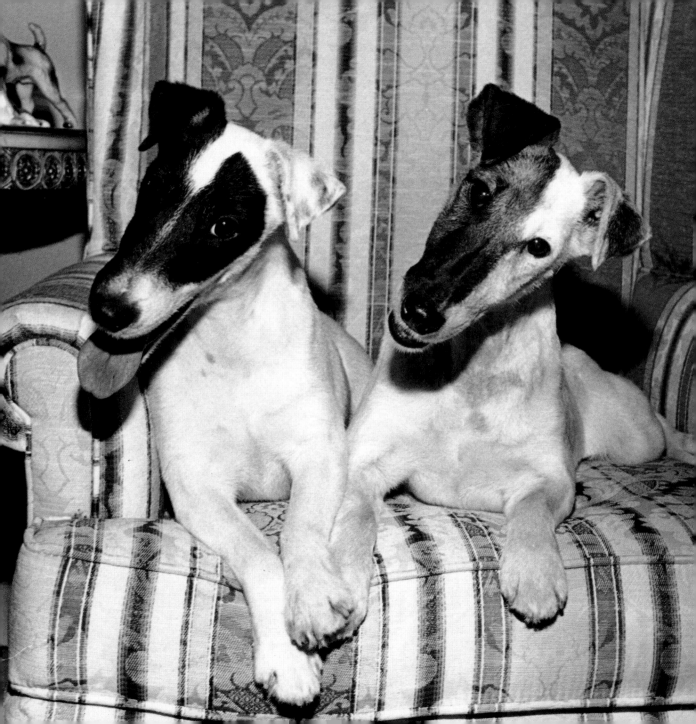

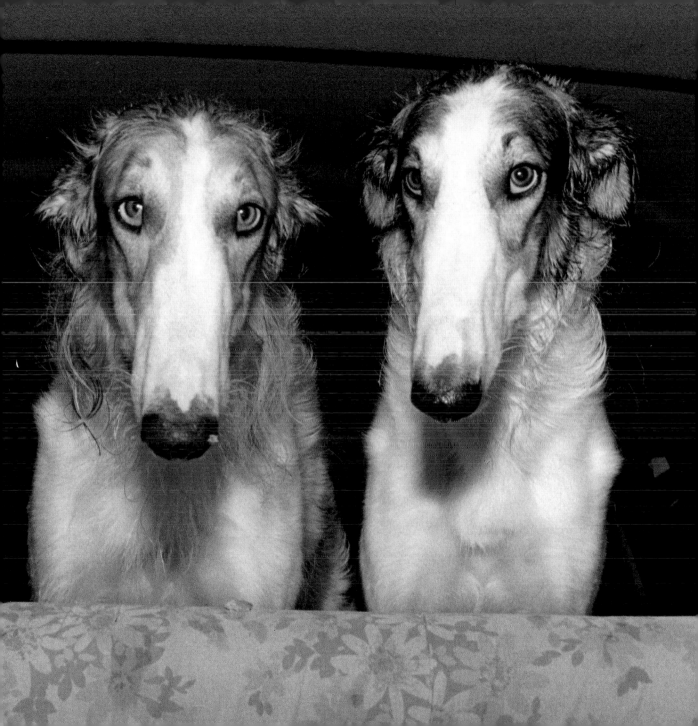

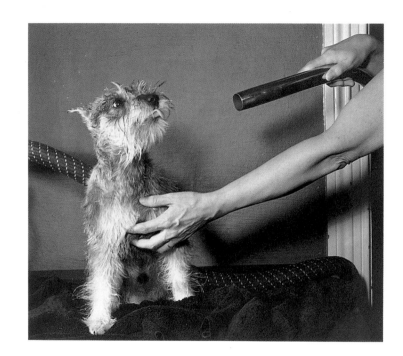

ILSE BING
*Staccato Being Shampooed and Dried*
New York, c. 1948

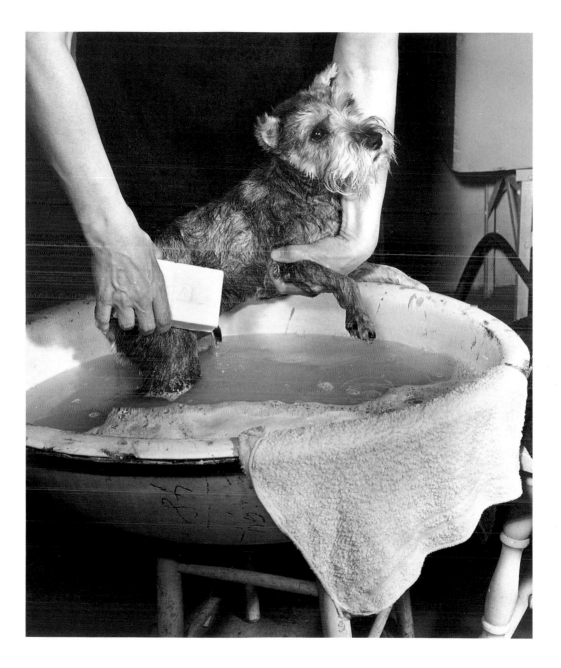

KARL BADEN
DOG SHOW, BOSTON, 1993

*This was backstage, as the dog, who is not a Poodle,
was being prepped for the ring. He stood very still.
He seemed to be an old hand at this routine.*

JOHN DRYSDALE
*Monkey Mothercare for a Jack Russell Terrier*
Coventry, England, 1988

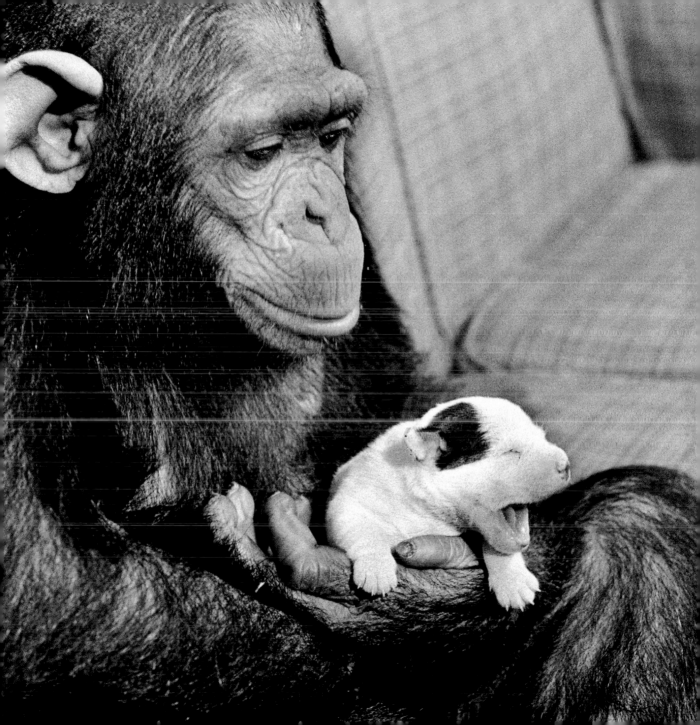

## My Eyes, My Hands

MARY BLOOM
*New Eyes*
*New York City, 1982*

Guide dogs have been serving people who are blind for over eighty years now. In the past, these dogs were typically German Shepherds. Today, many different breeds of dogs assist people with a wide array of other disabilities. And the results have been astounding. At the Delta Society, a national group with headquarters in Renton, Washington, awareness of the health benefits to humans these animals provide is the organization's top priority.

Susan Duncan, a registered nurse who is the Coordinator of the National Service Dog Center for the Delta Society, has first-hand knowledge of her field. She has been living with multiple sclerosis for eighteen years. For a decade she managed as best she could with a disease that was progressively worsening. Joe, a part–German Shepherd, part–Great Dane stray whom Susan saved from euthanasia, came to the rescue. Trained by Susan herself, Joe helps his mistress with the daily tasks most people take for granted—like getting out of bed in the morning: "Joe pulls my feet off of the edge of the bed and then uses his head to swing me up to a sitting position." Incredibly, Joe also helps with the banking ("I punch in the code at my ATM, he grabs the money") and shopping ("Joe can reach things I can't and carries it all in a backpack on his back").

No longer dependent on others to help her manage her day-to-day life, Susan is now free to pursue activities she couldn't possibly sustain previously. "I had always loved gardening. Now I've trained Joe to dig flower beds for me. He loves to do it. And my garden is finally thriving." Thanks to Joe the service dog, so is Susan.

ED.

312

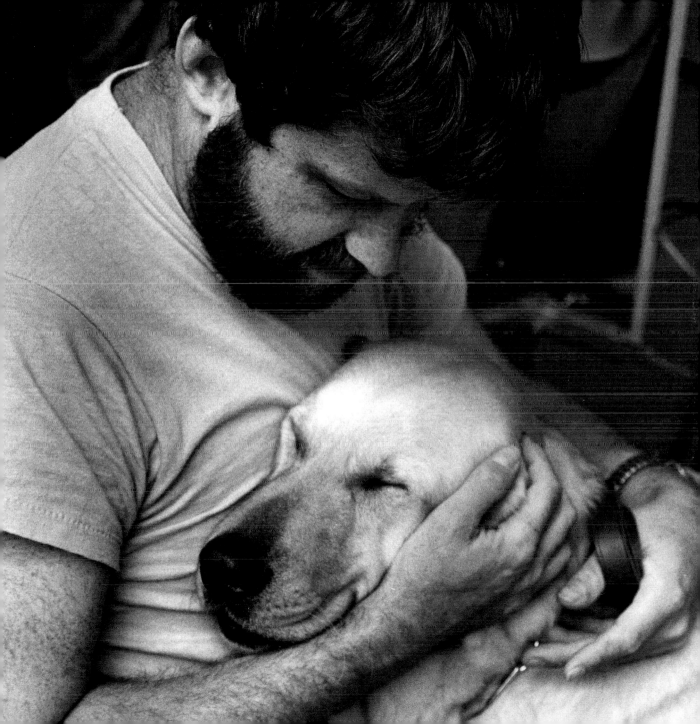

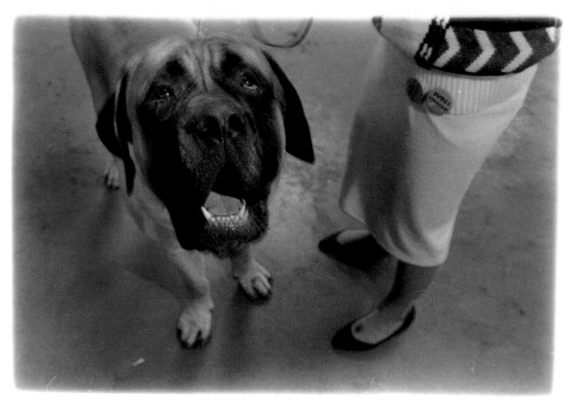

SUSAN COPEN OKEN
MASTIFF, 1989

*The dog was backstage, in the benching area at the Westminster Kennel Club.*
*His handler was really working hard. Much harder than he was.*

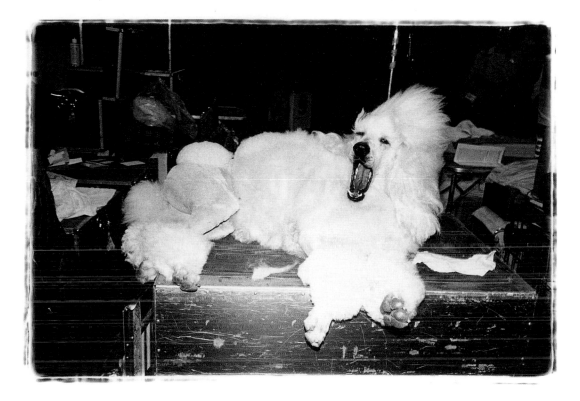

JOICE RAVID
POODLE YAWNING, 1980

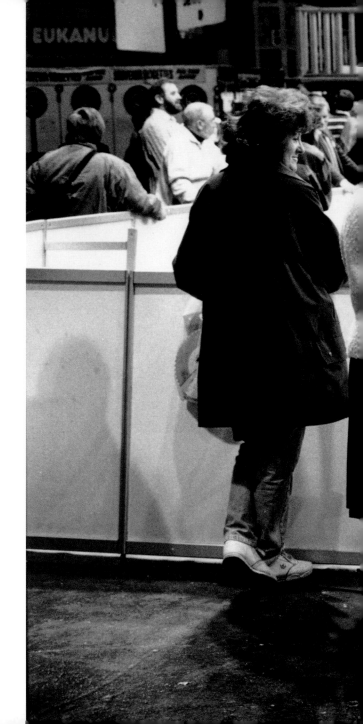

ELLIOTT ERWITT
BIRMINGHAM, ENGLAND, 1991
*You will often see a kind of relationship
between English owners and their pets that is
so close it is simply unbelievable.*

OVERLEAF:
UPI PHOTOGRAPHER
FISHING,
PONTIAC, MICHIGAN, 1970
*Nine-year-old Lewis Flack and his dog,
a terrior-hound mix, spend a quiet afternoon
waiting for the fish to bite.*

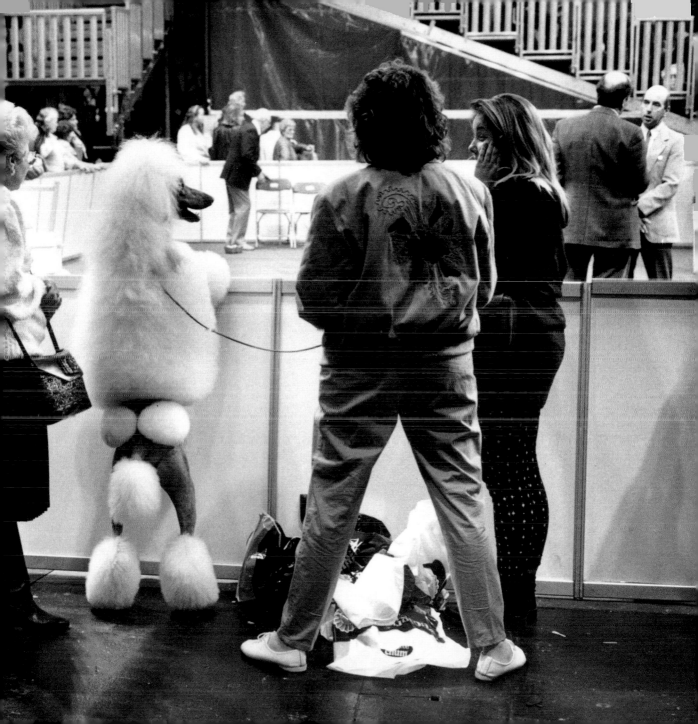

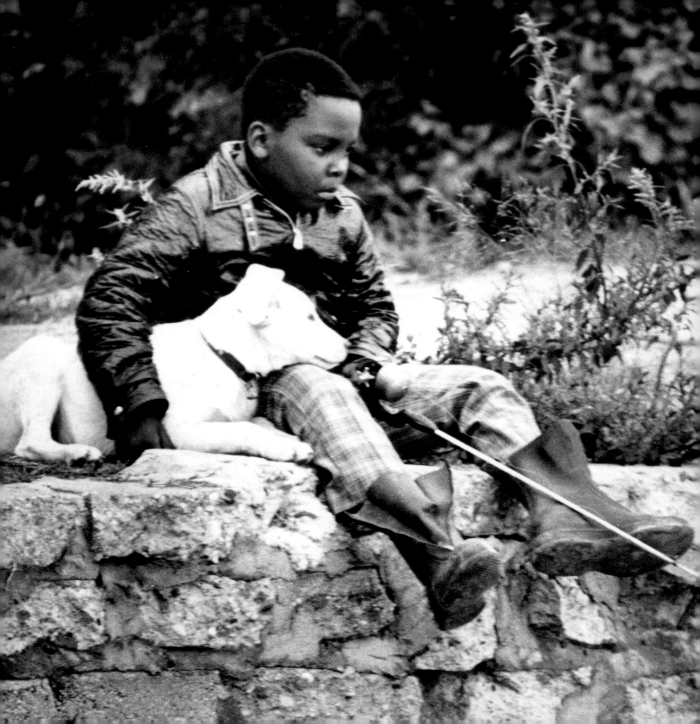

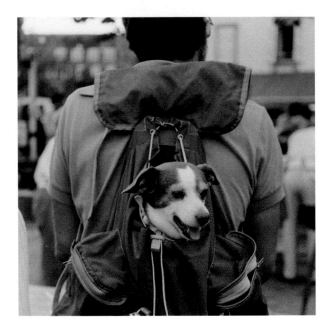

**MARILAIDE GHIGLIANO**
**BRITTANY, FRANCE, 1990**

This dog happily viewed the Fête de Filets Bleus
(which takes place every August in Concarneau)
from its master's backpack.

RIGHT:
**ROBIN SCHWARTZ**
**PARAMUS, NJ, 1995**

Ginger poses in her pumpkin outfit at the Halloween
costume contest held annually at the Pet Nosh super store.

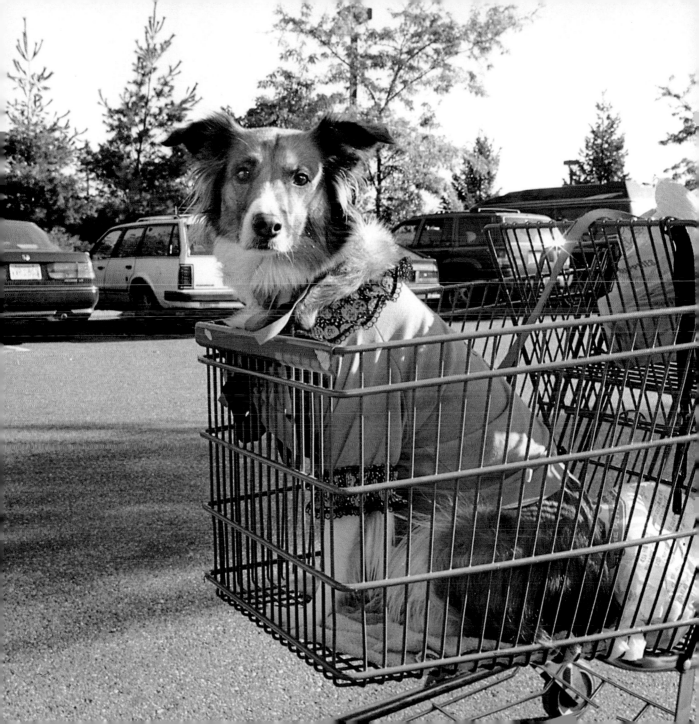

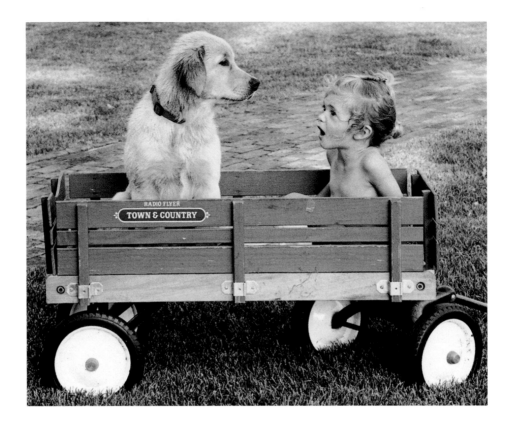

PRISCILLA RATTAZZI
*Two Honeys on the Wagon (Luna and Sasha)*
East Hampton, New York, 1997

right:
KARL BADEN
*Untitled*
Boston, Massachusets, 1987

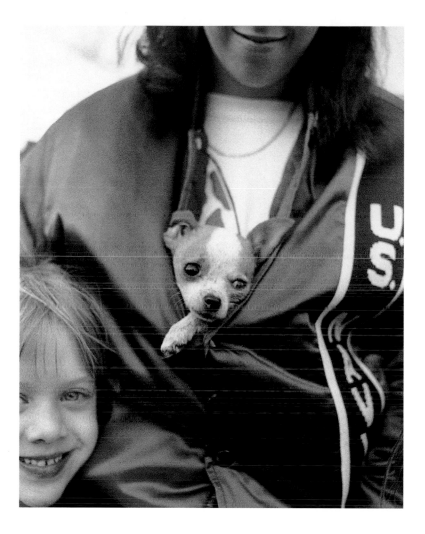

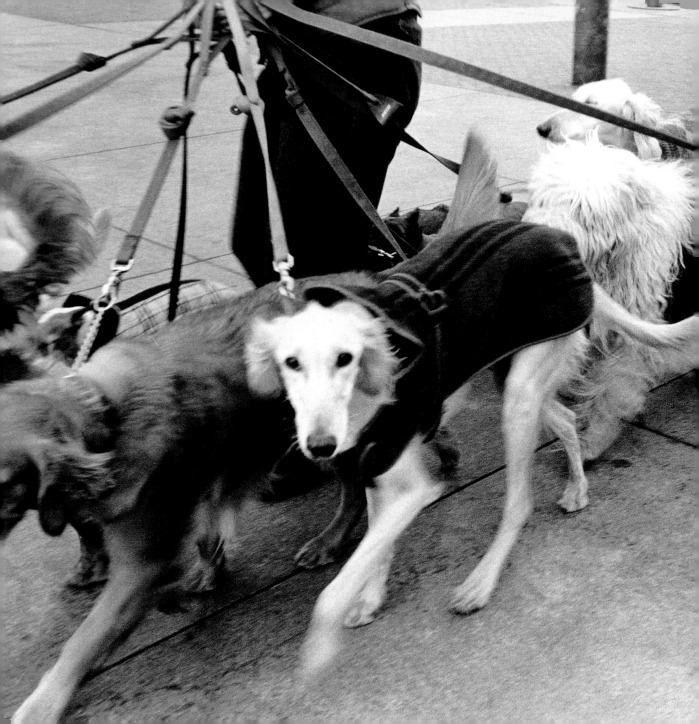

AMY ARBUS
*Dog Walker*
New York, 1985
"Kasbeck, the white Saluki, in a striped Tyrolean jacket; Faubion,
the black and silver champion Saluki, in a ribbed sweater;
Natalie, a Jack Russell Terrier in a plaid Paris original, and friends
walking by the Metropolitan Museum in the morning."

## The Dogs of Engine 53

UPI Photographer
*Smoky the Fire Dog*
*New York City, 1942*

Most of the firehouses in New York City don't keep Dalmatians anymore—but we've always kept the tradition alive. In the old days, every company had one, because Dalmatians are great with horses. In Europe, Dalmatians were originally bred to accompany carriages and protect passengers from highwaymen. Firefighters here in America used them to keep other dogs from nipping at their horses' feet when they were out fighting a fire—which was really important back then. Our dog, Blaze, has it a lot easier. He prefers to sit around the firehouse. Although they are really just pets today, Dalmatians do provide a valuable service. Kids from schools visit the firehouse at least once a week, and the first thing they want to see is the Dalmatian. Luckily, Dalmatians love kids—they are real gentle—so they really help us keep the children's interest in learning about fire safety. Of course, we grown-ups love Dalmatians as much as the kids. Our captain, Kevin Butler, even has his own Dalmatian, Mozart.

Mozart loves to visit the station. It's in his genes, I guess. His father, Domino, was our company's last Dalmatian. People would come from miles around to see Domino. He was sort of a legend around here, and people really missed him after he died. That's why we keep his ashes in an urn in the firehouse. It brings us good luck.

Tom Condon, firefighter, Engine 53/Ladder 43, New York City Fire Department

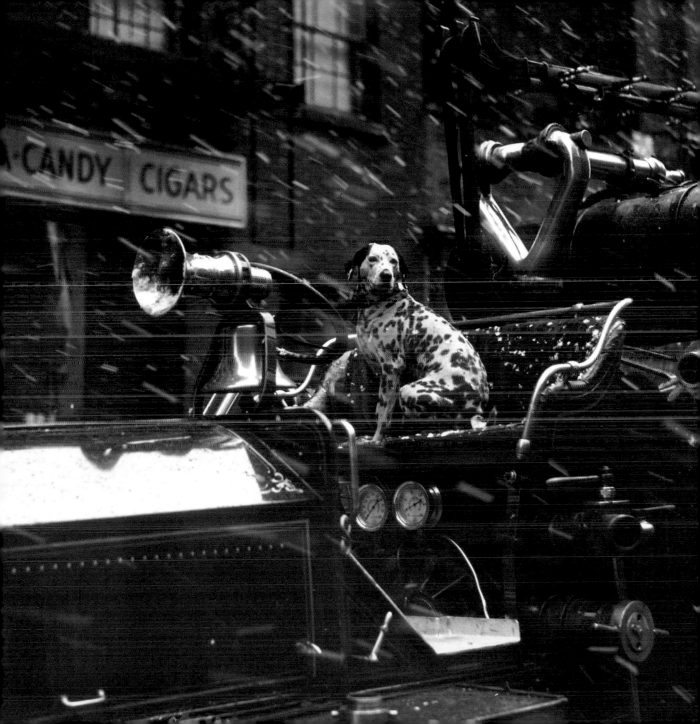

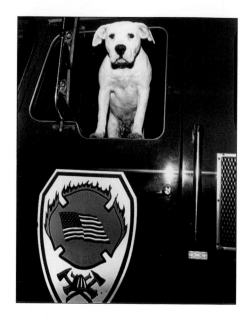

ROBIN SCHWARTZ
*Bailey in Hoboken Fire Truck*
*Hoboken, New Jersey, 1995*

Opposite:
UPI PHOTOGRAPHER
*Jiggs of the Hollywood Fire*
*Department*
*Los Angeles, California, 1924*

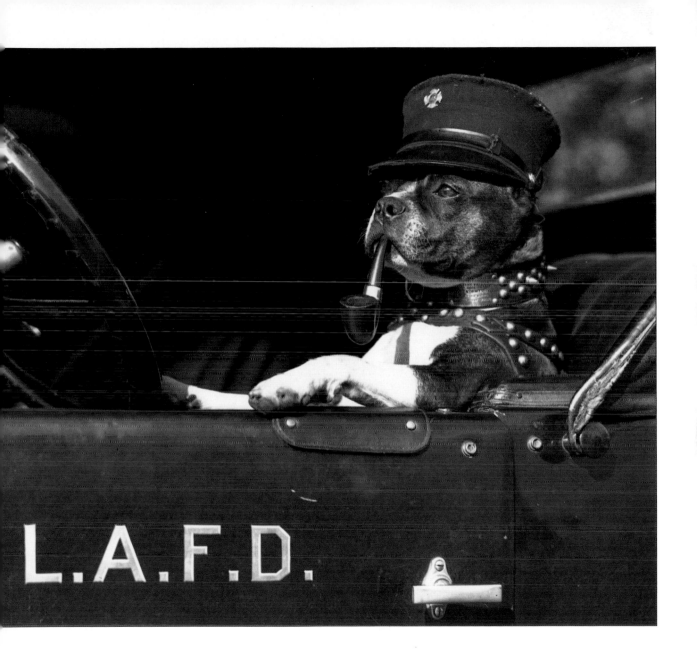

KARL BADEN
*U-Boat*
Cambridge, Massachusetts, 1991

HARVEY STEIN
*Sampson*
West 57th Street, New York, 1973
"My neighbor's dog, a tiny Yorkshire Terrier with a yappy bark,
was named Sampson for obvious reasons. He was convinced

WALTER CHANDOHA
*In the Doghouse*
Long Island, New York, 1961

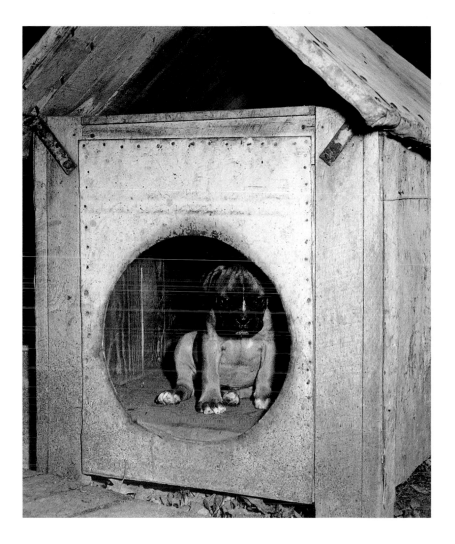

333

## Shy Katy

Search-and-rescue dogs are trained to be heroic. But my shy Australian Shepherd named Katy seemed like an unlikely candidate for such an honor. I hadn't properly "socialized" her as a puppy and she has always been terrified of other dogs and people—not a great quality for rescue work. But I knew the bond between a handler and his dog is the most important thing, and Katy was devoted to me. Still, I had my doubts.

The first test came when Katy was three years old and we were called to assist a rescue effort at a large trailer park that had been devastated by a tornado. My doubts were confirmed when we arrived at the gruesome scene and Katy immediately began to tremble. The swarms of rescue workers and the incredible commotion were just too much for her. I was reluctant to begin the search. Then I put Katy's orange reflective collar on, as I had always done during our training sessions, and she immediately stopped shaking. She looked at me enthusiastically, as if to say, "Now I'm ready to work!" She was truly heroic over the next three days, so undaunted, in fact, that the rescue team used her specifically to crawl into small spaces they had dug out looking for survivors. Today Katy is still terribly shy, but she does a Superman-like transformation the minute I put her collar on. Recently, she saved an elderly gentleman suffering from Alzheimer's disease who had wandered away from his house as a storm was approaching. Searchers on foot had given up, but Katy found her man. And in the nick of time. Had he been caught in the storm, he surely would have died.

DANA KAMMERLOHR, CANINE OFFICER, BARRY COUNTY [MISSOURI] SHERIFF'S DEPARTMENT, AND VOLUNTEER, MISSOURI SEARCH AND RESCUE CANINE

PHOTOGRAPHER UNKNOWN
*Army Medical Corps Training*
*New York City, c. 1917*

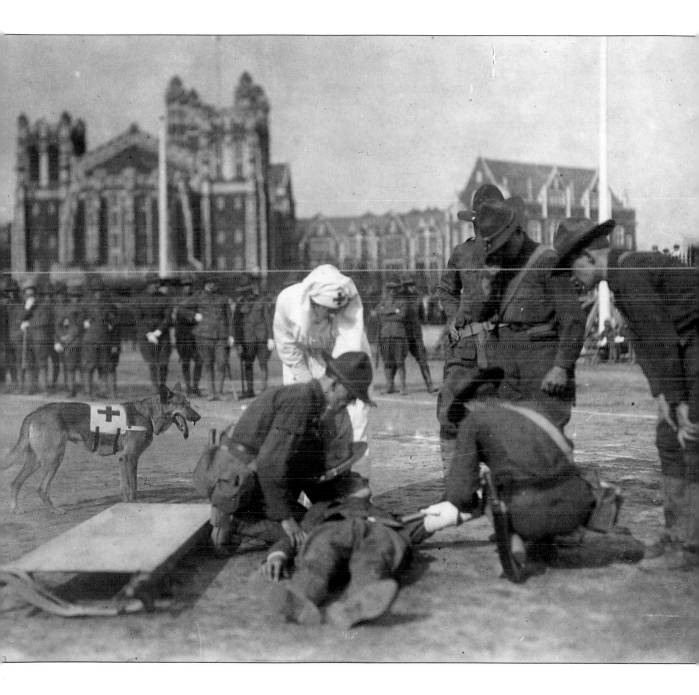

## All in a Day's Work

The Oklahoma bomb blast stunned the world, leaving destruction, grief and trauma in its wake. Not all the wounds were physical, however, and where a different kind of healing was needed, Partner's work began.

He appears to be an unassuming, middle-aged dog—just your average Golden Retriever. But there's nothing average about Partner, who, with his Delta Society/Pet Partners teammates, Kris and Amanda Butler, won Delta Society's 1995 "Family Service Award" for therapy animals. Together, the three assist health-care professionals at Southwest Medical Center's Jim Thorpe Rehabilitation Hospital in Oklahoma City, working with therapists and their clients in physical therapy, speech therapy, memory, sequencing, and motivation. For Partner, it's all in a day's work. And when a terrorist bomb left Oklahoma City in turmoil, it wasn't only blast survivors who were scarred. Rescuers, counselors, and health-care providers were almost as traumatized as those they sought to help. Partner's extraordinary aptitude for his work, and his unconditional love, made him a preferred treatment for these professionals. And his patient understanding began the healing process in those he served. According to Kris Butler, Partner's most measurable impact has been on his human family. "He helps us to shine," she says, "to help others and feel so good about ourselves. . . . It has been said that animals open doors so that healing can begin. Let us humans always listen so we hear opportunity when it knocks on those doors . . . and creatively work with our animals to open them."

DELTA SOCIETY

KENT AND DONNA DANNEN
*Patrick Dannen and Golden Retriever Puppy in Training to be an Assistance Dog*
*Longmont, Colorado, 1995*

Overleaf:
UPI PHOTOGRAPHER
*Dalmation War Dog Jumps Barbed Wire*
*n.l. c. 1944*

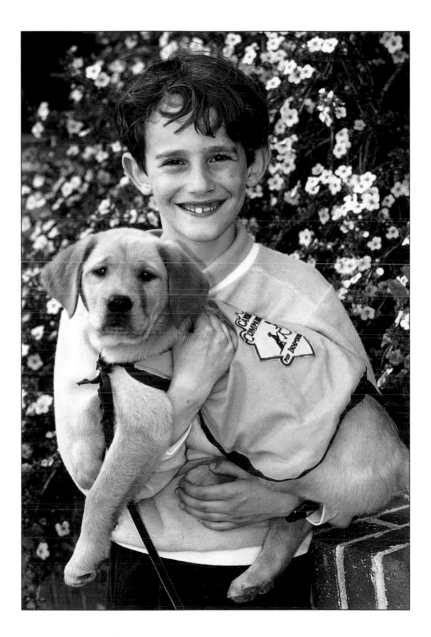

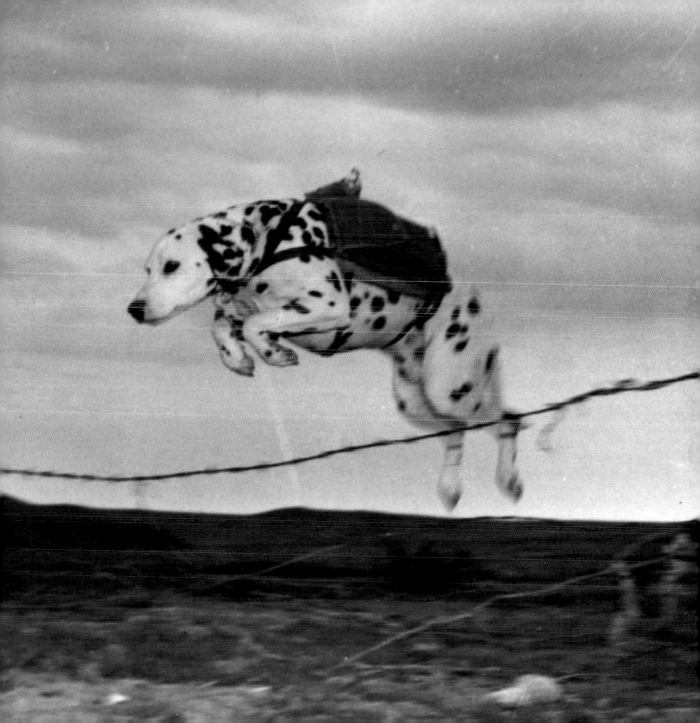

RICHARD KALVAR
NEW YORK, 1976

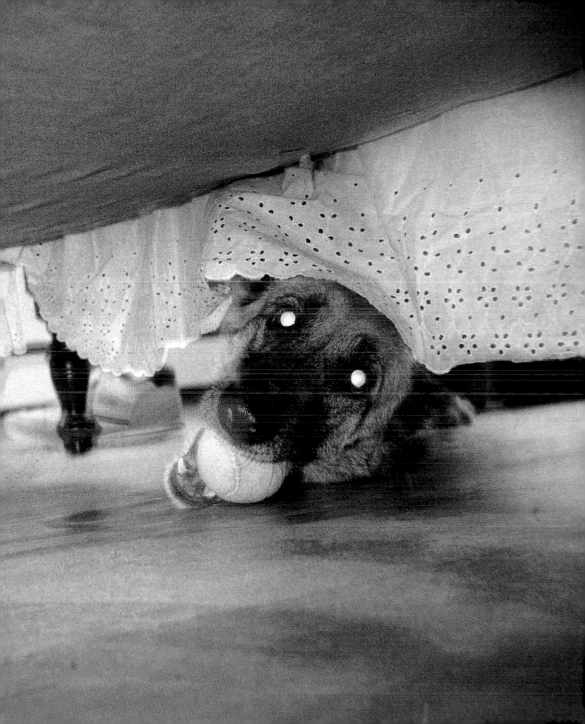

Leonard's is a well-known beach
on the east coast of England.
These bathing beauties are playing
with their dog and a hoop.

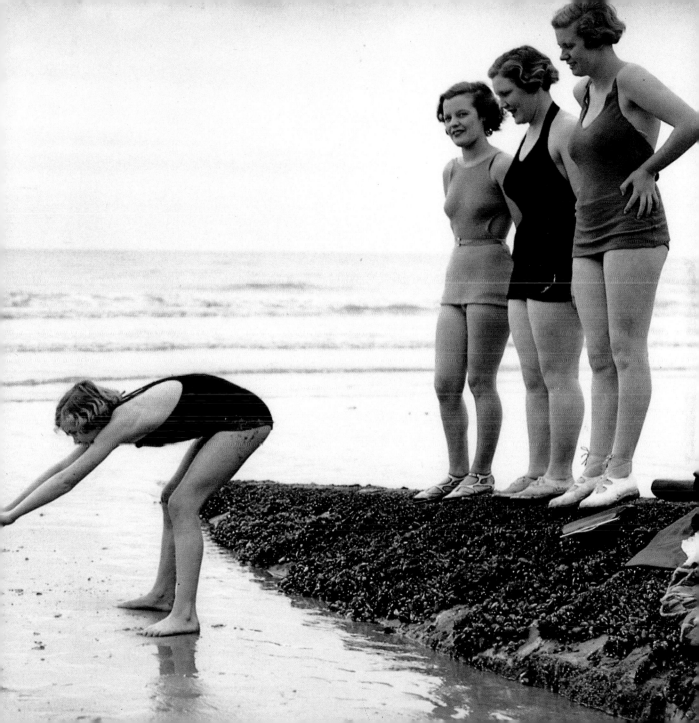

*The first time he ever saw a body of water, he trotted nervously along the steep bank for a while, fell to barking wildly, and finally plunged in from a height of eight feet or more. I shall always remember that shining, virgin dive. Then he swam upstream and back just for the pleasure of it, like a man. It was fun to see him battle upstream against a stiff current, growling every foot of the way. He had as much fun in the water as any person I have ever known. You didn't have to throw a stick into the water to get him to go in. Of course, he would bring back a stick if you did throw one in. He would have brought back a piano if you had thrown one in.*

..............................................

**JAMES THURBER**
**Snapshot of a Dog**

KARL BADEN
MAN AND DOG, REVERE BEACH,
MASSACHUSETTS, 1981

*I was out on the beach on the North Shore of Massachusetts. There was a fellow and his dog watching the planes come in low. They seemed very absorbed.*

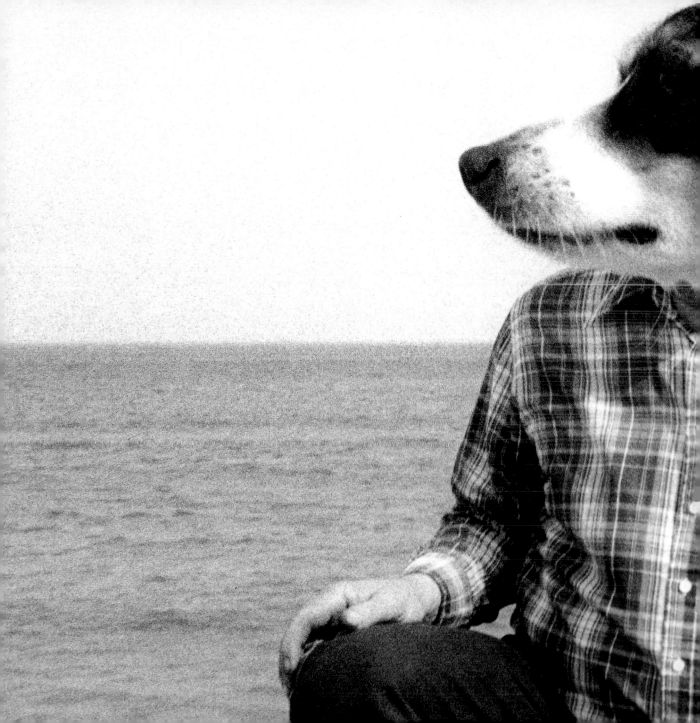

## Boo, Lifesaver

In 1989 the British national charity PRO Dogs, based in Kent, England, gave a medal to a dog called Boo for drawing attention to a cancerous mole on the leg of her owner, Mrs. Bonita Whitfield, which enabled her to get life-saving treatment. Each year PRO Dogs gives three awards to dogs, for Life Saving, Devotion to Duty, and Pet of the Year. The nomination for this dog was picked up following a letter in *The Lancet* by Doctor Hywel Williams and Mr. Andrew Pembroke of Kings College Hospital, London. Understandably, there is growing concern about the increasing incidence of melanoma (skin cancers), and the little Whippet-type dog called Boo continually drew attention to the mole on the back of Bonita's leg, by sniffing at it. Although the owner did not appreciate this attention and tried to shoo the dog away, Boo was so insistent that at last Bonita went to her doctor. She was immediately referred to Kings College Hospital where the mole was removed and confirmed as cancerous. Dr. Williams put forward the theory that such cancers may emit a distinctive odor which the very sensitive scenting ability of the dog may be able to pick up.

With so many more people suffering from skin cancers today, it is important for people to be aware that if their dog is interested in a mole growing on any part of their body, it is worth immediate attention and a visit to the doctor!

LESLEY SCOTT-ORDISH, EDITOR, *ARGOS* MAGAZINE; FOUNDER, PRO DOGS AND PETS AS THERAPY, AND VICE PRESIDENT, HEARING DOGS FOR THE DEAF AND COMPANION ANIMALS FOR INDEPENDENCE

KENT AND DONNA DANNEN
*Ch. Karibou in the Nursing Home*
Boulder, Colorado, 1989

Overleaf:
KENT AND DONNA DANNEN
*Samoyed Hearing Ear Dog*
Estes Park, Colorado, 1989

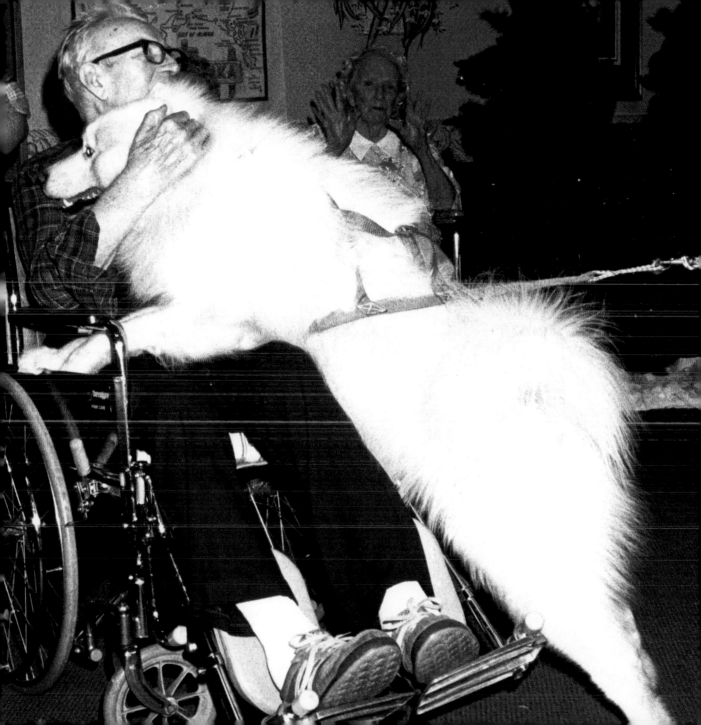

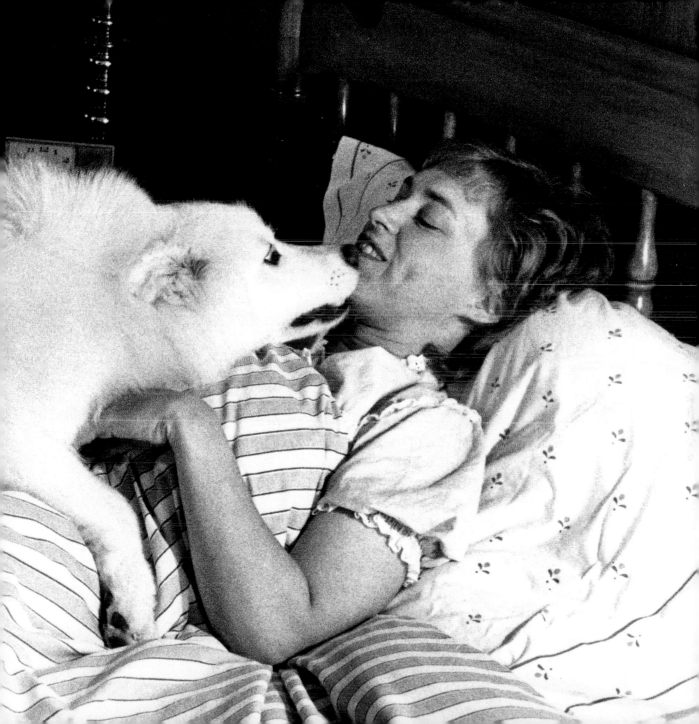

ROBIN SCHWARTZ
*Nell, English Bull Dog Puppy, at Thirteen Weeks*
Jersey City, New Jersey, 1995

right:
*Petie, Rescued Chihuahua Mix*
Jersey City, New Jersey 1995

overleaf, left, and right:
*Mattie, Jack Russell Puppy, at Five Months*
New York City, 1995

*Tia, Chihuahua, at Three Months*
Hudson, New Hampshire, 1998

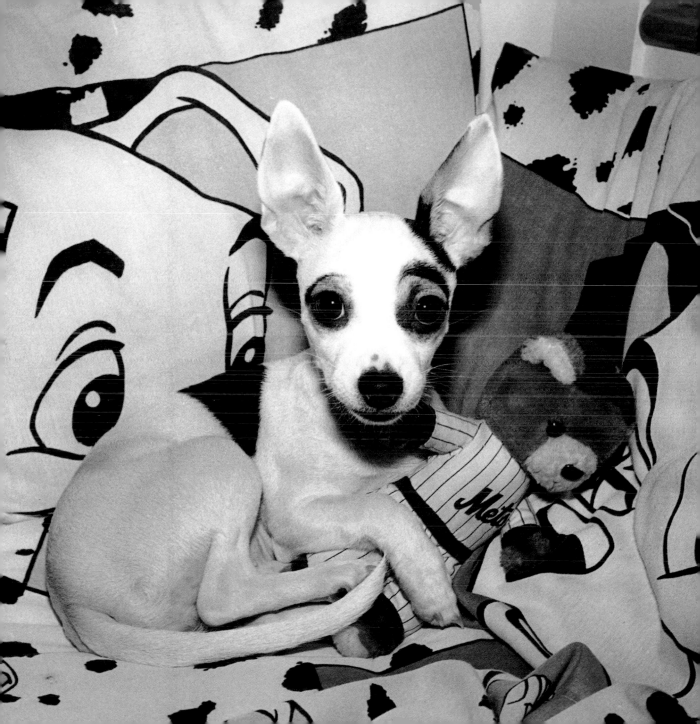

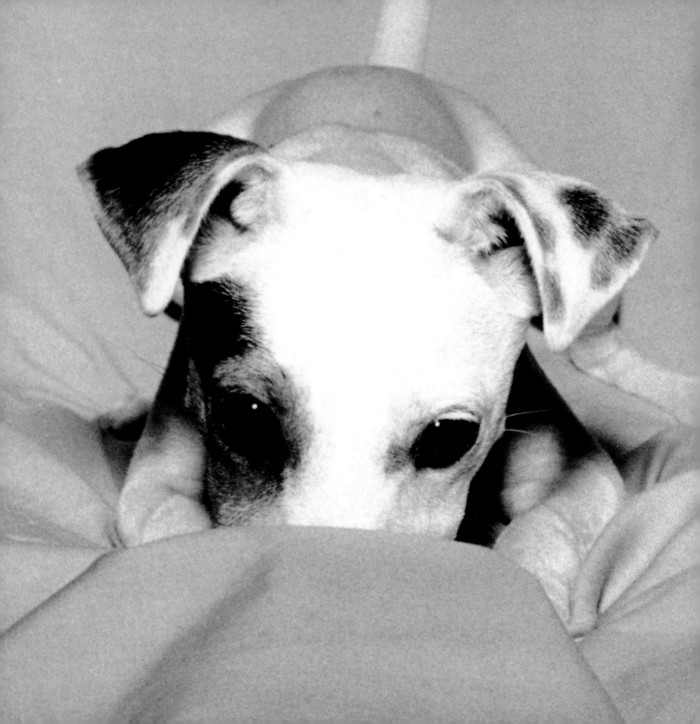

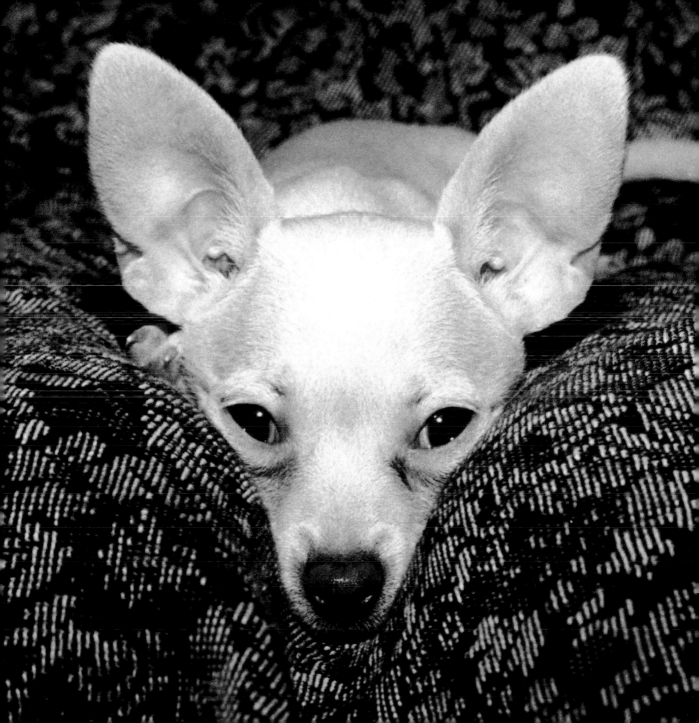

# Please Don't Go

Madge is a Rotteweiler, big as a pony now and queen of the house. But even as a puppy she threw her weight around. She somehow knew if I was headed out the door without her. So she'd go sit on my shoes.

STEVE SCHWARTZ

ARTIST

BROOKLYN

PAUL VAN DRIEL/ERIK ALBLAS
*Still Life with Sneaker and Chihuahua*
Dordrecht, Holland, 1993

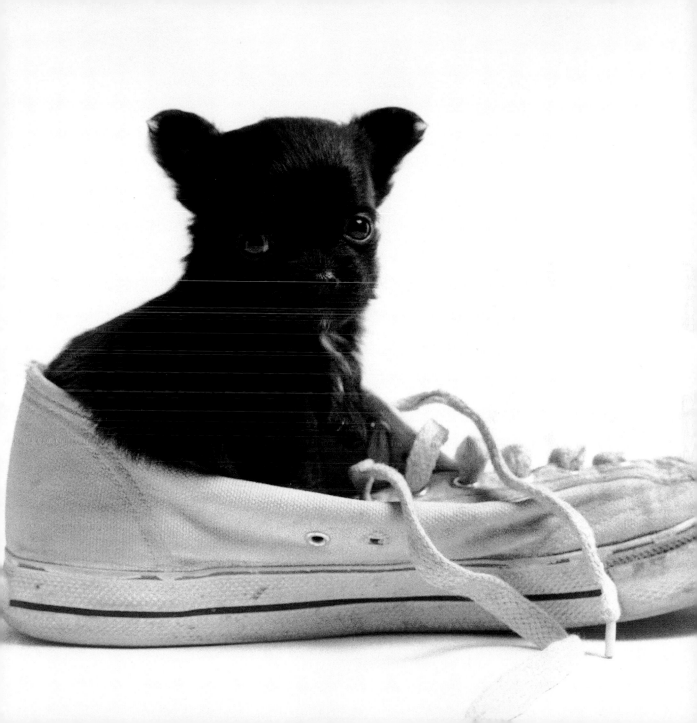

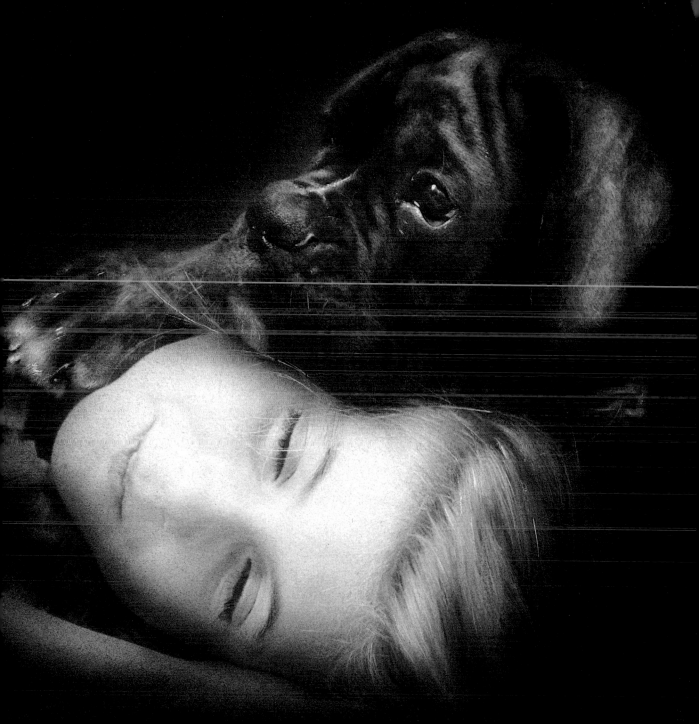

ROBIN SCHWARTZ
*Helen, Shar Pei, at Twelve Weeks*
Staten Island, New York, 1997

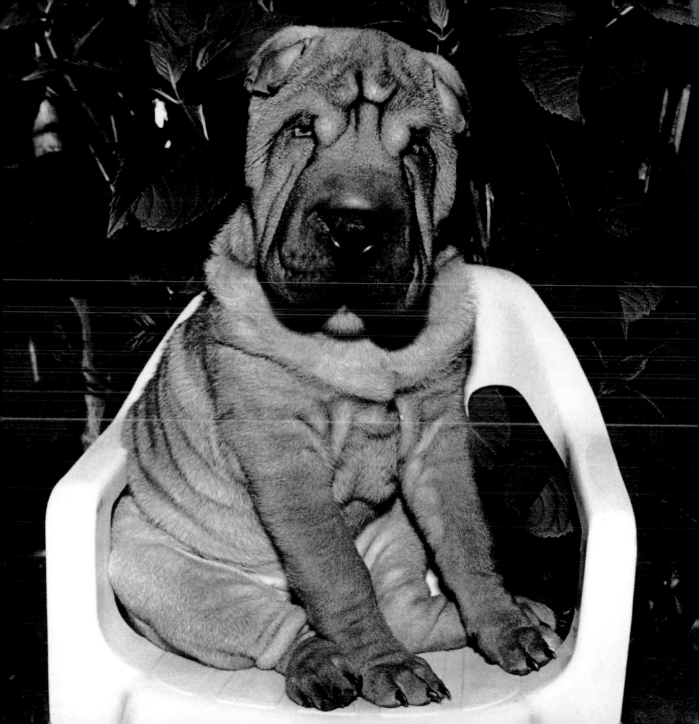

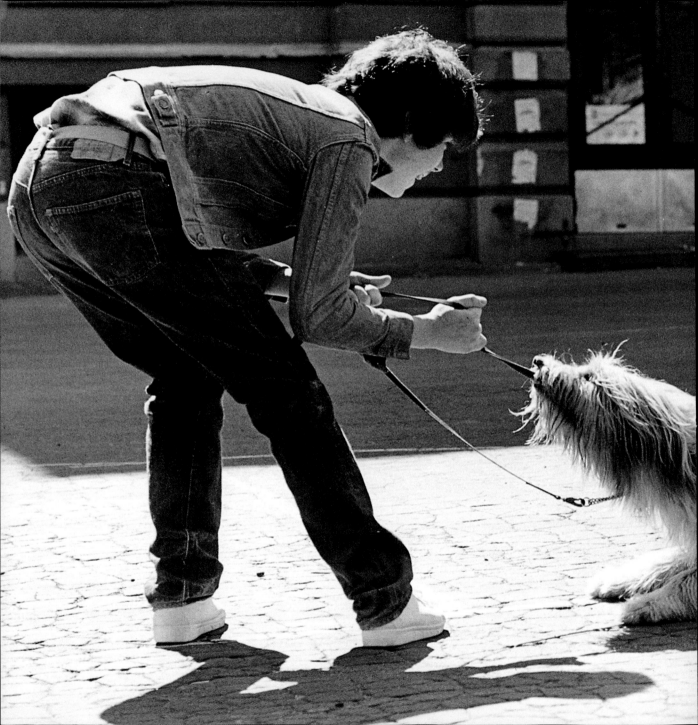

**THOMAS WESTER**
**STOCKHOLM, SWEDEN, 1988**

"This boy and his dog were playing
in a schoolyard. The dog hung onto
the rope and the boy swung him
around and around. They played
this way until finally both staggered
away like two drunken sailors."

## Hunter's Run

Most people don't think of Beagles as being terribly heroic. There's Snoopy, of course—who's heroic in his way! But Beagles are mostly cute and crazy—great companions but hardly heroic. My dog Hunter was an exception. Like most Beagles, he was a bit skittish and he bayed at anything that moved, especially at night. But we loved him, and it broke our hearts that we had to give him away when we moved to the city. In any case, Hunter wouldn't have liked the city—not enough rabbits to bark at. And he loved to bark! After a long and hard search, we found a perfect home for him—a Beagle breeder where Hunter would have lots of friends to play with.

Hunter's new master was a bit exasperated at first by Hunter's insomnia and decidedly noisy per-sonality. So she decided to give him to her husband, who drove a truck part-time to bring in some extra money. The husband had had a few near misses on the road lately after dozing off, and his wife had been begging him to give up his late-night runs altogether. Hunter saved the day. He had always liked to take long rides. The trucker outfitted the cabin of the truck with an elaborate nest for Hunter to sleep in during the day, so he was happy to sit up all night. And his constant baying at night kept his new owner awake on even the dullest stretches of road. In fact, Hunter eventually began to bark at the first sign that his new owner was falling asleep. Not only did Hunter save his new owner's livelihood, he probably saved his life as well.

James Scott, social worker, San Francisco

Photographer unknown
*Howling for Mary Miles Minter and Director Henry King*
Los Angeles, California
c. 1920

Overleaf:
Photographer unknown
*Rex, King of the Wild Horses, and Rin-Tin-Tin Jr., in* The Law of the Wild
n.l., c. 1930's

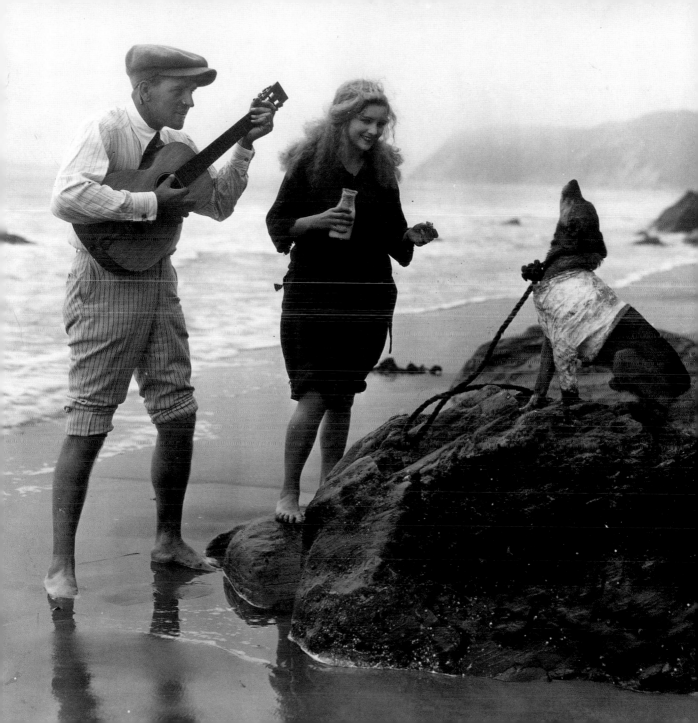

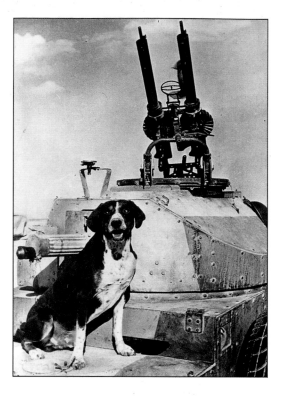

WIDE WORLD
PHOTOGRAPHER
*Butch Guards an RAF*
*Twin-Gunner*
*Western Desert, Libya, c.1942*

Opposite:
U.S. COAST GUARD
*Soogie, Morale Builder*
*First Class and Veteran of*
*Sicily, Salerno, and*
*Normandy Invasions*
*France, 1944*

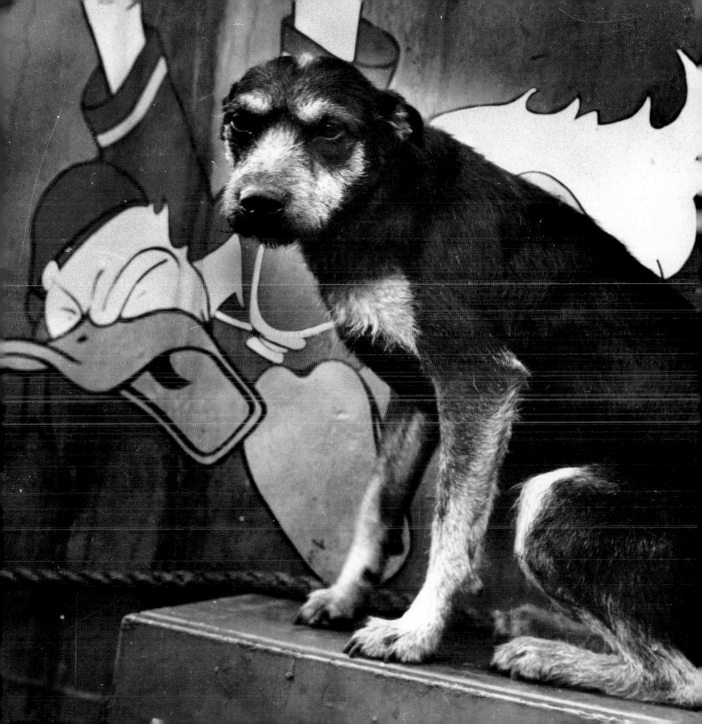

## Demining Dogs

Antonín Malý
*Kazan, U.S.S.R., 1988*

While negotiators from around the world continue the frustrating scramble to keep some sort of peace in war-torn Bosnia, heroic teams of specially trained dogs from the United States are actually saving lives. In tiny Bosnia an estimated two to six million land mines strewn throughout the countryside are responsible for the daily deaths of soldiers and civilians alike. Faced with the daunting task of cleaning up this dangerous mess, the U.S. Army and Department of Defense have begun training teams of highly intelligent dogs—Shepherds, Terriers, and mixed breeds—who will comb the Bosnian countryside hunting for a most deadly prey. Among the first dogs sent overseas were Rega and Chita, two crack deminers trained by the Texas-based Global Training Academy, the world's premier source of demining dogs. Trained to locate explosives by scent, these dogs receive at least twenty weeks of highly sensitive training, twelve weeks longer than that for other types of "bomb dogs." Although a trained deminer working four to six hours a day can clear only a 200-square-meter area (the dogs locate the bombs, which are then detonated by army personnel), some twenty demining teams have finally begun to clean up a sizable portion of Bosnia's deadly landscape. As the peacekeepers bicker at the bargaining table, our canine comrades-in-arms have already distinguished themselves on the frontline.

Ed.

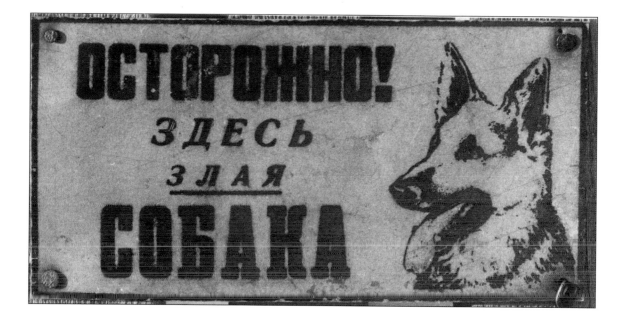

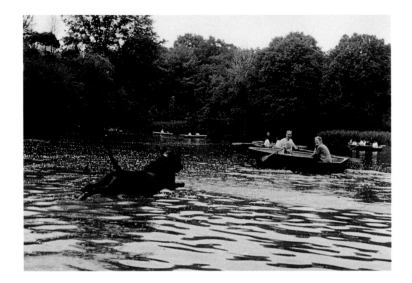

**ROBIN SCHWARTZ**

**CENTRAL PARK, NEW YORK, NY, 1993**

In Central Park, dogs are not supposed to be allowed off their leashes, but they are released and sent for swims anyway. People throw sticks and they jump right in. This is a very common sight.

**TONY MENDOZA**

**GRAYTON BEACH, FL, 1990**

A mutt poses for a photography project called *Dogs On Vacation*.

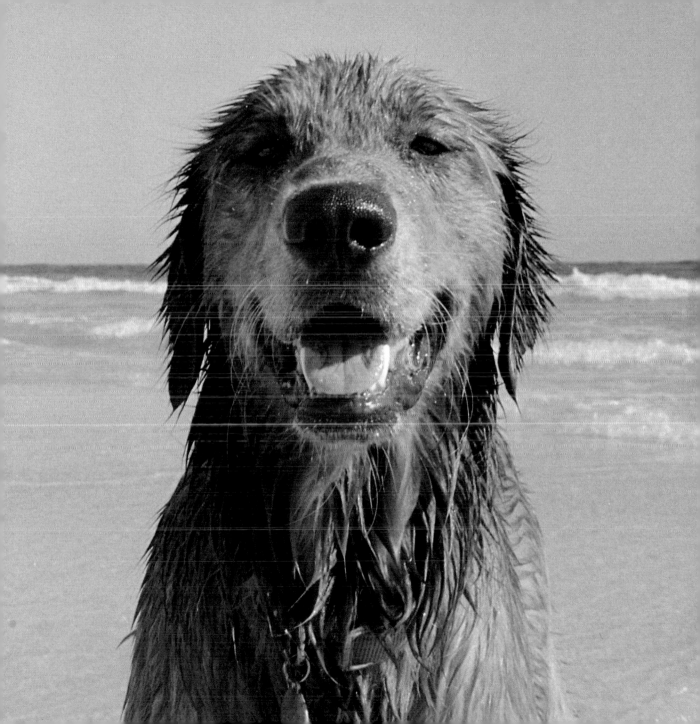

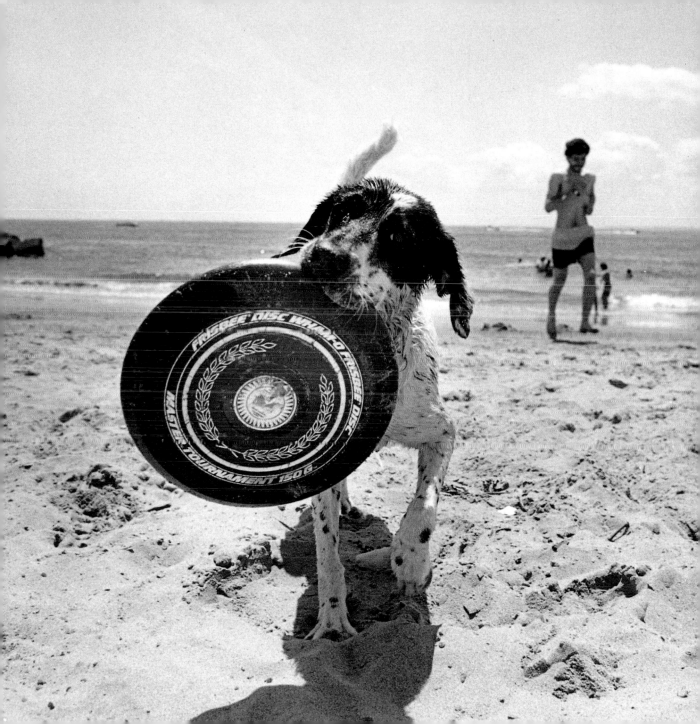

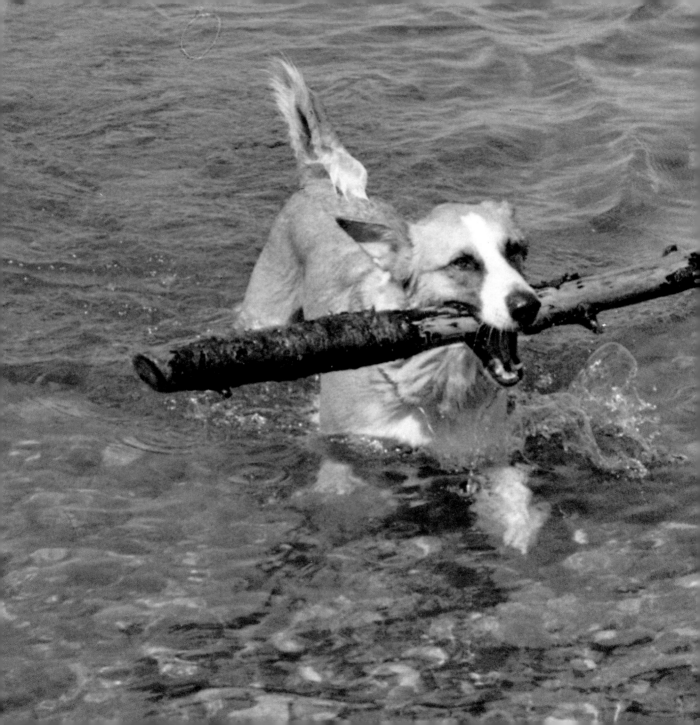

The best thing about a man is his dog.

**PROVERB**

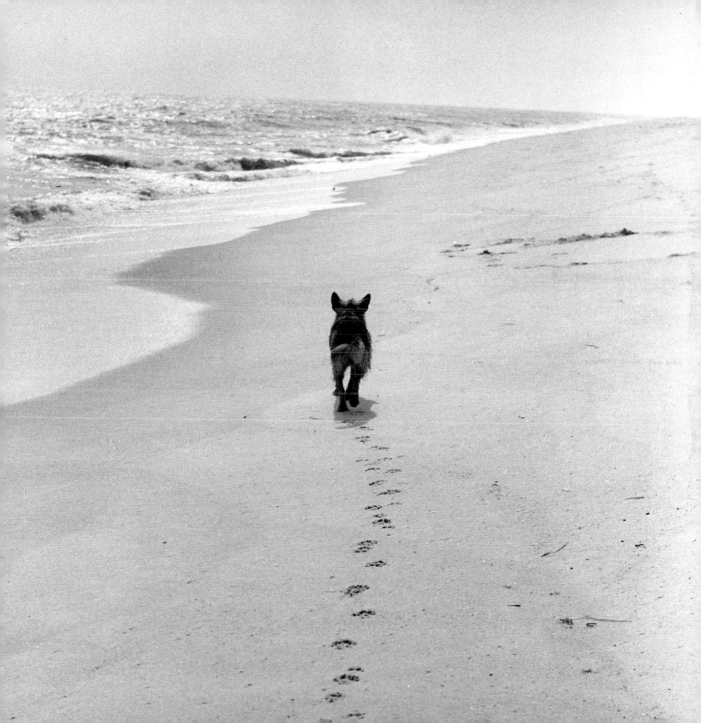

Page 1:
KARL WEATHERLY
*St. Bernard Pup on a Hot Day*
Chapel Hill, North Carolina, 1973

Page 2:
ELLIOT ERWITT
*Sandy, star of the Broadway musical* Annie, *takes a break in Central Park with his owner.*
Central Park, New York, NY, 1977

Page 4:
ROBIN SCHWARTZ
*Juliet Scott, French Bull Dog, at Three Months*
Brooklyn, New York, 1996

## PHOTOGRAPHY CREDITS

© Karl Weatherly/TONY STONE IMAGES: Page 1
© Elliott Erwitt/Magnum Photos: Pages 2, 31, 85, 276-77, 280-81, 303, 316-7
© Robin Schwartz: Pages 5, 28-9, 34-5, 67, 69, 78-9, 108-9, 110-11, 113, 127, 128-9, 158-9, 170-1, 172-3, 183, 200-01, 257, 283, 292, 304, 305, 321, 328, 352, 353, 354, 355, 363
© Laura Baker-Stanton: Pages 9, 45, 246-47, 300, 374
© Antonin Maly: Pages 11, 234-35, 359, 360-1, 373
© John Drysdale: Pages 12-13, 14-15, 39, 51, 54, 55, 71, 102-03, 135, 145, 149, 153, 163, 226, 237, 311
© (Masatoshi Makino)/PHOTONICA: Page 17

© Walter Chandoha: Pages 18-19, 21, 44, 167, 333, 381
Courtesy P.T. Jones/Archive Photos: Pages 22-3
© Karl Baden: Pages 25, 114-15, 116, 117, 168-9, 245, 308-9, 323, 330, 342-3, 347
Nina Leen/Life Magazine, © TIME INC.: Page 27
© Nancy LeVine: Page 33
© Joyce Ravid: Pages 37, 65, 212-13, 315
Courtesy Photofest: Pages 41, 90, 91, 123
© Lars Peter Roos/Tiofoto AB: Page 43
Courtesy Archive Photos: Pages 47, 146-7, 215, 219, 273
Ulnika Åling: Page 48
Ylla: Page 49
© Marc Riboud/Magnum Photos: Page 53
© Stephanie Rausser: Page 57
© Bruce Davidson/Magnum Photos: Page 59
© Rolf Adlercreutz/Tiofoto AB: Page 61
© Jack Jacobs/Art Unlimited, Amsterdam: Pages 62-3
© Teddy Aarni/Tiofoto AB: Pages 72-3
© Kent and Donna Dannen: Pages 75, 253, 337, 349, 350-1
© Lizzie Himmel: Pages 77, 296
© Donna Ruskin: Pages 80, 104, 165, 293, 377
Courtesy Culver Pictures, Inc.: Pages 81, 87, 99, 107, 124, 154-5, 160, 174-5, 190-1, 205, 207, 209, 221, 228, 229, 254, 255, 256, 334-5, 367, 368-9, 370, 371
Courtesy Bettmann/UPI: Pages 83, 240, 259, 260, 261, 264
Pelle Wichmann: Pages 86, 263
© Thomas Wester: Pages 88-9, 364-5
Jane Lidz from Zak: The One of a King Dog, published by Harry N. Abrams © 1997: Page 93
© Marilaide Ghigliano: Pages 94, 95, 289, 291, 320
Courtesy Corbis-Bettmann: Pages 96-7
Courtesy Everett Collection: Pages 100-01, 125, 204, 222
Courtesy UPI/Corbis-Bettmann: Pages 105, 119, 141, 178, 185, 186, 187, 199, 225, 318-9
© Express Newspapers/Archive Photos: Page 121
© Per-Olle Stackman/Tiofoto AB: Pages 130-1
© Tony Mendoza: Pages 133, 282, 375

Published in 2004 by Welcome Books ®
An imprint of Welcome Enterprises, Inc.
6 West 18th Street
New York, NY 10011
(212) 989-3200; Fax (212) 989-3205
www.welcomebooks.biz

Publisher: Lena Tabori
Project Director: Alice Wong
Designer: J.C. Suarès
Project Assistant: Larry Chesler

Distributed to the trade in the U.S. and Canada by
Andrews McMeel Distribution Services
Order Department and Customer Service: (800) 943-9839
Orders-only Fax: (800) 943-9831

The publishers gratefully acknowledge the permission of the following
to reprint the copyrighted material in this book:

Excerpt on pg. 8 from "Verse for a Certain Dog," from *The Portable
Dorothy Parker*, by Dorothy Parker, introduction by Brendan Gill.
Copyright 1928, renewed © 1956 by Dorothy Parker. Used by permis-
sion of Viking Penguin, a division of Penguin Books, USA, Inc.

Excerpt on pg. 10 from "The Dog That Bit People," copyright © 1933,
1961, James Thurber. From *My Life and Hard Times*, published by
HarperCollins.

Excerpt on pg. 30: Sigmund Freud © 1981 The Estate of Anna Freud,
by arrangement with Mark Paterson & Associates.

Elliot Erwitt's quotes pp. 30, 276, 281, 316 from *To the Dogs*, by Elliot
Erwitt, © 1992 by Elliot Erwitt, Magnum Photos.

Excerpt on pg. 50: *How to Get Your Dog To Do What You Want*,
copyright © 1994 by Warren Eckstein and Andrea Eckstein. Reprinted

by permission of Ballantine Books, a division of Random House, Inc.

Excerpt on pg. 132: *Water Dog*, by Richard A. Wolters. Copyright ©
1964, renewed 1992 by Richard A. Wolters. Reprinted by permission
of Dutton Signet, a division of Penguin Books, USA, Inc.

Excerpt on pg. 218 from "Confusing a Puppy" in *Every Dog Should
Own a Man*, copyright © 1952 by Corey Ford. Used by permission of
the Trustees of Dartmouth College.

Excerpt on pg. 238: *The Dog Who Rescues Cats: The True Story of
Ginny*, by Philip Gonzales and Lenore Fleischer, copyright © 1996 by
Philip Gonzales. Reprinted by permission of HarperCollins Publishers,
Inc.

Excerpt on pg. 248 from *Travels with Charley*, by John Steinbeck, ©
1961, 1962 by the Curtis Publishing Company, © 1962 by John
Steinbeck, renewed © 1990 by Elaine Steinbeck, Thom Steinbeck, and
John Steinbeck IV. Used by permission of Viking Penguin, a division of
Penguin Books, USA, Inc.

Excerpt on pg. 278 from "Dog Training," in *One Man's Meat*, by E.B.
White. Copyright 1941 by E.B. White. Reprinted by permission of
HarperCollins Publishers, Inc.

Excerpt on pg. 336: Reprinted from InterActions (Vol. 13, No. 4,
1995) with permission of the Delta Society.

Excerpt on pg. 346 from "Snapshot of a Dog," Copyright © 1935,
James Thurber. Copyright © 1963 Helen Thurber and Rosemary A.
Thurber. From *The Middle-Aged Man on the Flying Trapeze*, published
by HarperCollins Publishers, Inc.

Every attempt has been made to obtain permission to reproduce mate-
rials protected by copyright. Where omissions may have occurred, the
publisher will be happy to acknowledge this in future printings.

Library of Congress Cataloging-in-Publication Data on file.

ISBN 1-932183-21-3

Printed in Singapore

First Edition

10 9 8 7 6 5 4 3 2 1